JASPER JOHNS

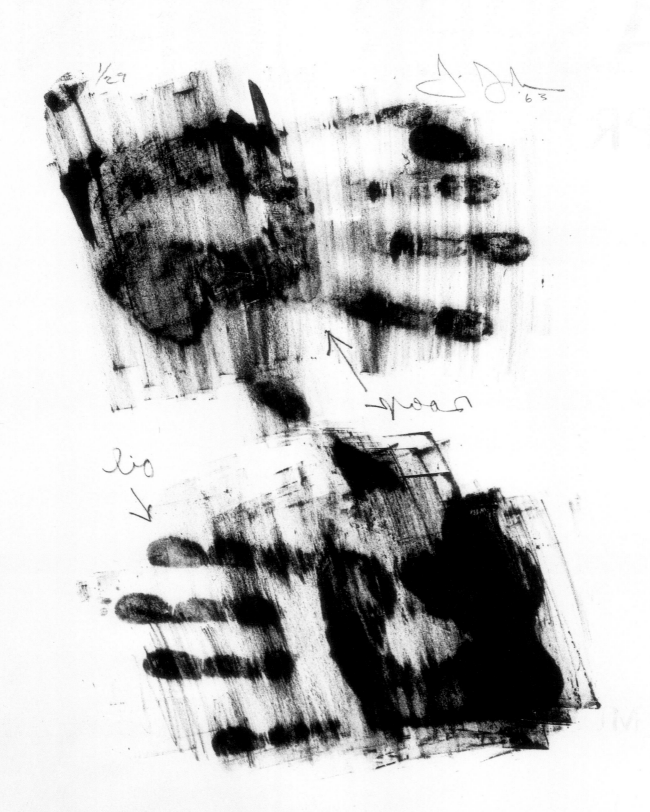

JASPER JOHNS
A PRINT RETROSPECTIVE

RIVA CASTLEMAN

THE MUSEUM OF MODERN ART, NEW YORK

Distributed by New York Graphic Society Books / Little, Brown and Company, Boston

Published on the occasion of the exhibition
Jasper Johns: A Print Retrospective
May 20–August 19, 1986
directed by Riva Castleman
Director of the Department of Prints and Illustrated Books
The Museum of Modern Art

Edited by James Leggio
Designed by Carl Laanes
Production by Tim McDonough
Typesetting by Concept Typographic Services, New York
Color separation by Fotolito Gammacolor, Milan
Printed by Arti Grafiche Brugora, Milan/L.S. Graphic Inc., New York
Bound by Torriani & C., Milan

Distributed outside the United States and Canada
by Thames and Hudson Ltd., London

The Museum of Modern Art
11 West 53 Street
New York, New York 10019

Printed in Italy

frontispiece: HAND (detail). U.L.A.E., 1963.
Lithograph, 22½ × 17½″ (57.1 × 44.5 cm).
The Museum of Modern Art, New York.
Gift of the Celeste and Armand Bartos Foundation.

FOREWORD

IN 1958 THE MUSEUM OF MODERN ART ACQUIRED ITS FIRST PAINTING BY Jasper Johns. Four years later the Museum acquired his first lithographs for the country's foremost collection of modern prints. Only three years after he began making lithographs in 1960, they became important features of print exhibitions held at the Museum. In 1968 a traveling exhibition of Johns's lithographs was sent by the Museum's International Program to eight countries, including Czechoslovakia, Poland, and Yugoslavia. In 1970, at the conclusion of the tour, the exhibition was expanded and shown at the Museum, accompanied by a publication designed by the artist.

While there are several living artists who have made a larger number of prints than Johns, his incorporation of print techniques in every medium gives printmaking a uniquely substantive role in his artistic repertoire. Imprints of his hands and various objects together with silkscreened passages have been significant elements in his drawings and paintings since the early 1960s. Although his works in all mediums are vitally related, it is very rewarding to study the myriad facets of his thought and expression by focusing on the prints alone. Additionally, this emphasis reveals the exceptional craft he has brought to printmaking. Providing a full retrospective view of Johns's prints, this exhibition also presents the first showing of several lithographs made in the 1980s and a series of exceptional, 7½-foot-wide monotypes created in 1983.

The artist's role in preparing an exhibition such as this is always central, particularly when he interests himself in its form and content. Johns has generously given both thought and time to this project, for which we are most grateful. The concept of this book was that of Riva Castleman, Director of the Department of Prints and Illustrated Books, who organized the exhibition with her customary connoisseurship and intelligence, assisted very capably and energetically by Wendy Weitman, Assistant Curator in the department. Both have benefited from the enthusiastic cooperation given to them by the following of the artist's associates, dealers, and publishers: Brooke Alexander, Ted Bonin, Debra Burchett, Patricia Caporaso, Leo Castelli, Sarah Cooke, Sidney Felsen, Bill Goldston, Eileen Kapler, Susan Lorence, Robert Monk, Elizabeth Payne, and Tamie Swett. Our sincere appreciation to them and to the custodians of several collections who have given further invaluable assistance: Monique Beudert, PaineWebber Group Inc.; Carlotta J. Owens, Assistant Curator, Prints and Drawings, National Gallery of Art, Washington, D.C.; Christian Geelhaar, Director, Oeffentliche Kunstsammlung, Kunstmuseum Basel; and Esther Sparks, former Associate Curator, The Art

Institute of Chicago. Among the many members of the Museum staff who have contributed to the realization of the exhibition are notably: Vlasta Odell, Assistant Registrar; Antoinette King, Director of Conservation; Richard Palmer, Coordinator of Exhibitions; Jerry Neuner, Production Manager, Exhibition Program; Richard Tooke, Supervisor of Rights and Reproductions; and the Museum's photographers, Kate Keller and Mali Olatunji. The catalog is a result of superb teamwork and sensitivity on the part of its designer, Carl Laanes; its editor, James Leggio; and the Publications Production Manager, Tim McDonough.

We owe them all our gratitude and admiration.

Richard E. Oldenburg
Director, The Museum of Modern Art

CONTENTS

PREFACE 9

ESSAY / STATEMENTS BY THE ARTIST II

REFERENCE LIST 50

PLATES 51

SELECTED BIBLIOGRAPHY 135

CATALOG OF THE EXHIBITION 138

LENDERS TO THE EXHIBITION 144

TRUSTEES OF THE MUSEUM OF MODERN ART 145

PHOTOGRAPH CREDITS 146

INDEX 147

PREFACE

IN THE FACE OF RELENTLESS INTERPRETATION AND VIRTUOSO DISPLAYS of critical and intellectual agility, Jasper Johns's work maintains a seductive and impenetrable mystery. To say what it looks to be is what it is implies stalwart reliance upon personal perception (though the artist, insinuating that nothing else is required, has said, in an interview with Roberta J. M. Olson in 1977, "The spectator gets everything that I get"). However, the work, no matter how it may provoke avalanches of meaning, reveals itself only as its parts may be identified and related to each other. The sort of iconographical games that this revelation provides never opens the right or wrong doors to the mystery of the work. Like all enigmatic art, Johns's is profoundly complicated by his own labyrinthine preoccupations, yet it offers clues; truth is there, and one finds one's own measure of it.

The following essay has not been embellished with footnotes. Rather than interrupt the reader with such diversions, a bibliography of sources of information pertinent to Johns's prints has been appended. Parallel to the essay text is a selection of quotations from conversations and interviews carried out with the artist by art historians, critics, writers, and friends from 1959 to 1985, and some of his own writings (the sources are identified in the Reference List). One hopes that a sense of the personality, interests, and ambition of Jasper Johns is developed by the intermingled reading of his words and an historical exposition of his prints.

I am indebted to the following, who have made Johns's work the subject of their scholarship and contributed profoundly to mine: Richard S. Field, above all, and Roberta Bernstein, Michael Crichton, Richard Francis, Christian Geelhaar, Judith Goldman, Max Kozloff, Barbara Rose, and David Shapiro. Over many years the printers and publishers mentioned herein have been forthcoming with technical information and thoughtful comments about their projects with the artist. I regret that it was impossible to name many others who have been involved with Johns's work. My gratitude extends to all who have provided the machines, skill, energy, finances, encouragement, and imagination that assured the production of so many impressive works of art in the print mediums by this gifted artist. Among his many associates who have helped with the planning of the exhibition and given welcome and useful advice, my warmest thanks go to two special and longtime friends, Mark Lancaster and David Whitney. Jasper Johns is the author, not only of the works that are the subject of this essay, but of the subtly wrought association that permitted, in conversations and silences, the special qualities of his ideas to pass to me. On the trail of insight and intelligibility, this generous and inspiring experience made my own work more challenging and rewarding.

R. C.

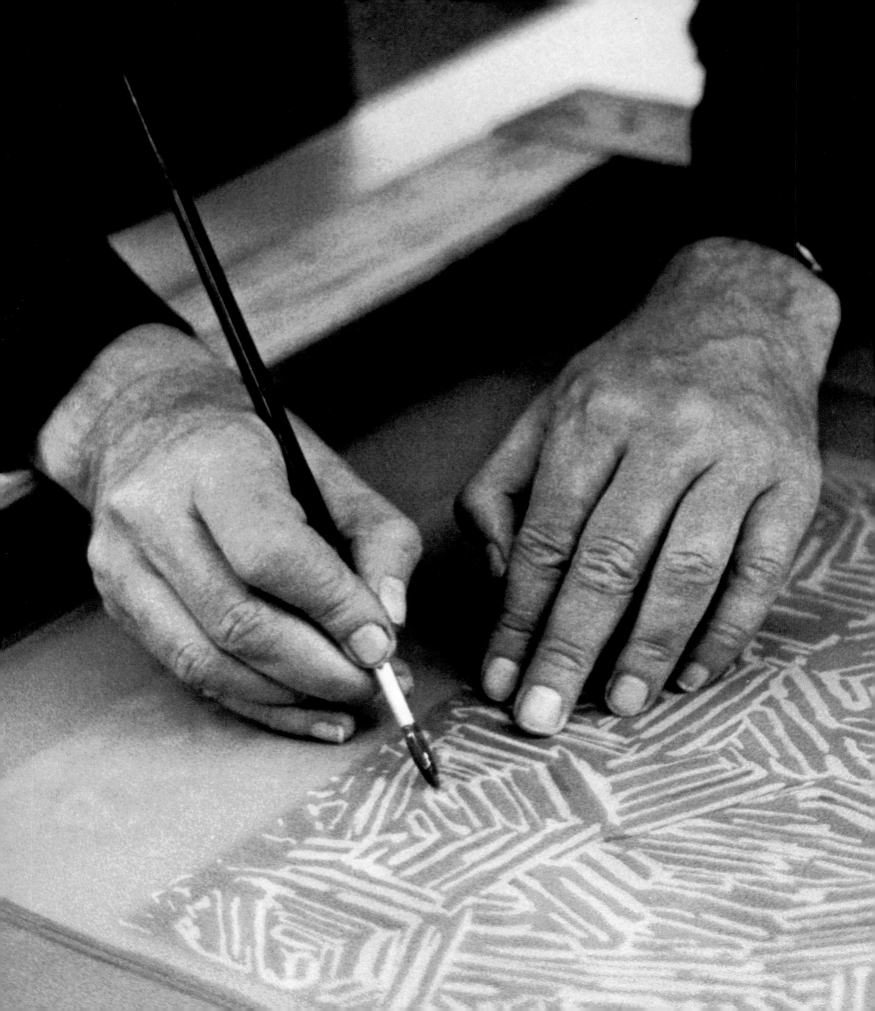

FOR A QUARTER OF A CENTURY JASPER JOHNS HAS WORKED IN THE various techniques of printmaking. That quarter century has spanned the artist's passage from provocative youth to undisputed master. Having established a definitive identity in his paintings during the mid-1950s, immediately eliciting intellectually complex responses from critics, Johns took up the graphic mediums in a structured way that relied exclusively on the compositions he had already achieved. His prints seemed to replicate the flags and targets that were his public signature, as was also the case with his drawings. Conventional expectations required drawings to be studies for such carefully worked-out compositions as Johns made, while prints should be as creative as painting and add to, not derive from, its imagery. Fundamentally, it was suspect that an American artist should seem to follow the spurious traditions of the French school which allowed a Cézanne, a Lautrec, or a Picasso to produce printed (usually lithographic) versions of their paintings. Awareness of the pertinent differences in mediums was not yet sensitized in 1960, and subsequently evolved through exposure to the works of Johns and other artists who investigated the processes by which art was made concrete. Thus, the atmosphere into which Johns's first lithographs of flags, a target, numerals, and a coat hanger entered in 1960 was not yet receptive to what then appeared to be attempts to proliferate the infamous images of a "star." These monochromatic lithographs appealed to some people, but rarely those who appreciated prints. Now, twenty-five years later, when there is little question that Johns has contributed more, qualitatively, than any living artist to the printed form of art, it is difficult to understand why at first the object representations of the compositions distorted the appreciation of their imaginative, controlled, and masterly execution.

When Tatyana Grosman—the painter Maurice Grosman's Siberian-born wife—decided to ask Jasper Johns to make a lithograph, she had already made several important decisions in her late-blooming career as a print publisher. Her husband had made silkscreen

I'd wanted to be an artist from age 5. No one in my immediate family was involved in art (I had a grandmother who painted, though I never knew her) but somehow the idea must have been conveyed to me that an artist is someone of interest in a society. I didn't know artists, but at an early age I realized that in order to be one I'd have to be somewhere else. I always had a tendency to try to be somewhere else. (Glueck 1977)

[Army tour of duty in Japan:] I made posters that advertised movies and that told soldiers how not to get VD. And I painted a Jewish chapel. (Bourdon 1977)

My first mentors were the people whom I met and whose work I saw in New York. I didn't know Duchamp's work until I first saw the Motherwell book. In fact, when my work was first compared to Duchamp and termed Neo-Dada I didn't know who Duchamp was. Therefore I read a copy of Motherwell's book and went to Philadelphia to see the Arensberg Collection of Duchamp's work. After that I started looking at other books written on Duchamp.

The few painters whom I admired and knew when I came to New York were Philip Guston and Jack Tworkov. (Olson 1977)

You get a lot by doing. It's very important for a young artist to see how things are done. The

reproduces of paintings in the 1950s to help support the immigrant couple. When a heart attack weakened his ability to carry on a normal life of painting and teaching, Tatyana tried to sell some of Maurice's silkscreens made after works by their friends. William S. Lieberman, at that time curator of prints at The Museum of Modern Art, and Carl Zigrosser, curator of prints at the Philadelphia Museum of Art and formerly director of the Weyhe Gallery, where he commissioned prints, told her that her prints in the then-unfavored medium of silkscreen, which were not conceived and worked by the artist directly in the medium, were merely reproductions. Anxious for both income and artistic success, Tatyana Grosman turned to lithography, which was reputed to be easily autographic, though considerably more expensive than silkscreen to produce and laborious to print. Printing equipment, materials, printers, and the unknown quotient, skill, required a tremendous commitment—philosophical, physical, and financial. The development of skillfully produced prints depended upon others: knowledgeable printers and willing artists. This was achieved slowly since the printers, in 1957, were few, and artists had little understanding or direction in procedure. In a cottage in West Islip, Long Island, an hour's drive from New York City, Mrs. Grosman put in motion this brave undertaking called Universal Limited Art Editions (U.L.A.E.). Aspiration was high, need to succeed of utter necessity, and integrity fiercely maintained.

Through questioning, looking, and her ability to communicate some sense of artistic mission, Tatyana Grosman brought into her U.L.A.E. workshop many of the innovative artists of the fifties and sixties. She saw Johns's paintings for the first time in the exhibition *Sixteen Americans* at The Museum of Modern Art, in 1959. Uncertain whether printmaking was a worthwhile activity, Johns was persuaded to accept her invitation to work at U.L.A.E. by Larry Rivers, who told him that prints helped pay the rent. Having developed a ploy of leaving lithographic stones at an artist's studio, Mrs. Grosman often trapped the artist

kind of exchange we had was stronger than talking. If you do something then I do something then you do something, it means more than what you say. It's nice to have verbal ideas about painting but better to express them through the medium itself. (Glueck 1977)

I think I had never organized any thinking, any of my own thinking, so that I don't think other people's thought was very interesting to me. (Hopps 1965)

The whole business here in America, of my training and even more the people before me, was rooted in the mythology that the artist was separated and isolated from society and working alone, unappreciated, then dying and after that his work becoming very valuable, and that this was sad. That was part of the way I was trained. I think it's even less true than thinking that one is finding one's own values in the act of painting. One does it—paints—and wishes to do it. If not, you're making it into a kind of martyr situation which doesn't interest me very much. (Swenson 1964)

Sometimes I see it and then paint it. Other times I paint it and then see it. Both are impure situations, and I prefer neither.

At every point in nature there is something to

(fortunately, some found the satiny surface of the stone seductive; unfortunately, others, like Franz Kline, completely ignored it). Johns's primary memory of his own experience was that the stones were heavy and he needed the assistance of Robert Rauschenberg and a local bum to carry them up to his lower Manhattan studio. Johns drew a zero on his first stone. This zero, unlike his first completed print, *Target* (1960; p. 53), which was derived from a drawing, was an essay in figuring out how to go about making a lithograph. It was a symmetrical image not requiring any facility for reversing order, and the single digit seems not to have been placed on the stone with any composition in mind. The frieze of numbers at the top was added, derived from a second drawing, so that the stone now carried two elements never associated before. Johns later decided to use the transformational character of printmaking to create an entire set of numerals from zero to nine on one stone. As he had never made a lithograph, his concept of what he would do hardly arose from understanding; he knew only that he could make corrections and at each stage perhaps prints could be taken. Robert Blackburn, who printed Johns's work between 1960 and 1962, had mastered lithography in France, principally for his own creative work. Yet neither he nor Johns nor Mrs. Grosman knew of Picasso's similar lithographic project, a series of bulls in which the shape of the bull became more abstract in successive stages, through changes made on the same stone. Mary Callery, the sculptor who had aided Mrs. Grosman in the establishment of U.L.A.E., even had a set of the prints in her nearby Long Island home. Johns proceeded over a period of nearly three years to create a suite of all the numbers, drawn, as he had conceived, on the same stone. To reinforce the element of transmutation, each portfolio (there were thirty in the published edition: ten in color inks, ten in black, and ten in gray) carried a uniquely overprinted numeral identical with the number that portfolio represented in the edition. A determination to take ideas involving sets of elements to an ultimate yet infinitely repeatable conclusion is perfectly achieved in the suite *0–9* (1960–63; pp.

see. My work contains similar possibilities for the changing focus of the eye.

Three academic ideas which have been of interest to me are what a teacher of mine (speaking of Cézanne and cubism) called "the rotating point of view" (Larry Rivers recently pointed to a black triangle, two or three feet away from where he had been looking in a painting, and said "...like there's something happening over there too"); Marcel Duchamp's suggestion "to reach the Impossibility of sufficient visual memory to transfer from one like object to another the memory imprint"; and Leonardo's idea ("Therefore, O painter, do not surround your bodies with lines...") that the boundary of a body is neither a part of the enclosed body nor a part of the surrounding atmosphere.

Generally, I am opposed to painting which is concerned with conceptions of simplicity. Everything looks very busy to me. (Miller 1959)

Three works from the past have been important to me: Picasso's *Les Demoiselles d'Avignon*, Marcel Duchamp's *Large Glass* and Cézanne's *The Bather*. But also, for any artist, things that occur during the period in which he's working have equal importance, as Rauschenberg's paintings do for me.

The Picasso painting has a kind of coarseness that's interesting. It makes available different

54–55). Much later, when Johns developed the crosshatch motif that dominated his work during the 1970s, this closed circle of sets became more difficult to detect in its far more complex progressions.

Before the suite *0–9* was completed, Johns produced several prints that displayed his extraordinary ability to mark the stones with the lively jabs and lush strokes that characterized the facture of his drawings and paintings. Starting out, logically, with a monochromatic composition, his instinct to add, transform, scratch away, and otherwise manipulate the greasy drawings on the stones immediately produced works that were "printerly." This innate quality of a composition that could be nothing else but a print is difficult to describe, since monochromatic lithographs tend to be perceived as replicating the drawing on the stone instead of being something quite discrete or unique. The three *Flag* prints of 1960 display, upon sympathetic examination, just what constitutes the difference between a printed drawing and a "printerly" work of art. The brush and tusche (the greasy ink of lithography) passages that encompass the stripes, stars, and field of Johns's emblematic subject must control the rectangular area covered. The dimensional tension that holds together the surface of his paintings and drawings occurs because the matter of these works exists upon the surface within a predetermined and delineated space, rather than being impressed into it. In addition, most of Johns's prints have margins that add to the pictorial implications of the composition, a convention Johns has determinedly sought to exclude from his other work. Therefore, accepting this convention in his prints has meant manipulating the edges of his drawings in a way that holds the printed and unprinted areas taut, reserving the unprinted margin area in a carefully balanced relationship. For example, *Flag II* (1960; p. 59), utilizing the same stone as *Flag* (1960; p. 58), but densely overworked and printed in white, is on a sheet of tan Kraft paper two inches wider and longer than the white paper carrying the black ink of *Flag*, while *Flag III*, again the same stone now scratched

kinds of qualities that are meaningful to me. Duchamp's *Large Glass* shows his conception of work as a mental, not a visual nor a sensual, experience, in which one thing can mean another. With Duchamp language has primacy, and the *Glass* is a pun on opaque meaning and transparent material. He presents in literal terms the difficulty of knowing what anything means—you look through the glass and don't see the piece itself.

As for the Cézanne, it has a synesthetic quality that gives it great sensuality—it makes looking equivalent to touching.

These might be considered great, but in one's own working things not great often have equal or

deeper meaning. One isn't attached just to great things. (Glueck 1977A)

So I was very inquisitive about his [Duchamp's] work and ideas. But he was not a person that I would ever have bothered asking too much, actually I asked very little. He was not terribly generous about exposing himself. (Fuller 1978)

What was negative in Marcel, for himself, became positive in my work, certainly. He said that he wanted to kill art, or to destroy art, [for] himself. Then of course he said that he was nothing but an artist. . . . My interest in his work is not from the point of view of killing art. I

and fragmented, is printed in a recessive gray on white. Although there were manifold choices possible throughout the whole creative process, they varied radically according to the number of technical options available (i.e., only a few types of paper were available in the size needed for this print, and Mrs. Grosman preferred to use the available Rives, Arches, or German Copperplate sheets whole; the Kraft paper, Johns's choice, had to be cut from a large roll and was both an unforeseen and unpopular choice from Mrs. Grosman's point of view, since she felt that a print on cheap paper would be difficult to sell).

Another factor in the conception and execution of these and other prints of the early 1960s was matting. At that time very little margin was shown once the print was put into a window mat and framed. There was, after all, little control over how the purchaser of a print would do this (Johns admits that at the time, even he had folded back margins in order to put a print he owned into a small, affordable frame). The impact of the flatter imagery in art like that of Johns was beginning to put the physical aspect of margins into perspective. Formerly simply removed after being used in pulling the print from the plate, margins regained a usefulness in the nineteenth century as areas for notations by the artist and printer, conventionally printed or, after Whistler, hand-signed and annotated with specific information on the state and edition. In the twentieth century most prints have had margins spacious enough for signature and edition markings. Partly because of the actual limitations in variety of paper, both in size and quality, after World War II some lithographs were printed to the edge of the sheet, and the signature was placed within the composition. At Universal Limited Art Editions, however, Mrs. Grosman maintained the margin. Where Johns's work was concerned, she preferred to have the image drawn on the stone well within its edges so that the fragile edges of the stone did not impress the paper or take more pressure than necessary. Larry Rivers, the first artist to work at Universal Limited Art Editions, in 1957, always drew his compositions to the edge of the stone, making its uneven

know one's not supposed to say this, it's not quite proper, but I regard his work as art of a positive nature. I see it as *art*. (Fuller 1978)

Basically, artists work out of rather stupid kinds of impulses and then the work is done. After that the work is used. In terms of comment, the work probably has it, some aspect which resembles language. Publicly a work becomes not just intention, but the way it is used. If an artist makes something—or if you make chewing gum and everybody ends up using it as glue, whoever made it is given the responsibility of making glue, even if what he really intends is chewing gum. You can't control that kind of thing. As far

as beginning to make a work, one can do it for any reason. (Swenson 1964)

There is a great deal of intention in painting; it's rather unavoidable. But when a work is let out by the artist and said to be complete, the intention loosens. Then it's subject to all kinds of use and misuse and pun. Occasionally someone will see the work in a way that even changes its significance for the person who made it; the work is no longer "intention," but the thing being seen and someone responding to it. They will see it in a way that makes you think, that is a possible way of seeing it. Then you, as the artist, can enjoy it—that's possible—or you can

impression a vital part of his prints. His album done with Frank O'Hara, *Stones* (1957–59), emphasized this physical characteristic of lithography, particularly as it was printed on soft, handmade paper. However, so little technical expertise then existed in the studio that the friability of the edges of the stones was not yet clear. As they chipped and cracked, Mrs. Grosman began to realize the economic and functional impact of each operation. Remarking, recently, on the situation of prints during the early 1960s, Johns noted that the margins of a print were frequently chopped off when buyers discovered that a frame large enough to hold the entire sheet cost more than the print. When Mrs. Grosman recognized that prints had the possibility of becoming important wall objects, she advised her customers to mat and frame them more generously, with the whole sheet visible, giving it a larger presence and possibly a more apparent value. At that moment the artist's signature took on a new relationship to the printed image, and began to have compositional repercussions. Given these historical circumstances it is understandable that Johns insists that margins are integral parts of his compositions.

The lithographic prints Johns worked on in 1962 were far more ambitious in scale and composition. By then the developments made in his paintings consisted of a greater repertoire of signs, actions, and disjunctions that provided a different level of procedure in printmaking. His first multicolor prints (*Painting with Two Balls* and *False Start*; pp. 61, 62) appeared. These works did not yet fully utilize the layering of transparent tones that may be exploited in lithography, but the thick build-up of ink in *False Start I* and *False Start II* gives some sense of the artist's intention to attack and twist the medium into a form that offered a new sort of physicality to print. The flat, unprinted paper, stabilized by a rigidly straight line at the lower edge of the printed area, keeps at bay the tumbling strokes of thinned and thickened tusche, here and there pinned down with Johns's preferred stenciled letters, now spelling the names of colors. Occasionally, the technical capabilities of both the artist and

lament it. If you like, you can try to express the intention more clearly in another work. But what is interesting is anyone having the experiences he has. (Swenson 1964)

My paintings are not simply expressive gestures. Some of them I have thought of as facts, or at any rate there has been some attempt to say that a thing has a certain nature. Saying that, one hopes to avoid saying I feel this way about this thing; one says this thing is this thing, and one responds to what one thinks is so.

I am concerned with a thing's not being what it was, with its becoming something other than what it is, with any moment in which one identi-

fies a thing precisely and with the slipping away of that moment, with at any moment seeing or saying and letting it go at that. (Swenson 1964)

I think that the picture isn't pre-formed, I think it is formed as it is made; and might be anything. I think it resembles life, in that in any, say, ten-year period in one's life, anything one may intend might be something quite different by the time the time is up—that one may not do what one had in mind, and certainly one would do much more than one had in mind. But, once one has spent that time, then one can make some statement about it; but that is a different experience from the experience of spending the time. (Sylvester [1965] 1974)

the printer were overreached to achieve the subtle and ended in timid or disastrous results (*Red, Yellow, Blue* and *Alphabets*; p. 57). Nevertheless, even in the abandoned *Alphabets*, the elements that were to be combined show a method, taken in part from drawing, thought out as a series of discrete operations. These reinforcements and graphic insinuations, unifying elements that otherwise have a rather boring contiguity, vivify the surface, giving it both contrapuntal and rhythmic variety.

Johns's use of words—which he has characterized as directional, changing the movement of the surface through their stubbornly left-to-right reading—is clearest and most concise in the 1962 prints. The words move throughout the field of *False Start*, taking the eye diagonally and vertically, right-side up and upside down. As he tried to free the field from any perspective, Johns disoriented normal viewing procedures by making the eye read words in unaccustomed directions. Years later, examining reproductions of some of his favorite paintings, Johns turned them every which way, displaying the traditional painter's manner of studying the progress of his own work. Compositional incidents that organize works are often revealed by looking at them sideways or upside down. The dynamics of negative space, more acute when viewed this way, are given a special clarity in Johns's works as he makes the activity of his compositions rotate in front of the viewer. Eventually a kind of inertia results, intensified by the confusing realization that the names of colors do not always stand for the colors they name.

The two prints that recapitulate the painting and drawings *Painting with Two Balls* presented in a new medium the distraction of illusion. The two balls that seem to hold the canvases apart now had to be rendered in the round while the flat, split canvases, tensed by the intrusion, have been even more distorted by the energetic skeins of crayon appearing on the left. The print *Painting with Two Balls* is not only Johns's first color print and the first to incorporate the bands of red, yellow, and blue that will be sustaining compositional

Well, sometimes it happens unconsciously that we return to something, some aspect of something which is done returns in another painting unconsciously. There's another thing. In working, if you attempt to work in a way that changes, which I try to do, it can be exhausting at times and you may go back to something more familiar just as a rest. And then sometimes there is some deliberate reason for perhaps doing something that you had always meant to do and had never done. (Hopps 1965)

I understand that if you have an idea for a picture and if you make a picture, and if you take certain characteristics of a picture or whatever and make another picture, that they will share something, there will be some information, perhaps, which is conveyed by either of them. But I think what is more interesting to me is the particular object encountered at any moment. Oh, that's questionable, but I tend to think that the one object which is being examined is what's important. (Hopps 1965)

...one ought to be able to use anything that one can see and any quality one can perceive. It's difficult for me to just do that...because I formed habits which only let in certain things or sometimes because the qualities simply are not visible, until a certain time. Suddenly you see

elements in his prints for over twenty years, but also the first to incorporate representations of clearly three-dimensional objects. Up to this time flat objects, such as the one in *Coat Hanger* (1960; p. 60) and the sticks that produced the semicircles in *Device* (1962), had relatively two-dimensional presences in these works as their functions emphasized the surface, thus differing from the intrusive balls.

The next work to include objects rounded and seen in depth was Johns's most popular print, *Ale Cans* (1964; p. 63). Taken from the representation of his sculpture *Painted Bronze* (1960), depicting two cans of Ballantine Ale, that was on the cover of Leo Steinberg's book about Johns, issued in 1963, the drably colored images of opened and unopened cans in their real scale emerge from a dark and definitively unstructured ground. Certain elements in the sculpture, such as the difference in the product symbol on the tops of the cans and the finger-marked textures of their modeled surfaces, are discarded. Busy tracks of crayon lines weave together the planes of the base, the curves of the cans, and the black void. Finally, a few lines break loose at the edges, pinning the picture flat to its margins. Much has been said about this print: its theme seemed presumptuously "Pop," its details were ambiguous, and its presentation at odds with what appeared to be Johns's prior intentions. In later renditions of the subjects of his sculptures, from *First Etchings* (1967–68) to the last *Savarin* monotypes of 1982 (after another *Painted Bronze* of 1960), Johns explores their spatial, iconographic, and personal functions. The sculptures have considerable affinities with figurative bronzes, say of Matisse or Picasso, in the early twentieth century. They are forms modeled after reality—recumbent light bulbs and frontal portraits of cans. As Johns explored further the rendering of three-dimensionality in his prints (the objects in *Pinion* and *Voice*, the cast fragment of a body part in *Passage*) he preferred to use photographs of the objects as they were in his paintings, instead of drawing them.

Introduced into his work in 1962 was another, more direct formula for physical or

something you have not seen. I don't know for what reason. It's clearly not something you've invented. (Hopps 1965)

Sometimes I have an idea for a picture. It may just be a detail that I want to use in a picture and I may make a sketch of it and then at a certain point it seems that it's time to begin and I begin. It doesn't mean that the painting is formed before but it means at least that there's enough to be done that I can start doing it. (Solomon 1966)

I thought that one thing to do with the written word was to pretend that it was an object that could be bent, turned upside down and I began more or less folding words or painting the illusion of a folded word. (Solomon 1966)

I have attempted to develop my thinking in such a way that the work I've done is not me—not to confuse my feelings with what I produced. I didn't want my work to be an exposure of my feelings. Abstract-Expressionism was so lively—personal identity and painting were more or less the same, and I tried to operate the same way. But I found I couldn't do anything that would be identical with my feelings. So I worked in such a way that I could say that it's not me. That accounts for the separation. (Raynor 1973)

personal representation. Maintaining the flat yet not static foundation of his work, Johns began to imprint his own hands and other body parts onto his canvases, drawings, and prints. Bound to medium (the majority of his painting has been done in encaustic, the heated wax-based paint that entails an unusual degree of mastery but in return provides distinct layering which neither mars nor melds prior work), Johns experimented with two greasy materials (oil and soap) to imprint his hands on the lithographic stone in *Hand* (1963). In *Hatteras* (1963; p. 125), a single-stone version of one of his tributes to a poet he admired, Hart Crane, a sweeping arm and hand produce the semicircle, which had been the task of the sticks in *Device*. The arm appears here to cut through the bands, now lettered RED, YELLOW, and BLUE, that stabilize the surface but still insinuate the infinite repetition of the spectrum. Between 1961 and 1967 Johns regularly worked at his home on Edisto Beach, South Carolina. The appearance of sweeping hands and arms, as well as other valuable human traces, coincides with his life in this sandy environment where the body becomes utterly sensitized to its own impact. While the sweep of his arm in *Hatteras* (and later its lunging trajectory in the prints *Land's End* of 1978 and *Periscope* of 1979) has the drama of past movement, the bodily impressions in *Pinion* (1963–66; p. 126) are those of a person on one knee, about to race off from a runner's starting position. Begun as a work to contain a poem by Frank O'Hara, the stone carrying the imprint was finally combined with a photoplate (from the painting *Eddingsville* of 1965) printed in a rainbow roll or spectrum of inks.

Skin with O'Hara Poem (1963–65; p. 127) was the definitive body impression on stone that followed four drawings of the same format (1962). Engineers' drafting paper gave the delimiting format to the imprint, somewhat as rulers, straight marginal lines, and scales of numbers had done in other works. The semitransparent, brittle paper provided an unusual and anonymous surface for the artist's uninhibited embrace of the stone. The poem

I find all use of space emotionally affective. But there's no intention on my part to achieve that—then you lead people on. There's a Leonardo drawing that shows the end of the world, and there's this little figure standing there, and I assume it's Leonardo. For me, it's an incredibly moving piece of work—but you can't say that, in any way, was an interest of Leonardo's. (Stevens 1977)

[The image] comes from a thought, basically. The thought has certain implications and then if you try to deal with the implications you have to do a certain amount of work. (Martin 1980)

I was interested in what was seen, and what was not seen. One wanted to avoid the idea of an interpretation, and—I know how simple-minded it is—but nevertheless those sorts of images gave a sense of objectivity rather than of subjectivity. And then one could deal with the question of when you see it, when you don't see it, what do you see, what do you think it is, how do you change what you see, and what differences do these changes make to what you see and to what you think. It's a rich area for nuance there. It's a pretty limited area if you are going to make any strong point. But I was interested in the kind of nuance, modulation, play be-

by O'Hara was added to the composition two years after the imprint was made, and remains the sole example from what was intended to be a portfolio of prints on unusual papers in a variety of shapes and sizes incorporating new works by the poet. There is an uncomfortable eroticism in Johns's references to the human body, whether in cast fragments or in the imprinted residue of his own acts. To use the body as an object, a piece of it or a remnant of its presence, is to emphasize the morbid and/or erotic. Ex-votos, the shroud of Turin, and Veronica's veil are models of the same evocation of passion, wherein such specificity gives a singular and powerful dimension.

The next concept that Johns took up in print was doubling, using the form of the map of the United States that he first painted in 1960. *Two Maps I* (1965–66) and *Two Maps II* (1966; p. 102) were the earliest examples of works in the print mediums that recapitulated within themselves Johns's concept of doing something and then "something else" to an object. While the prints of *Flag* and *Painting with Two Balls* had been extended through further work into other states and *False Start* had been printed two ways, in color and in grays, their subtly differed images were separate ones. In *Two Maps,* doubling occurred within the composition, presenting a model for an important aspect of Johns's work. Because Johns enjoys playing the visual game of identification, particularly when there is the confounding principle of identicalness involved, such subjects as *Ale Cans* and, much later, the crosshatch compositions have an hypnotic fascination. In 1959 he painted two flags, one above the other, emulating the Zen *koan* articulated by his friend John Cage that the repetition of something boring might make it interesting. In 1965, he told Walter Hopps about his sculptured ale cans, "I like that there is the possibility that one might take one for the other, but I also like that, with just a little examination, it's very clear that one is not the other." With the maps, there are differences arising simply from the application and puddling of tusche which cause, for example, Lake Superior to nearly disappear in the lower

tween thinking, seeing, saying and nothing. (Fuller 1978)

The idea is often simply a way to focus your interest in making a work.... The function of the work is not to express the idea. (Martin 1980)

I'm always interested in the physical form of whatever I'm doing and often repeat an image in another physical form just to see what happens, what the difference is, to see what it is that connects them and what it is that separates them ... the experience of one is related to the experience of the other. For me it is. (Martin 1980)

Seeing a thing can sometimes trigger the mind to make another thing. In some instances the new work may include, as a sort of subject matter, references to the thing that was seen. And, because works of painting tend to share many aspects, working itself may initiate memories of other works. Naming or painting these ghosts sometimes seems a way to stop their nagging. (Francis [1982] 1984)

An object that tells of the loss, destruction, disappearance of objects. Does not speak of itself. Tells of others. Will it include them? Deluge. (Sketchbook [n.d.] 1964)

map. The negative/positive reversal of the two versions of the print adds to the enchantment of a vigorous visual exercise in which memory plays the leader.

In 1967–68 he put into lithographic form the paintings *Flags* (1965) and *Targets* (1966), completed during the time *Two Maps* was being printed. In these lithographic versions the orange, purple, and green target and orange, green, and black flag (p. 103), on gray grounds, hover over lightly drawn white and gray representations of the same objects, which, like their upper companions, contain a dot. Concentration on the dot above produces an afterimage in complementary colors when the eye moves to the dot below. At a time when so much attention was being paid to kinetic and optical effects in art, it is not surprising to find in Johns's work some reaction, taken far beyond the superficial trick to an unpredictable area of insolubility: the lower target and flag are incomplete, losing about a quarter of their image at the edge of the sheet. With these prints there is no margin; the necessity for the lower objects to disappear meant that the total sheet had to be printed. Unlike *Pinion,* where a descending wire invades the lower margin, or *Two Maps I,* where splatters of white ink make the black boundaries continue rather than enfold the image, the *Targets* and *Flags* prints avoid the framing aspect of the margin, making the works pseudopaintings on paper. This character was reinforced in a second version of *Flags* (1967–70), in which an overrun of the first edition was broadly worked and overprinted with a resulting waxlike surface that obscured the optical game. Reusing the added plates of the 1967–70 *Flags,* but placing them vertically, and side by side, Johns set up the diptych form in *Two Flags* (Gray) (1970–72; p. 104) from which the crosshatch prints *Corpse and Mirror* and *The Dutch Wives* (pp. 106–9) might be extrapolated.

Johns's fondness for the print mediums derives in great part from their inherent retention of actions, as they continue to exist on separate stones and plates. He would have liked to have kept every stone, every screen, every copperplate—envious of Edvard

Competition as definition of one kind of focus. Competition (?) for different kinds of focus. What prize? Price? Value? Quantity? (Sketchbook [n.d.] 1964)

Focus. Include one's looking. Include one's seeing. Include one's using. It and its use and its action. As it is, was, might be (each as a single tense, all as one). A = B. A is B. A represents B (do what I do, do what I say). (Sketchbook [n.d.] 1964)

Make something, a kind of object which as it changes or falls apart (dies as it were) or increases in its parts (grows as it were) offers no clue as to what its state or form or nature was at any previous time. Physical and Metaphysical Obstinacy. Could this be a useful object? (Sketchbook [n.d.] 1964)

A Dead Man. Take a skull. Cover it with paint. Rub it against canvas. Skull against canvas. (Sketchbook [n.d.] 1964)

One thing made of another. One thing used as another. *An arrogant object.* (Sketchbook [n.d.] 1965)

Beware of the body and the mind. Avoid a polar situation. Think of the edge of the city and the traffic there. (Sketchbook [n.d.] 1965)

Munch, who returned periodically to his woodblocks and stones, as well as to the subjects of his painting, for yet another transformation. Having never had his own printing facilities, Johns has never been able to totally control this factor and regrets that because of economics, "you can't keep everything." It becomes clear as he returns again and again to familiar images that he seeks not solutions per se, but further values, insights, and emotions. In his 1985 lithograph *Ventriloquist* (p. 132), the mere edges of some two-flags images that are ruthlessly cut off at the side margins appear to be glimpses of old friends, and only then do they confound eye and logic by their placement. Seeking the familiar as a foundation for understanding the new, it is possible to use even the merest fragment of a Johns print to start an entire chain of revelations.

Infinitely repeatable sets, notation through indication, and doubling appear to be important formulae for the construction of Johns's compositions and are ways of dealing with wholeness. These formulae represent methods of closing off or completion so that what seems continuous is only so within the context of each individual work. An example of this in his prints is *Device* (1962 and 1972; p. 80), in which the scraped semicircles at each side offer two choices: continuation of their circuits beyond the composition's perimeter or completion of each by joining the picture's edges, thereby creating a cylinder. In other works, such as *Fool's House* (1972; p. 81), the stenciled title or name of the artist is incomplete at the left side of the composition, inevitably leading the eye to search out the missing letters on the right. This cylindrical formation was developed in greater depth in the *Four Panels from Untitled 1972* (1973–74), *Usuyuki* (1979–81), and *Voice 2* (1982–83) prints and in the untitled monotypes of 1983.

Paintings that incorporated real objects presented several problems when transposed into print, requiring unconventional technical and compositional solutions. The portrayal of the hanger in the *Coat Hanger* (1960) lithographs has a one-to-one relationship with its wire

Objects should be *loose* in space. Fill (?) the space loosely. RITZ (?) CRACKERS, "if the contents of this package have settled," Etc. Space everywhere (objects, no objects) MOVEMENT. (Sketchbook [n.d.] 1965)

The watchman falls "into" the "trap" of looking. The "spy" is a different person. "Looking" is and is not "eating" and "being eaten." (Cézanne?—each object reflecting the other.) That is, there is continuity of some sort among the watchman, the space, the objects. The spy must be ready to "move," must be aware of his entrances and exits. The watchman leaves his job & takes away no information. The spy must remember and must remember himself and his remembering. The spy designs himself to be overlooked. The watchman "serves" as a warning. Will the spy and the watchman ever meet? In a painting named SPY, will he be present? The spy stations himself to observe the watchman. If the spy is a foreign object, why is the eye not irritated? Is he invisible? When the spy irritates, we try to remove him. "Not spying, just looking"—Watchman. (Sketchbook [n.d.] 1965)

Take a canvas
Put a mark on it.
Put another mark on it.
 " " " " "

ancestor in Johns's 1958–59 drawing and painting. It took many different approaches, however, before Johns was able to adjust his compositions to the serious intention of presenting rather than representing real objects. Photography provided a means of inserting **three-dimensional** forms into his lithographs and etchings. In the photoplate used in *Pinion*, a ruler indicates how carefully he maintained the real scale of the objects. In *Passage I* (1966; p. 73), the foundation of the entire print is a photograph of the painting *Passage II* of the same year. Considerable alteration occurred through the addition of heavy brushstrokes surrounding the circular imprint of the bottom of a can, recomposing the lower right portion of the picture and bisecting the red and yellow panels. The lithographic marks contrast with the veiled screen-texture of the photographic rendering of the painting—yet another level of masking in a composition replete with mystery and insinuation. The angle of the photograph of the cast legs extends the printed area into the upper margin, where, like the flipped letters spelling out RED, ORANGE, and YELLOW that intrude into the lower margin, there is a battle between illusion and graphic fact.

The use of photographic elements as portions of prints became more systematized and exclusive after *Passage*. A fork and spoon hanging from a wire in the painting *Voice* (1964–67) were photographed and, before a plate was made, Johns wrote on the photograph that the size of the "fork should be 7″ long." While this note has been obliterated in the print *Voice* (1966–67; p. 83), the full note with fork and spoon are the substance of paintings called *Screen Piece* in 1967–68 (reworked as his fifth screenprint in 1972), appear as part of *Wall Piece* (1969), and were screened onto the painting *Voice 2* in 1971.

Among the most personal objects in Johns's work, the fork and spoon have been subjected to much iconographic conjecture, particularly in their relationship to *Voice*, where they might allude to eating, which interferes with the functioning of the voice. Forks and/or spoons were included in several of the paintings with objects that Johns produced

Make something.
Find a use for it.
AND / OR
Invent a function.
Find an object.

One thing working one way
Another thing working another way.
One thing working different ways
at different times.

Take an object.
Do something to it.
Do something else to it.
″ ″ ″ ″ ″

(Sketchbook [n.d.] 1965)

2 kinds of "space"
one on top of the other
and/or /other?)
one "inside" the other (Is one a detail of the
 ″ around ″ ″
What can one do with "one includes the other"?
"something" can be either one thing or another
(without turning the rabbit on its side)

(Sketchbook [n.d.] 1968–69)

Whether to see the 2 parts as one thing or as two things.
Another possibility: to see that something has happened. Is this best shown by "pointing to" it or by "hiding" it. (Sketchbook [n.d.] 1969)

during the most productive period of his career, 1961–62. Unlike the paintbrushes, cans, and rulers that pointed to his profession, the table implements may be assumed to have intimate references that go beyond the life of the studio. If it is to be understood that one of the strongest elements in Johns's works is its autobiographical nature, then items such as spoons and forks take on an importance over and above their presence in the realm of seeing and saying. Bound together in perpetual embrace, a spoon and fork occupy the center of one panel of the painting *In Memory of My Feelings—Frank O'Hara* (1961). After O'Hara died in a tragic accident on the beach, Johns concluded his work on the painting *Voice* by hanging the spoon and fork at its side. Later, in one illustration to the poem "In Memory of My Feelings" in a memorial publication of O'Hara's work (1967), Johns formally places the fork and spoon accompanied by a knife in a normal table setting, and on the last page of the poem the spoon is shown alone. In an etching he depicts the hanging fork, now joined with his familiar ruler (1969; p. 85). As in the memorial illustration of two years earlier, these objects are drawn rather than photographed.

It is in *First Etchings* (1967–68; p. 64), however, that the artist confronts the viewer with the most esoteric conjunction of photographic representation and autographic rendering of objects. The subject of the album is the sculpture that Johns had created between 1958 and 1960. Beginning with the earliest piece, a mounted flashlight, Johns proceeds to jot down in wiry, nervous lines the outline of each object, simply for the *Lightbulb*, shadowily for the *Ale Cans* and *Paintbrushes*, systematically for *Numbers* and the *Flag* (represented in reverse). With the exception of a seventh print, derived though not actually printed from the actual ale can that was unrolled and fitted onto the cover of the album, each etching shares space on its sheet of paper with a photoengraving of the object that spawned it. Coupling these etchings with the photographic appearance of the objects, three-dimensional or in low relief, that inspired them clarifies to some degree how Johns recasts subjects for diversified

It is what it does. What can you do with it? Alternatives. Not a logical system. That is, not contained. continuity/discontinuity (Sketchbook [n.d.] 1969)

Shake (shift) parts of some of the letters in VOICE (2). *A not complete unit* or a new unit. The elements in the 3 parts should neither fit nor not fit together. One would like not to be led. Avoid the idea of a puzzle which could be solved. Remove the signs of "thought." It is not the "thought" which needs showing. (Sketchbook [n.d.] 1968–69)

... one also thinks of things as having a certain quality, and in time these qualities change. The Flag, for instance, one thinks it has 48 stars and suddenly it has 50 stars; it is no longer of any great interest. The Coke bottle, which seemed like a most ordinary untransformable object in our society, suddenly some years ago appeared quart-sized: the small bottle had been enlarged to make a very large bottle which looked most peculiar except the top of the bottle remained the same size—they used the same cap on it. The flashlight: I had a particular idea in my mind what a flashlight looked like—I hadn't really handled a flashlight, since, I guess, I was a child—and I had this image of a flashlight in my head and I wanted to go and buy one as a model. I looked for a week for what I thought looked like an ordinary flashlight, and I found all kinds

impact. The twentieth-century viewer is programed to accept the photographed image as closer to reality than a hand-rendered image. Credibility is put in a state of suspense when the object photographed is also hand-rendered, but eventually that representation seems still more real than a linear representation.

Hopeful that his point—that there are myriad possibilities of looking at, seeing, and believing—could be maintained in a less empirical format, Johns reworked all the plates, including the photoengravings, for an album of *First Etchings, Second State* (1967–69; p. 65). Using aquatint and open-bite etching over the linear etchings, he produced lushly modulated surfaces, which in the patterns of his *Flag* and *Numbers* become intricately plastic. Most remarkable is the cursory manner in which he transformed the photoengravings, now set like jewels in generous expanses of creamy, textured, handmade paper. With rapid scratches of the etching stylus or swabs of a brush loaded with acid, Johns cancelled the photographic reality of his sculptures. He unknowingly treated photoengravings of his own creations in a way similar to Picasso's illustrations for a book by Georges Hugnet, *La chèvre-feuille* (in 1943 Picasso etched lines into photoengravings of his drawings). In both cases the additions confuse and confound the realness of the photograph. In Johns's prints, however, where the pictures are of sculptures of objects not ordinarily considered worthy of commemoration in this manner, acceptance of the representation requires more acute observation. A reproduction of a drawing, such as Picasso's, is simply a step further from the reality of lines on paper. Adding lines to the reproduction affirms this step and adds another layer of reality. A reproduction of a Johns sculpture, however, is not only a transformation of three to two dimensions but a reorganization of matter. Like the photographed areas in *Passage*, these photoengravings reorder our sense of the real and demonstrate the artist's determination to give equivalent value to objects, language, color, line, process, and technique.

of flashlights with red plastic shields, wings on the sides, all kinds of things, and I finally found one that I wanted. And it made me very suspect of my idea, because it was so difficult to find this thing I had thought was so common. . . . It turns out that actually the choice is quite personal and is not really based on one's observations at all. (Sylvester [1965] 1974)

. . . we look in a certain direction and we see one thing, we look in another way and we see another thing. So that what we call "thing" becomes very elusive and very flexible, and it involves the arrangement of elements before us, and it also involves the arrangement of our senses at the time of encountering this thing. It involves the way we focus, what we are willing to accept as being there. In the process of working on a painting, all of these things interest me. I tend, while setting one thing up, to move away from it to another possibility within the painting, I believe. At least that would be an ambition of mine; whether it is an accomplishment I don't know. And the process of my working involves this indirect unanchored way of looking at what I am doing. (Sylvester [1965] 1974)

I don't know whether one wants anything other than to just work and stop work. (Sylvester [1965] 1974)

The metamorphosis of what is represented by the process used is most extensive in printmaking. *Decoy* (1971; p. 74), with its frieze of the unembellished photoengravings of *First Etchings,* now cancelled and transferred to a lithographic plate, recapitulates this early phase of balancing and equating. The *Passage* photolithographic plate reappears, while dead center there emerges from a mass of black brushstrokes another perfunctorily inserted photorepresentation, this time a three-quarter view of a Ballantine Ale can with written directions as to its proper scale. The images in the frieze begin to repeat themselves, and, strung together with a chromatic line, they reiterate the closed structure or idea of the work. Unlike most of Johns's prints, *Decoy* was not derived from a painting, but became the basis of two paintings: one the same size and partially printed (p. 75), the other much larger but, like the print, presenting objects in their printed embodiment (p. 76). A hole through the paper in the center of the frieze disturbed the picture plane of the print and, fitted with a grommet, took on more prominence in the paintings. Tatyana Grosman, who preferred to let the works she published speak for themselves, could not prevent herself from pointing to the hole in the print as the means of "escape." In *Decoy II* (p. 77), a further state of the print with seven additional plates, the hole is no longer necessary nor is there a reason to read the frieze. Spatters, a rainbow roll from blue to yellow to red that evokes the cylindrical passage which was formerly the responsibility of the frieze, and a mammoth, negating X re-form the lower section. The photographed legs gain attention as crayon drawing delineates a wood plank and covers most of the other portions retained from *Passage.* Heavy brushstrokes surround the reticent icon of the ale can while an additional white circle of a can's imprint quiets and reaffirms the ominously disturbed surface.

First Etchings and *Decoy* represent important landmarks in Johns's graphic work. Both projects were composed uniquely for print mediums and both were early attempts at working in a new discipline. When, in 1966, Tatyana Grosman successfully applied to the

I think the processes involved in the painting in themselves mean as much or more than any reference value that the painting has.
[Interviewer:] *And what would their meaning be?* Visual, intellectual activity, perhaps; "recreation." (Sylvester [1965] 1974)

I usually begin with some sort of an idea of what I want to do. Sometimes it is an image. I always want to see what it will make. Then, I actually start working. During the process I don't have any morality about changing my mind. In fact, I often find that having an idea in my head prevents me from doing something else. It can blind me. Working is therefore a way of getting rid of an idea. The manner in which I work constantly involves a feedback. I paint out parts, change others, and add and subtract as I go along. I don't think about chance. One's initial ideas may have to do with chance, but as one continues, one watches and controls the effects. (Olson 1977)

I'm not a very accomplished colorist, although I do think that I've improved somewhat. I think that I can improve even more. I've always used schematic coloring and since there's always a tendency to move onto something [else], I want to do something different with color. (Olson 1977)

newly formed National Endowment for the Arts in Washington for a grant to set up a workshop for etching, it was not in response to a strong desire on the part of any of her artists to make etchings. Lithography as a creative vehicle for American artists had become the established printing medium, sharing some part of the market with silkscreen, newly accepted as the quick and bright medium of Pop art. Intaglio techniques (etching, engraving, aquatint, and so on) were still considered the domain of the "printmaker" who practiced that craft exclusively. The processes had been considered so personal and subtle for so long that it was rare to find a printer who would undertake the responsibility of adding an aquatint tone or biting a line for someone else. In Europe, to be sure, the do-it-yourself attitude of American artists and craftsmen did not exist, but there was considerable secrecy about how much the printer contributed to a work. Having brought the lithographic printer and artist into a mutually accepted degree of collaboration, Mrs. Grosman confidently set out to promote the same situation in intaglio. In 1966 she hired Donn Steward to help Zigmunds Priede, the lithographic printer who succeeded Robert Blackburn in 1963. Steward was the first printer to work at U.L.A.E. who was trained at the Tamarind Lithography Workshop, set up in Los Angeles by June Wayne in 1960 under the sponsorship of the Ford Foundation. However, his main interest was intaglio and particularly the practice of engraving and etching that Stanley William Hayter brought to America in the 1940s. He therefore was given the task of carrying over the lithographic printer's profession of technical assistant to the artist into the realm of etching.

It is clear from Johns's etchings at U.L.A.E. that his apprehensions about the medium's seductive quality were valid. For someone who sought absolute control over every detail, it must have been difficult to relinquish to the printer artistic decisions—such as arriving at the correct tone of gray, brought about by adding a passage of aquatint, or of black, based upon "knowing" the length of time the plate should be bitten by acid. As Johns has

If society were different we might be content just to do something well. But no one is pleased to simply do what they do. What's important for us is always what doesn't exist.

If you repeat what you know it's not really very interesting. (Stevens 1977)

In working, one doesn't set out to make a work which will have a certain effect in the society. I don't think I have that kind of large grasp of society to begin with. I tend to relate to a smaller thing, like theatre, where you have an audience. That's my image of society. And one knows that the audience is always changing. So by the time you've imagined what the audience is, and formed your ideas, it is going to be something else. So, I think the best thing to do is . . . It's very tricky. As well as I can tell, I am concerned with space. And then as soon as you break space, then you have things. (Fuller 1978)

Once, if I did something in my work that reminded me of someone else's work—an idea, a gesture, paint quality—I would try to get rid of it. But now it wouldn't faze me in the least. (Bernard and Thompson 1984)

When you become more used to or more skillful with (I don't know which) ideas and media, you don't have to concentrate on them so much. (Bernard and Thompson 1984)

remarked, he had to learn how to adjust his work in order to achieve what he wanted, since each printer's technique, perception, and preference inevitably varied. In lithography he had quickly acquired the breadth of experience to control these variables to a great degree; in his few etchings of the 1960s he had to rely on Steward, who preferred to offer solutions rather than reveal techniques. When, in 1974, Johns went to France to work on *Foirades/Fizzles*, a book with text by Samuel Beckett, he made his etchings in the workshop of Aldo and Piero Crommelynck. There, under the guidance of printers who had spent a decade working with Picasso, Johns learned how to produce the types of lines and aquatint textures he sought.

Decoy, with its layers of photographic transfers and brushwork, benefited from Mrs. Grosman's acquisition in 1970 of a mammoth machine, an offset proofing press; a journeyman printer, James Smith, to run it; and an extremely versatile lithographic printer, Bill Goldston, who had been a student of Priede's. The offset printing process offered the possibility of making an image on a plate without drawing it in reverse, since in printing, the inked image was transferred from the plate onto a rubber roller which then imprinted it on paper. On a proofing press, the matrix (stone or plate) for the image rests on a flat bed, as in a standard lithographic press, so the artist's work remains similar to classic lithography with one exception—he gains the freedom to draw in a natural way and see all the compositional elements in their final or printed order. For an artist like Johns, who often puts asymmetrical objects such as letters in his compositions, offset made the rhythm and speed of composing much more agreeable. The advantages of offset in the printing process can be considerable, particularly when, as in *Decoy*, eighteen plates and one stone were used (and seven more in *Decoy II*). The thinner layers of ink laid down by the rubber roller produced less build-up on the printed surface, and each subsequent layer (or passage), not impressed with the usual heavy pressure of the lithographic press, did not disturb those printed earlier. Equally

The target seemed to me to occupy a certain kind of relationship to seeing the way we see and to things in the world which we see, and this is the same kind of relationship that the flag had. We say it comes automatically. Automatically you tend to do this, but you see that there are relationships which can be made and those seem to me the relationships that could be made between two images. They're both things which are seen and not looked at, not examined, and they both have clearly defined areas which could be measured and transferred to canvas. (Hopps 1965)

I saw a chart in a book that had that arrangement of the alphabet. Then I of course realized I could do the numbers that way too. But earlier than that, with the first numbers, I didn't do every number and I didn't work on them in any order and I deliberately didn't do them all, so that there wouldn't be implied that relationship of moving through things. (Hopps 1965)

Say, the painting of a flag is always about a flag, but it is no more about a flag than it is about a brush-stroke or about a colour or about the physicality of the paint, I think. (Sylvester [1965] 1974)

I one night dreamed that I had painted a flag of the United States of America and I got up the next morning and went out and bought mate-

important, the light impression of the roller did not destroy the texture of the paper.

By the time *Decoy* was printed in this novel manner Johns had been to Los Angeles, where in 1968 he began work on a series of single numerals at Gemini G.E.L. There, under the direction of Ken Tyler, the aim was to produce prints by established artists which would be of a scale capable of vying with paintings as wall pieces. Johns's *Black and White Numerals* (pp. 66, 68–70, 72), and the *Color Numerals* (pp. 67, 71), for which they formed the foundation, were of this nature. Not only were the individual numerals too large to be comfortably handled in a portfolio such as his previous set, *0–9*, but they most likely would be seen together, hung in frames, forming one extremely striking wall object. Tyler and his partners, Sidney Felsen and Stanley Grinstein, were oriented towards technical development, offering artists carte blanche as to materials and ways of processing them. Johns chose to take advantage of this largesse by creating a system whereby his luscious black numerals would be transformed through the rainbow roll to a dazzling spectrum, emphasized here and there with additions in white. To achieve this in the scale of the existing plates, rollers had to be manufactured and inking techniques, as well as new inks, developed. Charles Ritt was the chief printer of these and the other large prints Johns created at Gemini in 1968 and 1969. In one instance an object instead of a photograph of it was attached to a print: an embossed piece of lead spelling NO. In the painting *No* (1961), after which this print was devised, the word, made of two lead letters, is suspended from a wire. In the print (p. 84), the wire "passes" through the paper, a masterly piece of *trompe l'oeil* accomplished by embossing the paper (as Johns had tried to do in an experiment with his *Coat Hanger* in 1960).

There is a debut of a favorite image in *No:* the outline of Marcel Duchamp's sculpture *Female Fig Leaf* (1950). This bronze object, a cast of which Johns has owned since 1961, became the one prevalent and undisputed quotation attesting to Duchamp's presence in

rials and began to paint this flag. That's the way the first painting generally known was done. My reactions to it were neutral. It seemed to me to get rid of a lot of the problems I had been dealing with and trying to figure out what I was doing. ...I learned that there was the possibility of making something which didn't have to filter through judgments that one made about what one was doing; that one could set out to do something and do it. The paintings that followed immediately, which were paintings of targets and numbers, gave me the same opportunity—to feel removed from the work, neutral toward it, involved in the making but not involved in the judging of it. (Solomon 1966)

...the prints [*Fragments—According to What*] are highly representational. In every case, objects are represented, so they are very conventional illustrations. But in making what is a detail in the painting—and is often lost—the subject of each print, I made it more obvious, I think. What I did then was to print them in such a way that the suggestion of other things happening occurred. One of the ways I chose to do this is not to center the printing on the paper. Only the subject is centered, so the printing runs off the paper without margins. In every case they bleed, and this suggests they are fragments of something else. (Coplans 1972)

Johns's pantheon of influences. Only the linear outline, an impression of the base of the object, is used, the formal equivalent in Johns's works of marks emphasizing the surface of paintings or, like an Oriental seal, certifying the artist's participation in their creation. After the *No* painting it made its appearance in a complex and powerful painting of 1963–64, *Arrive/Depart,* placed next to the circular imprint of the bottom of a can. Imprints of a paintbrush, a skull, and a hand are accompanied by gestural explosions of color, accented by blocks of red, yellow, and blue. The same juxtaposition of can and *Female Fig Leaf* motifs appears next to the imprint of a foot in the painting *Field Painting* (1963–64), immediately above a dripped spot of sprayed paint. At the upper left corner of this same painting is a large X that has been nearly covered with paint. This X and the dripped spot are two signs that operate in the same way as the impressed marks but suggest negative and aggressive functions, as well. Both appear in a set of prints that are excerpted from one of Johns's most important paintings, *According to What* (1964), an homage to Marcel Duchamp (its formal program has been compared with that of Duchamp's painting with objects *Tu m'* of 1918) that has been considered the summation of a series of paintings with objects, such as *Field Painting.* The prints are details selected from the multipaneled painting and are titled *Fragments—According to What* (1971, pp. 92–93). In the *Fragment* called *Hinged Canvas* Johns has revealed the image on the unhooked hinged canvas at the bottom of the painting. On this canvas is the painted shadow of Duchamp's profile to one side and the dripped spot above the initials M.D. to its left. In the print, below the canvas is an X in the position where Johns's signature traditionally would be (and was) placed.

The X, more as it appears in *Field Painting,* occupies an important position on another *Fragment,* titled *Bent "Blue,"* which freely recapitulates the train of three-dimensional letters that spells the names of colors and divides two panels of *According to What.* A section of newspaper which actually appears in a somewhat different position in the painting,

[Interviewer:] *And the reference to Duchamp?*
Duchamp did a work which was a torn square (I think it's called something like *Myself Torn to Pieces*). I took a tracing of the profile, hung it by a string and cast its shadow so it became distorted and no longer square. I used that image in the painting. There is in Duchamp a reference to a hinged picture, which of course is what this canvas is. Beyond that I don't know what to say because I work more or less intuitively.
And the black splattered blob to the side of the Duchamp profile with the trickle coming down?
I sprayed that with a spray gun.
But does that have a particular reference?
The painting was made up of different ways of doing things, different ways of applying paint, so the language becomes somewhat unclear. If you do everything from one position, with consistency, then everything can be referred to that. You understand the deviation from the point to which everything refers. But if you don't have a point to which these things refer, then you get a different situation, which is unclear. That was my idea. (Coplans 1972)

Why did you cross out the printed matter in Bent *"Blue"?...*
In a sense to say it is of no importance, because in *Bent "Blue,"* that area is constantly changing, so it's not too important what's there. But

where it has been repeatedly silkscreened, is covered with a large X. Where, in the painting, frenzied brushstrokes cover the newspaper (as they had covered the X in *Field Painting*), the X now appears to take on that same masking or cancelling function. *Bent "Blue"* makes the most of the bending and mirror-imaging of the words for colors that provided so much active movement in the paintings of the early 1960s. The print, done in 1971, may be seen as a precursor of *Corpse and Mirror*—a crosshatch painting (1974) and prints (1976; pp. 106, 107) wherein the X plays a prominent role in the same compositional position.

X marks the spot of particular attention in these works, much as a dripped spot makes a specific statement within Johns's normally unemotive terminology. In the paintings the spot seems to be specific to affirmation of the surface, focusing on impact, lack of penetration, and the consequent dripping of residue. Johns might have been pursuing Duchamp's idea of shooting paint-covered matches at his *The Bride Stripped Bare by Her Bachelors, Even [Large Glass]* (1923) to emulate the ejaculations of the "bachelors," but drips from a spray can in the studio or urination on a wall imply an equivalent proprietary notion. The dripped spot, therefore, can be a surrogate signature, like the X, as well as an indicator of the vertical. In its translation into lithography, however, its functional aspect becomes problematic. Working on a canvas stood vertically, gravity performs an important and intractable function. Johns has made much of the drips that run down his canvases, using them as a kind of network to meld the many ways he has manipulated the surface. In prints the factor of gravity must be handled differently since in most mediums the artist generally works on a flat, or nearly horizontal surface. Johns tilted his stone on a low angle, which accounts for frequent areas of pooling that are denser at the lower edge and thereby reaffirm the vertical orientation of the final print. For the dripped spot, therefore, Johns had to work vertically. Looking at other instances of the sign, one finds how completely codified it is, as it appears time and time again. On the fourth panel of the transitional painting

obviously it's of great importance what's there, because that is what is there. But it could be anything else—that or the next image. (Coplans 1972)

What unites things like the flags and flagstone pattern which I once fleetingly saw on a Harlem wall is that in both cases one does not examine the objects very closely. You could easily identify them, without looking very closely. One would ordinarily respond to them visually by looking at them quickly and then forgetting them. (Olson 1977)

Whatever I do seems artificial and false, to me. They—whoever painted the wall [in Harlem with the flagstone pattern]—had an idea; I doubt that whatever they did had to conform to anything except their own pleasure. I wanted to use that design. The trouble is that when you start to work, you can't eliminate your own sophistication. If I could have traced it I would have felt secure that I had it right. Because what's interesting to me is the fact that it isn't designed, but taken. It's not mine. (Crichton [1976] 1977)

It seemed that the cross-hatchings could be equated with the flagstones [in the untitled painting of 1972]. I know that the last section is psychologically loaded, but I wanted to see what would happen if the same artistic attitude was

Untitled (1972), there is a large dollop of dripped paint running onto the cast torso. Johns adds a dripped spot in his etchings of the torso in the *Foirades/Fizzles* plates, in one case placing it over the photogravure plate that was made after the painting and shows the original drips. An erotic aspect of the sign might be alluded to in the works titled *The Dutch Wives*. In the painting (1975) and prints (1977–78; pp. 108, 109), the dripped spot is placed directly within the circular can imprint, surrounded by a freely drawn red line, and would seem to justify Michael Crichton's reference to the sailor's Dutch wife, a board with a hole in it used as a means of masturbation. The plural title, however, would lead to other interpretations, particularly if the sign involved were read for its primary functions: marking the artist's territory and asserting verticality.

One other object that appeared frequently in Johns's paintings also presented a problem in its incorporation into print, but not necessarily for technical reasons. The depiction of the back of a canvas, showing the wooden stretcher and keys, plays a major role in breaking the edge-to-edge continuity of his paintings' supports. Often hinged, held up with a hook and screw eye, these studio objects piggyback onto the main canvas. Traceable to American *trompe-l'oeil* paintings (Peto often depicted stretchers as structures upon which he composed groups of objects), these hidden canvases may also be unhooked and reveal another aspect of the work (as in *According to What*). However, this dual function of the extra canvas is only one use that it cannot fulfill in print. In the series completed at Gemini in 1972, two works are after paintings that incorporate the back of a canvas: in *Viola* a portion of the canvas is shown fallen down, revealing its separate stretcher and emptiness; in *Fool's House* (p. 81) it remains face to the larger canvas and the painter has written "stretcher," implying that, like the other objects in the work which are also annotated, that is all it is: nothing hidden. When they exist as real objects these canvases present a mystery which, when they are drawn, becomes an illusion, as well.

taken toward all of the sections. . . . I think that I did take the same [formal] attitude toward them all. The size of the body fragments are related to the size of the flagstones as well as echoing their placement on the canvas. (Olson 1977)

Generally, when an object or thing appears in my work it's either the scale it is, it's life size, or it's done by a technique that can be taken as a kind of thing. If, say, a part of the body is going to be represented in a print, I have tended not to draw it. If there were to be a change of scale I always felt that using a photograph of the thing took care of the problem. A photograph can be any size. Of course it's very subjective, that kind of feeling; so can a drawing be any size. In

Fizzles I did make little sketches of the image and in the big *Savarin* print, which began because a poster was needed for my show at the Whitney Museum, I drew one of my sculptures much larger than life; but that was a deliberate attempt at advertising on my part. (Geelhaar [1978] 1979)

That business of the thing actually embodying the thought, rather than being an illustration of it, is tricky.

Take the painting *Scent*, for example. One section was painted on sized canvas and a good deal of oil and varnish was added to the paint to increase its glossiness. One section was painted on unsized canvas and no oil or varnish was

The program for eight prints done at Gemini in 1972 was to produce a series that consisted of "works after" paintings made between 1961 and 1964. While the *Fragments— According to What* were like quotations *from* a work, these eight prints were quotations *of* works, and to emphasize this fact each image was surrounded by a tan line that might represent a frame (instead of allowing the margin to act in that capacity). In some cases substitutions were made to show more clearly the intention of each element in the painting (often an object in relief), and in the case of the print *Viola* (from the painting *Portrait— Viola Farber* of 1961–62 with the dropped canvas), the fork and spoon, which were visible entirely in the painting, were depicted separately in the margin. All the prints use the same palette of grays, while second versions, printed in blacks from fewer plates, present a lusher sense of each painting.

The two *Decoy* prints, *Fragments—According to What,* and the eight lithographs after paintings were the major print undertakings for Johns between 1970 and early 1973. During part of this period Johns was working on a four-panel untitled painting, completed in 1972, which was to announce a new element in his compositional vocabulary. Where many works of the sixties used stenciled or bent three-dimensional letters to signify color transitions from primary to secondary hues, the paintings of the seventies would be devoted almost exclusively to abstract series of strokes that organized the display of these colors. This new use of color, in a form described as crosshatching, appeared first in the untitled 1972 painting. Johns has said that he saw this pattern on a car, quickly passed on a Long Island highway. A second pattern, used in the painting *Harlem Light* of 1967, consists of an interlocking group of flat, contoured forms that he had seen on a building in Harlem. As with the design on the speeding car, Johns's memory had to suffice for the translation of an instantaneous impression. The flat forms, later referred to as "flagstones," occupied the center two sections of the 1972 painting. The right section was a framework of seven

added to the paint. This allowed the paint to sink into the canvas and gave it a matte surface. A third section was painted in encaustic. One can say that the physique of the painting embodies the thought, allowing the mind to perceive both at once; or the two can be split, allowing one to sense them at different times. Again, in the printed version of *Scent*, the differences in the three media are noticeable but seem natural or effortless. In the *Untitled* prints there is a different feeling. Aspects of the painting to which they refer, seem to be illustrated or pointed to. Perhaps one senses that one is looking at one thing which is about another thing. That kind of distancing is interesting to me; not so much in itself, but as one of a number of ways of perceiving. (Geelhaar [1978] 1979)

[When making the lithograph *Voice*:] I had made a photograph of the wire with the spoon and fork, a detail from the painting, intending to have a photographic plate made, and I indicated on the photograph that the fork should be seven inches, so that the objects would be life-sized. The people who made the plate included my written instructions as part of the image. For the *Voice* print we removed the instruction, but first we pulled some proofs of the unaltered plate. It seemed very lively to me, the various possibilities in combination: the photograph, in which the image is reduced, with a hand-written indication of its true-to-life size; the photo lithograph, in which the image has been enlarged to the indicated measurement, with the

stretcher-like wood strips over a canvas panel. Attached to its interlacing, rather casually constructed framework are seven fragments of the human body, cast from life and, in two cases, associated with objects: a foot and a hand together rest on a sock and floor; two feet wear green shoes. Not long after the painting was completed it was shown in the 1973 Whitney Biennial exhibition, where it elicited considerable controversy. While the flagstone motif had appeared before (in paintings and drawings called *Wall Piece*, made up of two panels, the second panel using the same photograph of fork and spoon from *Voice*), it was difficult to comfortably place the grouping of elements in the 1972 painting within the context of Johns's prior work.

Johns began to work on prints (pp. 110–15) related to this painting within a year after its completion. The first prints appear to select ways in which the artist might clarify the new terminology that the painting encompassed. While fragments of the human body had appeared in his work since the two early target paintings with plaster casts of 1955, and the stretcher was the subject of a work titled *Canvas* in 1956, the conjunction of the two in such a disturbing way occurred only in 1972. Therefore, Johns's first prints after the painting treated this panel first as an organization of shapes, each labeled with the name of the part it represents, then as single prints, showing each object in traced outline, printed in single colors from red (face) back through the spectrum to orange (leg) and black (knee). Each of the individual *Casts from Untitled* (pp. 110–11), as this set was called, is labeled below the object with its name. Black states of these prints were also done, but in monotone the puddling takes on more prominence, an effect that had been exploited in *Two Maps* and in a print of 1970 titled *Light Bulb* (p. 110). These small prints were accomplished while Johns worked out the complex plan for his lithographic restatement of the complete painting, titled *Four Panels from Untitled 1972* and finished in 1974 (pp. 112–13). The four lithographs are on sheets somewhat larger than the printed surface and each was signed or initialed by

handwriting enlarged along with it; and later in *Voice 2* everything very much enlarged, making the instruction suggest that everything should be reduced. (Geelhaar [1978] 1979)

I think I told you that at one time I hoped that the three panels in *Voice 2* might be able to accommodate any order or disorder; might be upside down, sideways, backwards. While working in this way, trying to make the painting have no "should be," trying to make it be any way it wanted to be, the "should be" seemed amusing; but working with that idea became too difficult for me, too complicated. I couldn't deal with it and I settled for the more simple order. (Geelhaar [1978] 1979)

Much of the paint in *Voice 2* was applied through screens of different sorts. The patterns of the screens consisted of various sizes and distributions of dots and, in some cases, squares. The meaning of the work, to a large extent, depends on the existence of tiny particles within the large work. I don't know that this could be achieved in a small print. The sense of large and tiny would be difficult to get. (Geelhaar [1978] 1979)

The *Cicada* title has to do with the image of something bursting through its skin which is what they do. They have shells where the back splits and they emerge, and that basically splitting form is what I am trying to suggest. (Martin 1980)

the artist in the lower left, rather than the lower right margin, signifying in a small way the intention to depart from precedent. One important factor in the painting was the intervallic structure of the two flagstone panels. Made up of forms that seem to evolve from the *Female Fig Leaf* impression, which the artist has also related to the shapes of the cast fragments of the fourth panel, one flagstone panel echoes the other, the left third of the left panel becoming the right third of the right-hand panel. The crosshatch panel, as in the painting, is made up predominantly of secondary colors (purple, green, and orange), but the jotting sets of four to eight strokes obscure bits of primary colors. For the lithographs relief plates were made of each panel which were used to emboss the adjacent print, with the fourth or "fragment" panel embossing the first, or crosshatch section. Small marks were added to each panel to indicate that it "belonged" next to the following one, the fragment panel given marks on its right which implied that it might be matched up with similar marks on the first panel. These indications that would lead to a completed cylinder do not occur in the painting and represent yet another step towards systematic control, which found its most sophisticated plan in later crosshatch compositions, the repositories of the infinite in an implacable finite. Johns moves further towards this goal in the second, or gray version, *Four Panels from Untitled 1972 (Grays and Black)* (pp. 114–15). The elements of the painting are retained, but each panel is framed with an added segment replicating one-sixth of the nearest part of the adjacent panel; again, the right-hand sixth of the right panel frames the first panel on its left. Selected plates from the first or color versions were reused with the border sections added through transferring and drawing. (These prints, made on textured, handmade paper, were printed by Gemini's crew, still including Ritt, who worked on *Color Numerals,* but led by Serge Lozingot, a French printer who devoted several years of his life to some of the most complicated printing of the century, Jean Dubuffet's 362 *Phenomena* lithographs of 1958–59.)

I came upon the word [*usuyuki*] in something I was reading and then the word triggered my thinking, and I can't do it in a cause-and-effect relationship, but I know that's what happened. I think it means something like "thin snow." I think it has to do with a Japanese play or novel and the character, the heroine of the piece. That is her name and I think it was suggested that it's a kind of sentimental story that has to do with the fleeting quality of beauty in the world, I believe.... I read this and the name stuck in my head. (Martin 1980)

The paintings and the prints are two different situations.... Primarily, it's the printmaking techniques that interest me. My impulse to make prints has nothing to do with my thinking it's a good way to express myself. It's more a means to experiment in the technique. What interests me is the technical innovation possible for me in printmaking.

I think partly, I find printmaking an unsatisfactory medium. I keep working at it, trying to make it better. It encourages ideas because of the lapse of time involved, and one wants to use those ideas. The medium itself suggests things changed or left out. Whatever you think the medium is you find out it isn't so you try to test it some other way. I don't really enjoy the idea that it's a reproductive process.

Four Panels from Untitled 1972 (Grays and Black) was completed in 1975, by which time Johns had begun to work on a project with Petersburg Press of London to make prints for a proposed book to be titled *Foirades/Fizzles* (pp. 67, 116–17), with text by Samuel Beckett. Mention has already been made of some of the signs or terminology that Johns maintained in his vocabulary and used in the etchings for this book, which he made with the printer Aldo Crommelynck in Paris. The project had been in the conversational stage since 1973, and Johns had determined at the beginning of his work on *Four Panels from Untitled 1972* that the painting *Untitled* (1972) would be the perfect vehicle for his etchings. He had asked Beckett for fragments of unpublished work, which he planned to make part of his prints. Since the delivered texts were actually completed entities, Johns's idea of making each page a print incorporating Beckett's text had to be discarded and a complex book with text pages for both English and French versions of the five completed stories had to be designed and filled with black-and-white prints. Endpapers of crosshatchings and flagstones were done in the colors of the painting, but, as in the earlier lithographs, the pattern of crosshatching is reversed. Within the book, when all four panels are shown together the crosshatching remains in reverse, but in three large plates it is in the same direction as the painted panel. Two cast fragments—the torso and the feet—are similar to the lithograph in that they are photographic, then extensively reworked with etching and aquatint. The face was changed to an impression of the artist's own face, accompanied by the X we have seen in conjunction with his signature (in this case opposite a text that begins, "J'ai renoncé avant de naître...," which Beckett has translated, "I gave up before birth...").

All the etching, open-bite, and sugar-lift aquatint Johns utilized in this book magnify his concentrated technique—relieving one of the misapprehension that contemporary artists are incapable of finesse. While each pair of pages has a distinctive and incomparable balance and impact, the double-page etching and lift-ground aquatint spelling out the

A lot of time is taken to make printmaking reproductive, and that's not very interesting to me. In terms of making things, you do something. Then you have to wait for processing. Then you do something else. And then you wait—like a long-distance call through an overseas operator. (Young 1969)

I like to repeat an image in another medium to observe the play between the two: the image and the medium. In a sense, one does the same thing two ways and can observe differences and samenesses—the stress the image takes in different media. I can understand that someone else might find that boring and repetitious, but that's not the way I see it. (Geelhaar [1978] 1979)

In printmaking, I think it would be perfectly reasonable never to destroy the images on the plates and stones, and always to have them available for use in new works, new combinations. One might work like that if one had a big enough studio in which to store such material. (Geelhaar [1978] 1979)

[Responding to the observation that, in printmaking, he "likes the fact that his art is more available":] If indeed it is, and if that is the function of printmaking. I don't really believe it's true, because prints appeal to possessiveness in people even more than painting does. It's probably interesting what prints you have and

names of each body fragment in English and French (p. 117) is not only unique in his work but also one of Johns's most splendid images. Johns's admiration of the pungent chiaroscuro of Odilon Redon, accomplished with the simple marks of the lithographic crayon, is reflected in his subtle use of aquatint here in the shadowed transition of the left and right panels. Like most of his horizontal compositions since the mid-sixties, this page, the other double-page spreads, and endpapers consist of joined vertical parts. In this particular plate the division is not demarcated, but rather the words are mirrored.

After the untitled painting of 1972, Johns developed the theme of crosshatching, both in his paintings and in his prints, for the next nine years. The first entirely crosshatched painting, *Scent* (1973–74), and *Corpse and Mirror* (1974), *The Dutch Wives* (1975), and an untitled painting of 1975 all spawned prints within a very few years. Conversely, his work on *Foirades/Fizzles* gave inspiration to a painting titled *End Paper* (1976), reflecting Johns's intensely involving experiences related to the book. The complex print (1975–76; p. 119) engendered by the painting *Scent* may be examined as an example of Johns's capacity to make the tools of printmaking dance to his tune. The painting was done in the contrasting mediums of encaustic and oil, exploiting their superficial visual and tactile differences. The crosshatch patterns unite the differing panels, but promote in their concisely determined organization both confusion and unity. In the print, a tour de force of lithograph, woodcut, and linoleum cut, the pattern peculiar to *Scent,* in secondary colors of orange, purple, and green, is perhaps clearer because it does not rest on the obliterated bed of primary colors of the painting. To replace this painterly foundation, Johns used a cream-color ink that nearly disappears in those panels printed from blocks (from relief surfaces, that is) because the printing process itself intervenes, creating a slightly undulating surface. Johns's aim, to insinuate similarity by means of quite dissimilar acts, is condensed in both the painting and print.

When the same painted image is given form in more than one print medium, however,

what you don't have, and you know there's always the possibility of getting what you don't have; whereas in painting, that's just not true. (Raynor 1973)

[Interviewer:] *You started in 1960 with Tanya Grosman.*
Yes, I'd never made a print. I still don't know how to do it. I don't know how to treat a stone, how to make it print. If I were left in the studio, I think I could figure it out, because I've seen a good deal done, but I've never done it. I simply draw on the stone and then watch what the other people do to it. . . . It's marvelous when you're working with someone who seems to know really what he is doing. (Raynor 1973)

Prints are no less important to me. In them I'm able to use images and ideas I work over in painting and subject them to transformation. It's a different physique entirely. The business of making prints is involved with people. I always resented it but now I tend to like it if it works well. (Glueck 1977)

The only thing that's been new in my work is the use of the offset press at Tanya Grosman's. She got the press for the purpose of—I don't know why she got it, but anyway she got one. She was always opposed to it, you know. She always wanted everything on stone. [With offset] the image comes out the same way you did it (not

it is possible to clarify somewhat Johns's particular interest in articulating a motif. It has been seen that, working in two different workshops with printers and publishers of quite remarkable differences of methods and personalities, the artist has produced works of identifiably different character. His etchings at U.L.A.E. are not only more tentative, because he had not yet mastered the techniques, but also they are more personal, perhaps even private, objects. By the time Johns completed *Foirades/Fizzles,* he had as much expertise in the intaglio techniques and rapport with the printer as he could wish, and the prints show this confidence in both the most intricate compositions and the simplest linear sketches. The bold, ambitious nature of Gemini's directors, which, with a certain amount of California nonchalance, elicited a substantial amount of expansiveness, determined some of the differences between Johns's lithographs there and at U.L.A.E. Certainly the broader resolution of compositions that often required more diverse methods and materials had repercussions in all Johns's work after 1968.

Another element ultimately of great importance in the formation of prints with crosshatch motifs was Johns's inclusion of silkscreen (serigraph or screenprint) in his repertoire of techniques. As early as 1968 he had made a silkscreen poster, a drawn version of *Target with Four Faces,* for the Merce Cunningham Dance Company (to which he was artistic advisor from 1961 to 1973). Johns had made signs in the army, probably using the stencil technique of which silkscreen is only a more efficient and sophisticated method. Several screenprints he made in the next four years were specially drawn images on film, made to be transferred photographically to the screens. This method was used again in 1971 for a poster to accompany his graphics exhibition in Bern, presenting in bright, primary colors his *Painting with Two Balls* theme. A gray version (p. 79) was also printed, without text, by Alexander Heinrici at Aetna Screen Products, in New York, in a limited and signed edition. In 1972, Johns was introduced to a young man working at the Whitney Museum of

reversed, as in lithography), so it's a different kind of thinking—if backwards and forwards means anything to you. It has, of course, been very important to me, because I have worked with things that have a left and right orientation. (Raynor 1973)

If I remember correctly, my first work on the *Decoy* print was from stone printed on a hand press. At a certain point, we changed to a Mailander offset press which suggested that I could be more extravagant, increase the number of plates to achieve even rather small effects, somewhat in the way one might add brushwork to a painting. In printmaking, I would usually be

more economical than that; but working with this machine, which was new to me, changed the sense of labor connected with the process. One sees results more quickly and senses less labor on the part of the printers. (Geelhaar [1978] 1979)

. . . using the offset press, the image which exists on one plate can simply be printed onto another plate. These and other odd concerns make up the life of the work really. They are real concerns and make the work process a very lively activity, something other than the reproduction of an image; they alter what "image" is. (Geelhaar [1978] 1979)

American Art, Hiroshi Kawanishi, the son of a Japanese art dealer. He asked the artist to make some screenprints with him and a talented printer from Tokyo, Takeshi Shimada, whose prints for Genichiro Inokuma and Tadanori Yokoo Johns knew. With their Simca Print Artists, Johns found the congenial atmosphere which would allow him to learn how to handle the medium. *Screen Piece* of 1972 still was partly photomechanical in technique, but in 1973 Johns made a target by painting directly on the screens. That year he also worked on color and gray versions of flags (similar to the lithograph of 1970–72, *Two Flags* (Gray), which he did at U.L.A.E., and a painting, *Two Flags,* of 1973, in which one panel was oil, the other, encaustic). The stinging colors of the silkscreen *Flags I* (p. 105), printed from thirty-one screens, took full advantage of the skills of the Simca printers. In these heavily layered works, in which the inks were occasionally mixed with varnish to quote the differing surfaces of the painting and change the flat character of the printing, the immediate impression is of painting on paper. Only the unmodulated similarity of the surface, which is fragmented as each layer covers, but also reveals, bits of previous printings, betrays the process. It is a painstaking bit of trickery, whereby Johns produces an intricately fashioned surface of brushstrokes, making them, and the two flags, equally the objects of attention.

Perhaps when Johns began to work out his crosshatch compositions, it seemed appropriate and challenging to work in all the print mediums of which he was now master. After *Scent,* with its playful use of materials (even the grain of the woodcut was given a specific direction), Johns worked on three reprises of his two paintings titled *Corpse and Mirror* (1974 and 1974–75). The first print, an aquatint and drypoint of 1976, took advantage of his need to be in France, working on *Foirades/Fizzles.* It is most probable that this independent plate of quite small scale (10⅜ by 14 inches) was part of the trial work for the endpapers of the book or, perhaps, only a respite from its enormous, time-consuming occupation. A lithograph (p. 106), printed at U.L.A.E. on its offset proofing press,

The nature of the technique [lithography] is that I end up with great facility. In painting, I don't think there is less pretension, but it maintains its original clumsiness for me. (Stevens 1977)

I don't like the medium [etching], although I'm going to do some more etchings. It's extremely seductive. That line. You draw a line in the metal, and it has a very sensitive, sort of human quality—much more so than lithography which tends to go flat and simplify. I think that in etching what you traditionally call "sensitivity" is magnified. I don't like etching because I have the feeling that I have more control over drawing than etching. In any medium, I've never wanted

a seductive quality. I've always considered myself a very literal artist. I've always wanted to do what *I've* wanted to do. In etching, there is the distraction of the line which takes on the quality of a seismograph, as if the body were the earth. Within a short unit of an etching line there are fantastic things happening in the black ink, and none of those things are what one had in mind. (Young 1969)

It seems that etching can accept more kinds of marks than other print media can. In lithography one applies grease to the stone or plate, a greasy liquid or crayon; the result is a kind of wash effect or a crayon effect. That's about it.

appeared in 1976, a haunting image, predominantly white on black paper (in the earlier of the *Corpse and Mirror* paintings the strokes appear to be black on a white field). Finally, in the same year, Simca printed a thirty-six-screen print (p. 107) after the second painting, in which primary colors prevail (over layers containing secondary colors). In the earlier *Corpse and Mirror* painting and prints the composition is horizontal, divided into two vertical panels, each of which is divided horizontally into three parts. The program of marks, moving from the top of the three tiers, changes direction at each juncture (as in the Surrealists' game *cadavre exquis,* or "exquisite corpse," in which a player makes a drawing, then folds it so that only the edge may be used by the next player to continue the drawing, thus producing a connected but not logically contiguous composition). The right panel mirrors the left, but the image is blurred (more so in the painting than in the prints), and the upper right section has traces of pink lying under a large X. A vague visual memory of *Fragment—According to What—Bent "Blue"* hovers there as if it were a reflection. The silkscreen print follows the schematic organization of the later painting, *Corpse and Mirror II,* in which entirely different crosshatch patterns are still subjected to changes between each of three tiers and are mirrored. Instead of the X, an imprint of a can marks the surface in the right-hand panel. Again, as with *Flags I,* different materials were added to the inks to change the surface, now printed on a delicate Japanese paper.

The aspiration inherent in the crosshatch paintings is no less, it would appear, than that in the silkscreens. The intricacy of the patterns evolved from esoteric relationships or nonrelationships that the artist saw in the elements of his work. From the relatively straightforward panel of *Untitled* (1972), logical steps brought about increasingly complex arrangements of the four to eight strokes that formed organic sections within these compositions. In the group of prints made at Gemini in 1976 titled *6 Lithographs (after "Untitled 1975")* (p. 118), Johns presents graphically his thought processes exploring

Complicated tone and color and complexities relating to one's sense of time have to be achieved by using more than one stone or plate. In etching, the devices for attacking the plate are more elaborate. With aquatint, for instance, the variety in the sizes of particles that are available is great and can result in a great variety of tones. And for me, the most interesting thing about etching is the ability of the copper plate to store multiple layers of information. One can work in one way on a plate, later work in another way, and the print can show these different times in one moment. This is not the nature of lithography which can't accept that kind of work. So, in a sense, etching may seem to be more complex and subtle. (Geelhaar [1978] 1979)

Well, the silkscreen is the stupidest because it's only a stencil. There's nothing else to it. The work consists of putting color through the opening in the stencil. That's all one can do. So I think it is best used for images which require sharp edges and smooth-textured, flat, clear areas of color. By adding a rather large number of screens and having the stencil openings follow the shapes of brush strokes I have tried to achieve a different type of complexity, one in which the eye no longer focuses on the flatness of the colors and the sharpness of the edges. Of course, this may constitute an abuse of the medium, of its true nature. (Geelhaar [1978] 1979)

possible arrangements of these strokes, on a relatively simple program but utilizing the possibilities, afforded by printmaking, of transferring parts of the whole to second plates. Johns found that the effort of traveling to California demanded a sustained project and encouraged the creation of sets of prints when he was at Gemini; clarifying the formation of the crosshatch painting *Untitled* (1975) was a fascinating vehicle for such a project. The formal program, set up in a square divided into nine squares, required the groups of strokes to change direction, change color, change both color and direction, or simply continue across each juncture. At one point, the strokes mirror each other. With such a work at hand, examining the later prints is less daunting: waves of mental and visual exhaustion are calmed by insistently happy colors and seductive rhythms; uncovering the system becomes an exquisite endeavor.

In a small screenprint made for a catalog cover, Johns relied upon the photographic possibilities of screenprinting by reproducing bits of newsprint with the crosshatches. In his encaustic paintings the newspaper scraps that often formed a thick bed for the paint occasionally poked out, catching the eye and teasing the brain with their implications of choice or hazard. Translating this element into silkscreen, Johns prepared collages of newsprint strips that formed the basis of photoscreens used in the catalog cover and in the first version of *The Dutch Wives* (p. 108), in 1977. In the larger print, again a horizontal composition of two vertical panels, the sides and upper edges of each panel are similar in format. Twenty-nine screens carry the gray inks, thick with wax, and the reproduced newsprint, which contributes slight staccatos of black to the soft brushstrokes. As mentioned before, surface-controlling elements—a can imprint with a dripped spot—are in the right-hand panel.

The use of newsprint imagery has even greater impact in the silkscreens of *Usuyuki* and *Cicada*, works completed between 1979 and 1981. The several *Cicada* prints (p. 123)

What I tend to do is first work freely with the brush on the screens, getting whatever shapes the brush makes. Then I tend with additional screens to reinforce those shapes and that confuses a little bit the flatness of it and suggests a different kind of activity. It is basically an illusion created by adding not just many layers but layers that mimic one another—so that they tend to mimic the marks. Instead of seeing two things you're really seeing one that's richer in some way. (Martin 1980)

Well, you begin and you work as long as your interest holds up and if it interests you to change something you can change it. . . . You can change the drawing, you can change the order of the screens, you can change the inks, you can change the gloss, the physical quality of it, things like that.
[Interviewer:] *When are you done?*
Well, sometimes when it looks hopeless to do anything more sometimes you're done. When your mind stops working in relation to the print basically . . . when your mind stops working in relation to what you're doing either you've finished it or you throw it away. That seems to me to be the only choice. (Martin 1980)

Just the process of printmaking allows you to do things that make your mind work in a different way than, say, painting with a brush does. It

are single panels in which the program is coloristic, Johns representing the splitting of the insect's skin by using secondary colors in the central portion and primary colors to the left and right or vice versa. A thin line confines the brushstrokes and newspaper scraps at the top and sides, allowing the strokes to intrude slightly into the lower margin in one case; in another, where he has stenciled his name along the bottom the open letters perform a similar function of loosening the stringent repetition of the sets of strokes. *Usuyuki* (pp. 120–21), in its vertical and horizontal forms, is by far the most intricate composition using the crosshatch motif. The tender colors, fading like the "light snow" of the name (the tragic heroine of an eighteenth-century Japanese drama for puppets adapted for the Kabuki theater), are merely the powder and paint (or make-up) of the superficial appearance of one of Johns's most involved statements. Both compositions were done in silkscreen and lithography, the horizontal version worked out first in lithography in 1979. The silkscreens have newspaper bits and the patterns reverse the order of the lithographs.

The vertical *Usuyuki* compositions might be used as the key to the larger, horizontal works. In the vertical prints, the crosshatches match at both sides as well as top and bottom, as if a rectangle had been formed from a cut-open inner tube. A grid of lines accompanied by imprints of objects is superimposed on the crosshatches. The horizontal *Usuyuki* prints are divided into three panels: the crosshatch pattern of the right-hand panel is identical to that of the lower three-fifths of the vertical print; the center panel repeats the center three-fifths of the vertical composition but rotates to the right one-third of its width; the left-hand panel repeats the top three-fifths of the vertical print and rotates an additional third. In this more complex situation, the spectrum-printed grid and imprints progress in a manner similar to the pattern of crosshatches throughout the three panels but in the opposite directions—that is, down and rotating to the left. The abundance of disorienting and guiding devices engages the viewer in a process of mental gymnastics not normally so

changes your idea of economy and what becomes a unit. In some forms of printmaking it's very easy to reverse an image and suddenly have exactly what you've been working with facing the other direction and wanting to work with that, whereas if you were doing a painting you would only do that out of perversity. You would have to have a serious interest to go to the trouble to do that. But in printmaking things like that become easy and you may want to just play with that and see what it amounts to. Whereas if you had to do it in a more laborious way you wouldn't want to give it that energy. Curiosity wouldn't be that strong. There's a lot of that in printmaking and some of that feeds back into

painting because you find things which are necessary to printmaking become interesting in themselves and can be used in painting where they're not necessary but become like ideas. In that way printmaking has affected my painting a lot. (Martin 1980)

Unless there is some evidence of the technicalities of printmaking, much is lost of the beauty of the medium. I try to play in ways that sometime show and sometime hide this. (Castleman [1985])

[Interviewer:] *But shouldn't the artist have an attitude to his subject, shouldn't he transform it?*
Transformation is in the head. If you have one

deliberate in the perception of art (though essential in crossing the street or finding one's way through unfamiliar territory).

In one grand and final adieu to the crosshatches (which, one feels, Johns will find many opportunities to use as quotations in work to come), Johns turned to monotype in 1983, creating his largest printed works in a manner that utilized most of the skill, and profound comprehension of the meaning of imprinting, that he possessed. The eighteen monotypes (pp. 122–24) based on the composition of a seven-and-a-half-foot-wide untitled painting of 1979 that has hung in Johns's country home for years were both imprinted from Mylar sheets and offset from the monotypes themselves. The shifting five panels meet in four of five ways: lines continue in the same color; lines continue, but the color changes; lines bend in the same color; lines bend, but the color changes; and lines mirror each other. These changes are comparable to those in *Untitled* (1975). The monotypes, however, not only play out all the possibilities, but the character of the lines—predominantly red, yellow, and blue, interspersed with violet, green, and orange— is quite different from both painting and print. In the monotypes certain of the panels are second or even third impressions of the painted Mylar, which might have additional marks made directly on the print to be used on a subsequent monotype. In this way, when covering certain secondary colors with black in order to make a variant of the composition, Johns was able to create not only a second monotype in color and black but also a totally black version, which then provided the structure for monotypes with black, purple, and green only. As dispassionate as this highly organized project may seem in explanation, the resulting works have a very generous aspect to them, comparable in the beautiful sensations of light and color to the overall perception of a group of paintings like Monet's *Water Lilies*.

Johns first approached the idea of making monotypes in 1978. He had made a series of small lithographs at U.L.A.E. showing the Savarin can holding paintbrushes, and some of

thing and make another thing, there is no transformation, but there are two things. I don't think you would mistake one for another. (Swenson 1964)

One goes about one's business and does what one has to do and one's energy runs out. And one isn't looking throughout, but then one looks at it as an object. It's no longer part of one's life process. At that moment, none of us being purely anything, you become involved with looking, judging, etc. I don't think it's a purposeful thing to make something to be looked at, but I think the perception of the object is through looking and through thinking. And I

think any meaning we give to it comes through our looking at it. (Sylvester [1965] 1974)

I think one has to work with everything and accept the kind of statement which results as unavoidable, or as a helpless situation. I think that most art which begins to make a statement fails to make a statement because the methods used are too schematic or too artificial. I think that one wants from painting a sense of life. The final suggestion, the final statement, has to be not a deliberate statement but a helpless statement. It has to be what you can't avoid saying, not what you set out to say. (Sylvester [1965] 1974)

the lithographic plates were not printed. He then embellished a few of these with monotype passages, printing each two or three times (p. 100). These prints showed the Savarin can at its actual size, but the lithograph of the same subject made for the poster for Johns's retrospective at the Whitney Museum of American Art in 1977 was of a scale large enough to be seen from afar (p. 99). This larger *Savarin* was revised in 1981 into another lithograph, printed mostly in gray, in which the area below the can, a panel of wood pattern, was replaced with an imprint in red of an arm and the initials E.M. This homage to Edvard Munch (his self-portrait of 1895 consisted of his head emerging from a black background, a skeleton arm lying below) revealed the autobiographical nature of the Savarin can, while the intitials appear to have the same relationship to the portraiture implied as those of Marcel Duchamp had in *Fragment—According to What—Hinged Canvas*. The background of the Whitney poster and the subsequent *Savarin* print consisted of crosshatches in the pattern from *Corpse and Mirror*. After the second version, twenty-seven discarded proofs were used as the matrices for a series of monotypes in 1982 (p. 101). Various additions were made in color, either covering the whole image or superimposing marks (such as hand-prints all over the background in secondary colors), or the shape of the composition was revised (for example, forming an oval from the rectangular composition or adding drawn nails). The great spirit of adventure that inhabited these repaired images undoubtedly encouraged Johns to pursue monotype again when he next worked at U.L.A.E. Unfortunately, the circumstances were quite different from his first visit, in 1960. Tatyana Grosman died in 1982. When Johns made his great untitled monotypes in 1983, he was working to assure the continuation of her dream.

Between 1977 and 1985 Johns's work was in a state of flux. He continued to use the crosshatch motif as the basis of most paintings until 1982. Concurrently, he revived some very old themes for his increasingly rare forays into printmaking. For Petersburg Press he

I . . . would like to keep the painting in a state of "shunning statement," so that one is left with the fact that one can experience individually as one pleases; that is, not to focus the attention in one way, but to leave the situation as a kind of actual thing, so that the experience of it is variable. (Sylvester [1965] 1974)

. . . my work is in part concerned with the possibility of things being taken for one thing or another—with questionable areas of identification and usage and procedure—with thought rather than with secure things. (Raynor 1973)

I think art criticizes art, I don't know if it's in terms of new and old. It seems to me old art offers just as good a criticism of new art as new art offers of old. (Raynor 1973)

I try to be less enigmatic. And sometimes my mind tends to conjure up the negative of what I'm thinking, and I try to see if that's as equally valid as what I'm saying. I may get tied up in that kind of activity. (Bourdon 1977)

[A flag coming to him in a dream] was the only instance where a dream was my inspiration. . . . All other ideas have occurred during my waking hours. Whenever an idea comes or whenever you think that you see something it is astonishing as a dream and as natural. And afterwards you

completed two etched versions of *Land's End* (1978 [p. 128] and 1979) and one of *Periscope* (1981), both compositions painted in 1963 at the same time as he made his first large-scale lithograph, *Hatteras*. During the same period he worked at Gemini, producing a large black lithograph of *Land's End* (p. 129) and two lithographs of *Periscope* (pp. 130, 131). In 1982 a group of three untitled etchings, using reworked plates from the *Land's End* 1978–79 prints, appeared. In all these prints Johns had turned again to the moving arm, that device that could sweep, indicate a direction or the passage of time, and divulge in some subconscious way an impression of helplessness. Its appearance for the first time after nearly fifteen years requires that it be given special attention. Between 1978 and 1980 Johns completed color aquatints (p. 97) after his famous early paintings *Target with Four Faces* and *Target with Plaster Casts*. In the print *Target with Four Faces*, the colors are unusually jaundiced and impure; Johns has noted that he wanted it to look like a tinted photograph.

These works, concurrent with the crosshatch paintings and prints, not only imply a variety of directions and attitudes taken by the artist but seem to indicate that a regrouping of motifs, perhaps more revelatory of subjective content, was evolving. Indeed, in the last panel of the 1982 untitled etching that is a reprise of *Land's End*, the word BLUE is written on a cloth that is nailed up, like the drawings that appear in *In the Studio*, the first of the transitional and more personal paintings of the same year. A similar small cloth hangs, limply, in the painting *Perilous Night* of the same year, and has its genesis in the excruciatingly sad *Weeping Woman* (1937), an etching by Picasso that Johns saw in Aldo Crommelynck's home. Objects from Johns's own surroundings, such as his own prints and his collection of George Ohr's pots, occupy the central portion of *Ventriloquist* (1985; p. 132) and move the viewer from the detached, unencumbered neutrality of the gallery to the sympathetic intimacy of a life trying to reveal itself. Clearly self-referential is Johns's small etching (after a 1985 painting) that appears as the frontispiece (p. 133) to a book of

wonder why you never saw it that way before. (Olson 1977)

The spectator gets everything that I get. I have always loved it when works could be called what they really are. (Olson 1977)

I believe that the question of what is a part and what is a whole is a very interesting problem, on the infantile level, yes, on the psychological level, but also in ordinary, objective space. (Fuller 1978)

The mind can work in such a way that the image and technique come as one thought, or possibly one might say there is no thought. One works without thinking how to work. (Geelhaar [1978] 1979)

One assumes that one's relationship to the work is the correct or only possible one. But with a slight re-emphasis of elements, one finds that one can behave very differently toward it, see it in a different way. I tend to focus upon a relationship between oneself and a thing that is flexible, that can be one thing at one time and something else at another time. I find it interesting, although it may not be very reassuring. (Geelhaar [1978] 1979)

Such things run through my work, relationships of parts and wholes. Maybe that's [a] concern of

selected poems by Wallace Stevens (published by The Arion Press in 1985). Freely quoting a painting by Picasso of 1936 that shows a minotaur pulling a cart filled with its belongings, Johns has disclosed the fact of his own relocation by roping together items from his past in a similar fashion. Echoing the cart wheel of Picasso's composition, the sweeping arm from *Periscope* and *Hatteras* falls to the bottom. Instead of a struggling minotaur (Picasso's frequent alter ego), a man's shadow falls against a wall.

In 1978, when Christian Geelhaar interviewed Johns about his work he asked the artist if he had ever considered making prints after the composition of his painting *Voice 2* (1971; pp. 86–87), in the collection of the Kunstmuseum Basel, of which Geelhaar was then curator. Because *Voice 2* had many textural elements from painting through screens and from screenprinting the spoon and fork element from *Voice,* Johns had thought that its translation into a print medium would be problematic. Some years later the Schweizerische Graphische Gesellschaft, a Swiss print collectors' club, asked him to make a print for its members. It seemed appropriate to rethink his decision about *Voice 2* since it was not only in Switzerland but also contained a system that could be expanded upon in print. The first fruit of his thinking on the subject was a three-part lithograph (p. 88), quite faithful to the objects and patterns of the painting, which has three panels. Because the panels were separate, the idea of changing their order was already implicit in the painting, even though it is rarely hung in any order other than the sequence ABC, with the word VOICE beginning at the left (on panel A) and with the numeral 2 on the right (on panel C). In fact, Johns made sets of these large lithographs printed together on one sheet in each of three possible sequential orders (ABC, CAB, and BCA) for his own archive (p. 89). After finishing the large prints, Johns faced the problem of making a smaller print that would accommodate the budget of the print club. He finally produced four versions at U.L.A.E., one of which, like his personal set of the large prints, was a single edition that changed the order of the panels

everybody's. Probably it is, but I'm not sure it is in the same way. It seems so stressed in my work that I imagine it has a psychological basis. It must have to do with something that is necessary for me. But of course it *is* a grand idea. It relates to so much of one's life. And spatially it's an interesting problem. (Geelhaar [1978] 1979)

How does one deal with the space? Does one have something and then proceed to add another thing or does one have something; move into it; occupy it; divide it; make the best one can of it? I think I do different things at different times and perhaps at the same time. It interests me that a part can function as a whole or that a whole can be thrown into a situation in which it

is only a part. It interests me that what one takes to be a whole subject can suddenly be miniaturized, or something, and then be inserted into another world, as it were. (Geelhaar [1978] 1979)

My experience of life is that it's very fragmented. In one place, certain kinds of things occur, and in another place, a different kind of thing occurs. I would like my work to have some vivid indication of those differences. I guess, in painting, it would amount to different kinds of space being represented in it. But when I look at what I've done, I find it too easy to see the connections between one thing and another thing. It may just be that I know how I come to

within it (p. 90). Another lithograph shows the three in all positions, including their vertical associations (each panel of the painting and prints is divided, the first horizontally, the second vertically, and the third diagonally).

Besides reconstructing the elements of the *Voice 2* painting through this process, Johns, in his imaginative approach to the problems he had anticipated with the painting's surface, produced prints in which thin, interlacing lines of pen drawing not only detail the letters and other discrete parts of the composition but provide an overall filigreed texture as complex as the painting's pin-dotted surface. In another instance he used pastel colors which emerge from the grays as if diluted and washed away. This intermingling of color and gray seems to have been a challenge set by the artist to himself. Two years later, when he made his next lithograph, *Ventriloquist* (p. 132), the color is again drained away by the grays. Afterwards, Johns thought that it reminded him of Redon's 1897 lithograph *Beatrice*, in which her face barely emerges from the wisps of pale color that delineate it, producing the effect of a memory nearly lost. Through the *Voice 2* prints Johns achieved several objectives which more or less completed his thoughts about printmaking for a while. In *Ventriloquist* he began to use the results, but, as seen from his small etching of 1985 (p. 133), he is still in the process of moving on.

make a work: I know how hard it is to discard ideas or involvements that you already have, to come up with a different approach. (Fuller 1978)

[Suggestion about what the federal government should do for the arts:] They should use the lottery system. If we, the society, knew what we wanted, then we could pay for it, subsidize it. But we don't. I wouldn't want to choose the people for grants. My choices are private and subjective and not necessarily for the good. We're in a funny, broken society. It's not easy to know what's to be done. It's hard, of course, to determine how much is real rotting and how much is just the normal movement in a field of change. (White 1977)

My feeling about myself on the subjective level is that I'm a highly flawed person. The concerns that I have always dealt with in picture-making didn't have to do with expressing my flawed nature, or my *self*. I wanted to have an idea, or an image, or whatever you please, that was not *I*...I don't know how to put it. I don't know what supports what. I wanted something that wouldn't have to carry my nature as part of its message. I think that's less true now. (Fuller 1978)

I tend to think that all art work is heroic. I think it's a heroic enterprise from childhood, from the very beginning, whenever it begins. (Fuller 1978)

IN JANUARY 1958 LEO CASTELLI GAVE JOHNS HIS FIRST SOLO EXHIBITION. As his flags, targets, and numbers appeared to contradict established artistic concepts and confused a number of the most knowledgeable in the New York art community, inevitably Johns endured criticism that seemed particularly blind. Finding that his serious painting was misconstrued by some as comic or naive, he was astonished and deeply affected by such reaction. Only twenty-seven at the time of his show, Johns had spent a peripatetic childhood in South Carolina with various relatives. Although he attended the University of South Carolina for over a year, he was drawn to New York and the pursuit of the artistic career which he had believed since childhood was his destiny. He attended art school for a short time but was drafted into the army and stationed in South Carolina. After a brief tour of duty in Japan, he returned to New York in 1952. In 1954 he destroyed every artwork he had made that he could find, so that nothing remained to provide evidence of his paintings' evolution or put them into a context. Nearly three decades later Johns's memories reconfirm that the misunderstanding of his early work by some of the most discerning viewers was not simply vexing but profoundly influential. At the time, this situation must have been a goad to Johns, who in the following few years pursued his self-education by examining the theories of Ludwig Wittgenstein, intensively studying the works of Cézanne, Duchamp, Magritte, Peto, Picasso, Leonardo da Vinci, and many other artists, reading more philosophy, as well as psychology and poetry. As an artist who must be considered primarily self-taught, Johns's inquisitiveness and intellectual perspicacity have given his art a foundation unique among artists of his and the subsequent generation.

This state of affairs inevitably contributed to Johns's work in the print mediums. Other than his early fascination with the lithographs of Odilon Redon, which he has collected, Johns rarely looks at prints. When he does, he thinks of what he would have done and is fascinated by the choices that other artists have made. Since Johns has rarely developed new compositions in print, it is the actions of the mediums, what he learns from them and how they may be manipulated and enhanced, that determine the form and even the content of his printed work. The titles he chooses to give his works are, to him, quite literal, but emanate from a mind that finds paradoxes, ambiguities, and even puns authentic representations of what is real to him. Like a child's infatuation with nonsense, his sense of meaning has a playful bent. Asked to create a print for an album honoring Picasso, Johns found a profile photograph of the artist and by composing the profile facing itself, in mirror image, he devised in the space between them the chalice or toasting cup with which to honor the master. *Cups 4 Picasso* (1972; p. 95), a title purloined from Peto (*Cup We All Race 4*), was a discovery made from curiosity about the conjunction of this and this, where nothing becomes something.

Watching Johns draw crosshatches—brushstrokes taking their direction from his slightly spread fingers resting at the edge of the stone, plate, or screen—it is possible to glimpse the personal process by which he masters his medium. Changes occur, balances are achieved, and the work comes to its "natural end." Relying only upon himself, he is expert in showing outside, in his art, what has been accumulated and finely tuned inside. To convey meaning and feeling while remaining perfectly silent and still is considered the supreme accomplishment in the art of acting. The provocatively silent and still life that Johns creates conveys infinite nuances of meaning which multiply through his prints into a boundless territory of possibilities.

REFERENCE LIST

The abbreviations reference the artist's statements in the main text. Dates within brackets are those of interviews and statements when different from publication date.

Bernard and Thompson 1984 Bernard, April, and Mimi Thompson. "Johns on . . ." *Vanity Fair* 47 (February 1984), p. 64.

Bourdon 1977 Bourdon, David. "Jasper Johns: 'I Never Sensed Myself as Being Static.'" *Village Voice,* October 31, 1977, p. 75.

Castleman [1985] Conversation with the author. 1985.

Coplans 1972 Coplans, John. "Fragments According to Johns: An Interview with Jasper Johns." *Print Collector's Newsletter* 3 (May–June 1972), pp. 29–32.

Crichton [1976] 1977 Crichton, Michael. *Jasper Johns* (exhibition catalog). New York: Harry N. Abrams and the Whitney Museum of American Art, 1977. Interview conducted in 1976.

Francis [1982] 1984 Francis, Richard. *Jasper Johns.* New York: Abbeville Press, 1984. Interview conducted in 1982.

Fuller 1978 Fuller, Peter. "Jasper Johns Interviewed." Parts 1, 2. *Art Monthly* 18 (July–August 1978), pp. 6–12; 19 (September 1978), pp. 5–7.

Geelhaar [1978] 1979 Geelhaar, Christian. "Interview with Jasper Johns." In *Jasper Johns: Working Proofs* (exhibition catalog). Basel: Kunstmuseum Basel, 1979; London: Petersburg Press, 1980. Interview conducted in 1978.

Glueck 1977 Glueck, Grace. "'Once Established,' Says Jasper Johns, 'Ideas Can Be Discarded.'" *New York Times,* October 16, 1977, sec. 2, pp. 1, 31.

Glueck 1977A Glueck, Grace. "The 20th-Century Artists Most Admired by Other Artists." *Art News* 76 (November 1977), pp. 78–103; statement by Johns, pp. 87–89.

Hopps 1965 Hopps, Walter. "An Interview with Jasper Johns." *Artforum* 3 (March 1965), pp. 32–36.

Martin 1980 Martin, Katrina, dir. and prod. *Hanafuda/ Jasper Johns* (film of artist working on silkscreens at Simca Print Artists). 1980. 33 min.

Miller 1959 Miller, Dorothy C., ed. *Sixteen Americans* (exhibition catalog). New York: The Museum of Modern Art, 1959.

Olson 1977 Olson, Roberta J. M. "Jasper Johns: Getting Rid of Ideas." *SoHo Weekly News,* November 3, 1977, pp. 24–25.

Raynor 1973 Raynor, Vivien. "Jasper Johns: 'I Have Attempted to Develop My Thinking in Such a Way That the Work I've Done Is Not Me.'" *Art News* 72 (March 1973), pp. 20–22.

Sketchbook [n.d.] 1964 Excerpt from undated sketchbook notes, published in *Jasper Johns* (exhibition catalog), edited by Alan R. Solomon. New York: The Jewish Museum, 1964.

Sketchbook [n.d.] 1965 Excerpt from undated sketchbook notes, published in "Sketchbook Notes." *Art and Literature* 4 (Spring 1965), pp. 185–92.

Sketchbook [n.d.] 1968–69 Excerpt from undated sketchbook notes, published in "Sketchbook Notes." *Juillard* 3 (Winter 1968–69), pp. 25–27.

Sketchbook [n.d.] 1969 Excerpt from undated sketchbook notes, published in "Sketchbook Notes." *0 to 9,* no. 6 (July 1969), pp. 1–2.

Solomon 1966 Solomon, Alan R., dir., and Lane Slate, prod. *U.S.A. Artists #8: Jasper Johns* (film with interviews of the artist and Leo Castelli). 1966. 28 min.

Stevens 1977 Stevens, Mark, with Cathleen McGuigan. "Super Artist: Jasper Johns, Today's Master." *Newsweek,* October 24, 1977, pp. 66–68, 73, 77–79.

Swenson 1964 Swenson, G. R. "What Is Pop Art?" Part 2. *Art News* 62 (February 1964), pp. 40–43, 62–67.

Sylvester [1965] 1974 Sylvester, David. *Jasper Johns Drawings* (exhibition catalog). London: Arts Council of Great Britain, 1974. Interview conducted in 1965.

White 1977 White, Edmund. "Enigmas and Double Visions." *Horizon* 20 (October 1977), p. 55.

Young 1969 Young, Joseph E. "Jasper Johns: An Appraisal." *Art International* 13 (September 1969), pp. 50–56.

PLATES

Dates of publication follow names of publishers;
dates in parentheses do not appear on the works.
The publisher Universal Limited Art Editions is cited as U.L.A.E.
The plates reproduce the full sheet of each print;
dimensions given in the captions refer to sheet size.

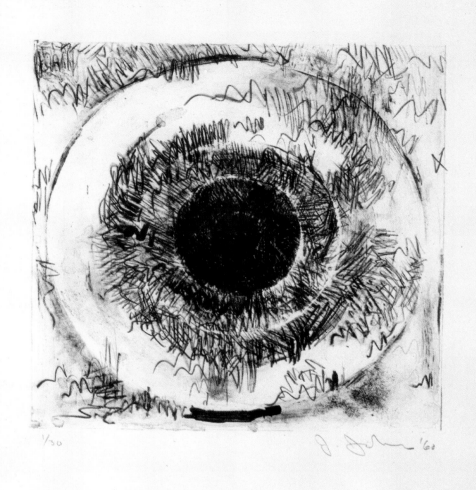

1/30 J. Johns '60

TARGET. U.L.A.E., 1960.
Lithograph, 22⅝ × 17⅝" (57.5 × 44.7 cm).
The Museum of Modern Art, New York. Gift of Mr. and Mrs. Armand P. Bartos.

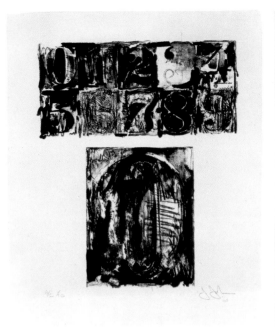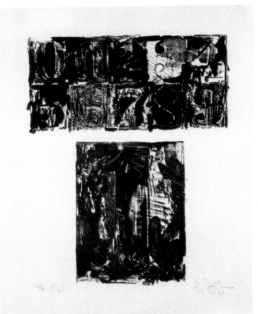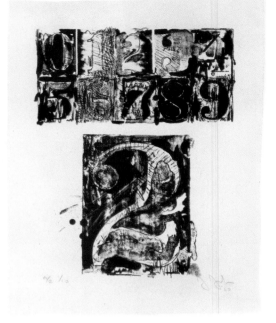

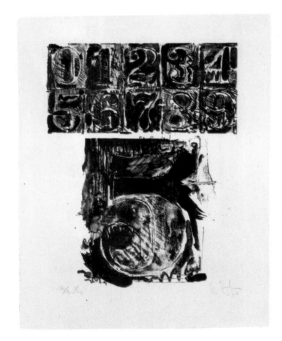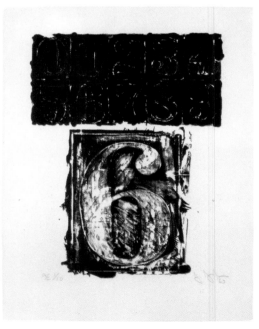

54

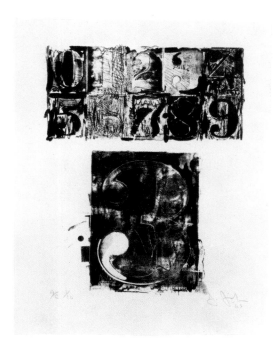

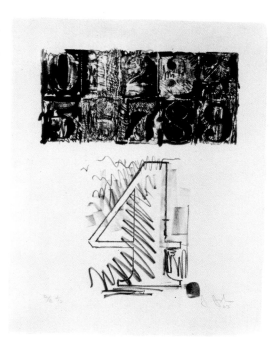

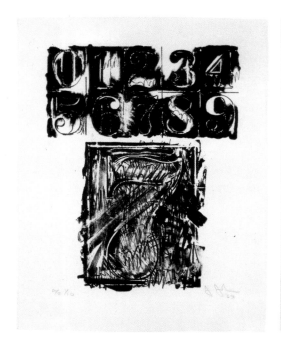

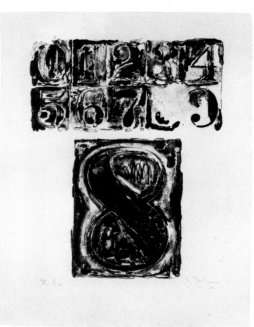

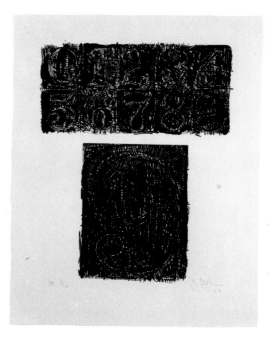

0–9. U.L.A.E., 1963.
Portfolio of ten lithographs, each (variable) 20½ × 15½″ (52.1 × 39.4 cm).
The Museum of Modern Art, New York. Gift of the Celeste and Armand Bartos Foundation.

above: 0–9. U.L.A.E., 1960.
Lithograph, 29⅞ × 22½″ (75.9 × 57.2 cm).
The Museum of Modern Art, New York. Gift of Mr. and Mrs. Armand P. Bartos.

opposite: ALPHABETS. Unpublished, (1962).
Lithograph, 36⅛ × 24¹⁄₁₆″ (91.8 × 61.1 cm). The Museum of Modern Art, New York.
Acquired with matching funds from James R. Epstein and the National Endowment for the Arts.

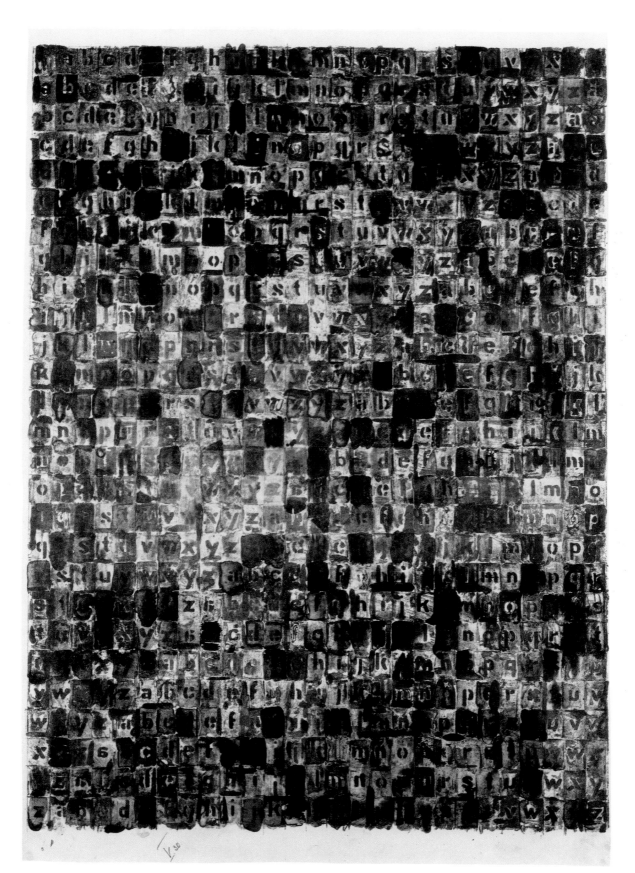

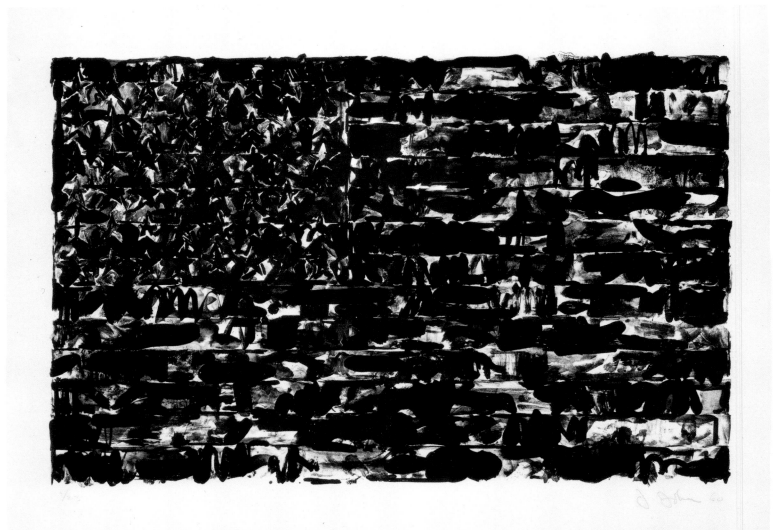

FLAG. U.L.A.E., 1960.
Lithograph, 22¼ × 30″ (56.5 × 76.2 cm).
The Museum of Modern Art, New York. Gift of Mr. and Mrs. Armand P. Bartos.

58

FLAG II. U.L.A.E., 1960.
Lithograph, printed in white, 24 × 32″ (61 × 81.3 cm).
Collection Mr. and Mrs. Victor W. Ganz, New York.

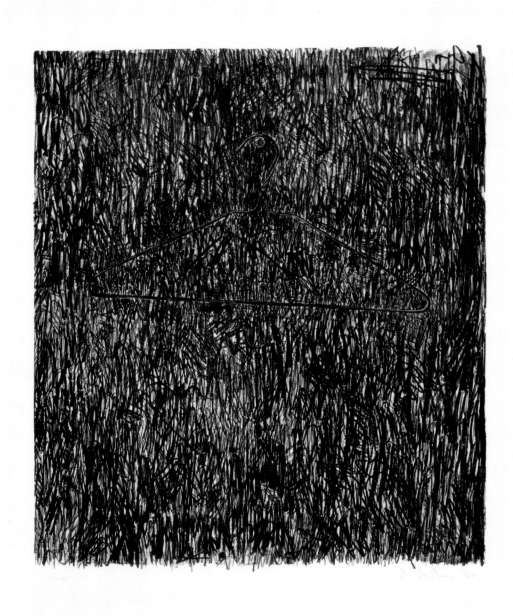

CoAT HANGER. U.L.A.E., 1960.
Lithograph, 36 × 27″ (91.4 × 68.6 cm).
The Museum of Modern Art, New York. Gift of Mr. and Mrs. Armand P. Bartos.

FALSE START I. U.L.A.E., 1962.
Lithograph, printed in color, 30³⁄₁₆ × 22¼″ (76.7 × 56.5 cm).
The Museum of Modern Art, New York. Gift of the Celeste and Armand Bartos Foundation.

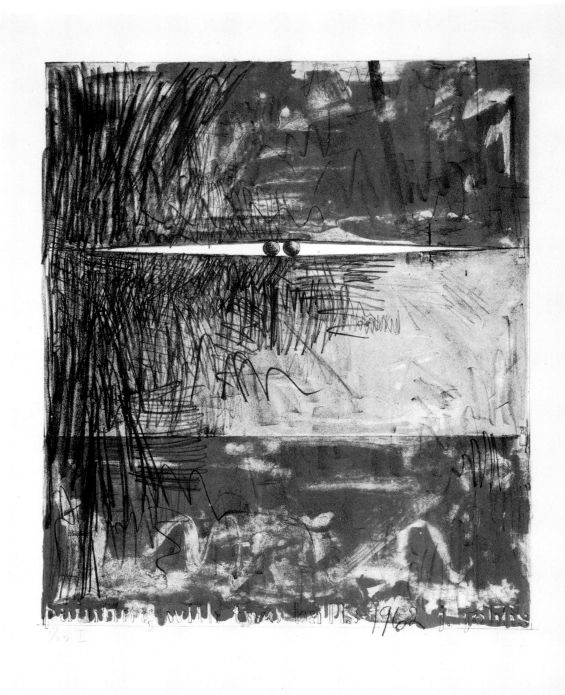

PAINTING WITH TWO BALLS I. U.L.A.E., 1962.
Lithograph, printed in color, 26⁹⁄₁₆ × 20³⁄₈″ (67.5 × 51.8 cm).
The Museum of Modern Art, New York. Gift of the Celeste and Armand Bartos Foundation.

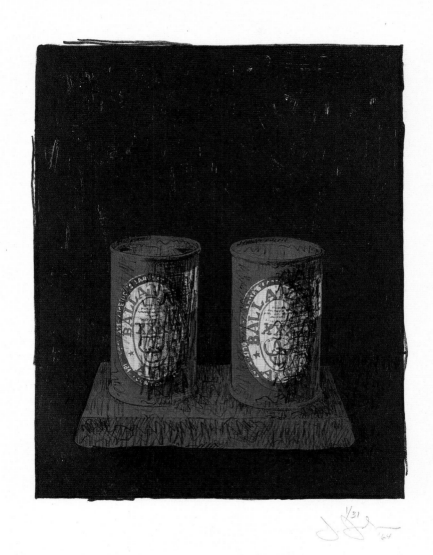

ALE CANS. U.L.A.E., 1964.
Lithograph, printed in color, 22⅞ × 17¾" (58.1 × 45.1 cm).
The Museum of Modern Art, New York. Gift of the Celeste and Armand Bartos Foundation.

above: PAINTBRUSHES from the portfolio FIRST ETCHINGS.
U.L.A.E., 1968.
Etching and photoengraving, 25¼ × 19½″ (64.1 × 49.5 cm).
The Museum of Modern Art, New York.
Gift of the Celeste and Armand Bartos Foundation.

above right: NUMBERS from the portfolio FIRST ETCHINGS.
U.L.A.E., 1968.
Etching and photoengraving, 26 × 20¹⁄₁₆″ (66 × 51 cm).
The Museum of Modern Art, New York.
Gift of the Celeste and Armand Bartos Foundation.

right: FLAG from the portfolio FIRST ETCHINGS.
U.L.A.E., 1968.
Etching and photoengraving, 26 × 20¹⁄₁₆″ (66 × 51 cm).
The Museum of Modern Art, New York.
Gift of the Celeste and Armand Bartos Foundation.

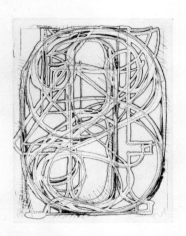

NUMBERS from the portfolio
FIRST ETCHINGS, SECOND STATE.
U.L.A.E., 1969.
Etching, 26 × 19¹¹⁄₁₆″ (66 × 50 cm).
The Museum of Modern Art, New York.
Gift of the Celeste and Armand Bartos Foundation.

FLAG from the portfolio
FIRST ETCHINGS, SECOND STATE.
U.L.A.E., 1969.
Etching and roulette, 25⅞ × 19¹¹⁄₁₆″ (65.7 × 50 cm).
The Museum of Modern Art, New York.
Gift of the Celeste and Armand Bartos Foundation.

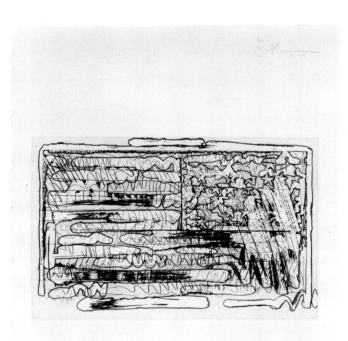

65

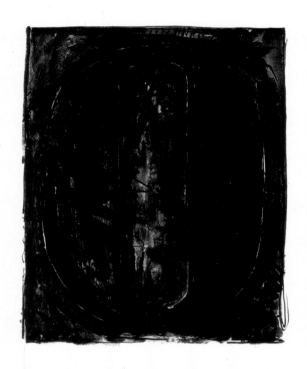 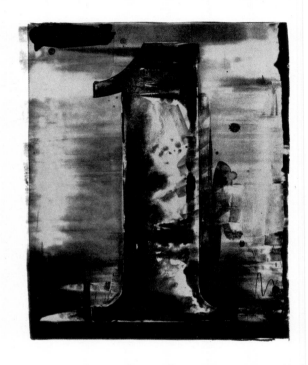

above: FIGURE 0 and FIGURE 1 from the series BLACK AND WHITE NUMERALS. Gemini G.E.L., 1968.
Lithographs, each (variable) 37 × 30″ (94 × 76.2 cm).
The Museum of Modern Art, New York. John B. Turner Fund.

opposite above: FIGURE 1 from the series COLOR NUMERALS. Gemini G.E.L., 1969.
Lithograph, printed in color, 38 × 31″ (96.5 × 78.7 cm).
Collection Mr. and Mrs. Victor W. Ganz, New York.

opposite below: NUMERAL 1 from FOIRADES/FIZZLES by Samuel Beckett. Petersburg Press, 1976.
Etching and drypoint, 13 1/16 × 9 15/16″ (33.2 × 25.2 cm).
The Museum of Modern Art, New York. Gift of Celeste and Armand Bartos.

66

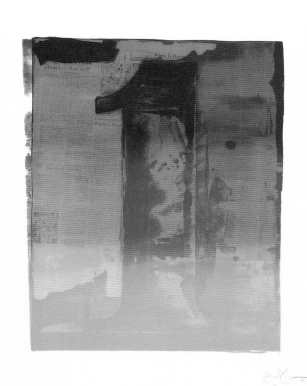

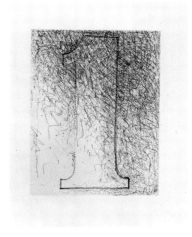

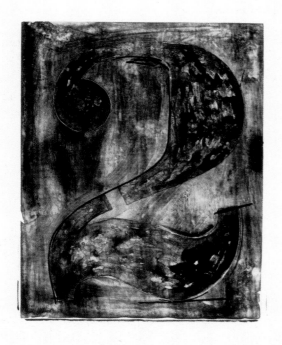
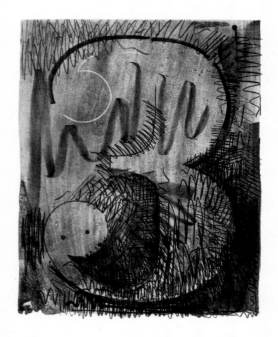

FIGURE 2 through FIGURE 6 from the series BLACK AND WHITE NUMERALS. Gemini G.E.L., 1968.
Lithographs, each (variable) 37 × 30″ (94 × 76.2 cm).
The Museum of Modern Art, New York. John B. Turner Fund.

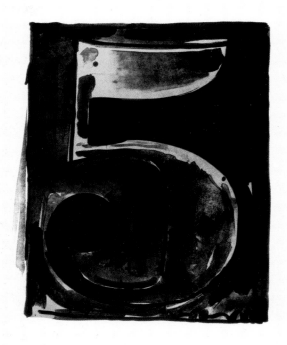

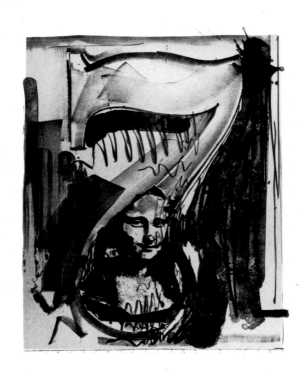

FIGURE 7 from the series BLACK AND WHITE NUMERALS. Gemini G.E.L., 1968.
Lithograph, 37⅛ × 30″ (94.3 × 76.2 cm).
The Museum of Modern Art, New York. John B. Turner Fund.

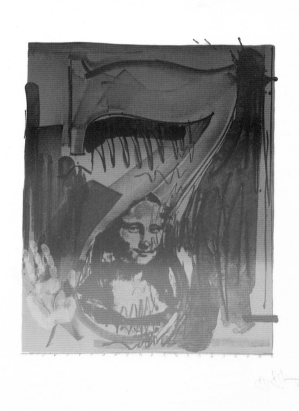

FIGURE 7 from the series COLOR NUMERALS. Gemini G.E.L., 1969.
Lithograph, printed in color, 38 × 31″ (96.5 × 78.7 cm).
Collection Mr. and Mrs. Victor W. Ganz, New York.

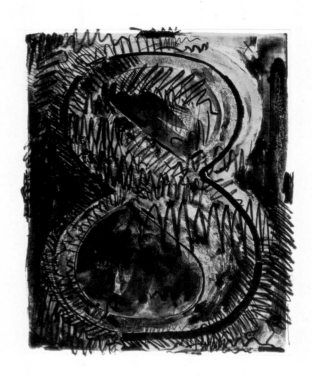 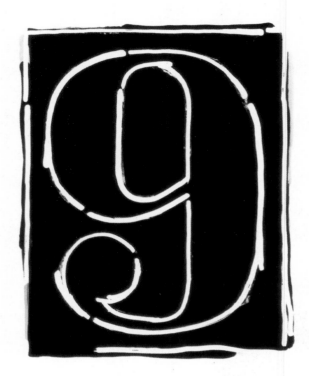

FIGURE 8 and FIGURE 9 from the series BLACK AND WHITE NUMERALS. Gemini G.E.L., 1968.
Lithographs, each (variable) 37 × 30″ (94 × 76.2 cm).
The Museum of Modern Art, New York. John B. Turner Fund.

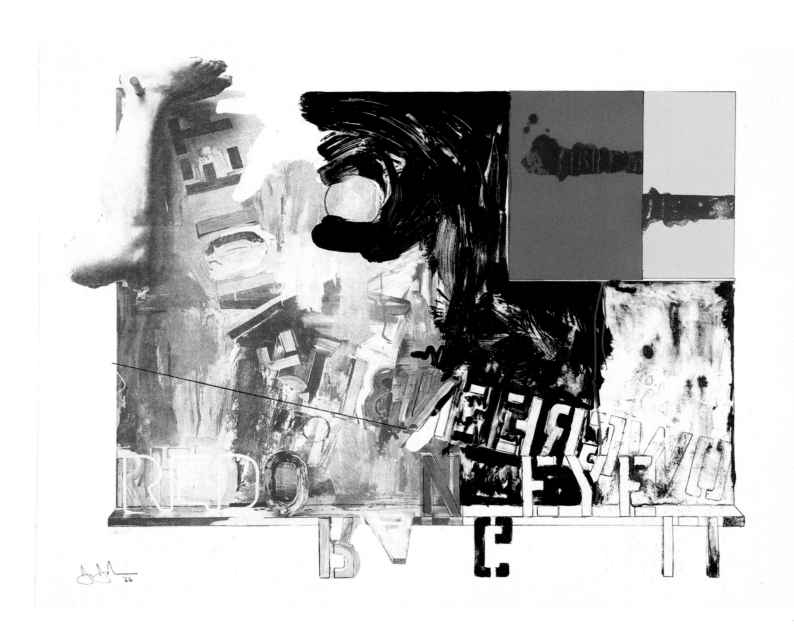

PASSAGE I. U.L.A.E., 1966.
Lithograph, printed in color, 28⅛ × 36⅜″ (71.4 × 92.4 cm).
The Museum of Modern Art, New York. Gift of the Celeste and Armand Bartos Foundation.

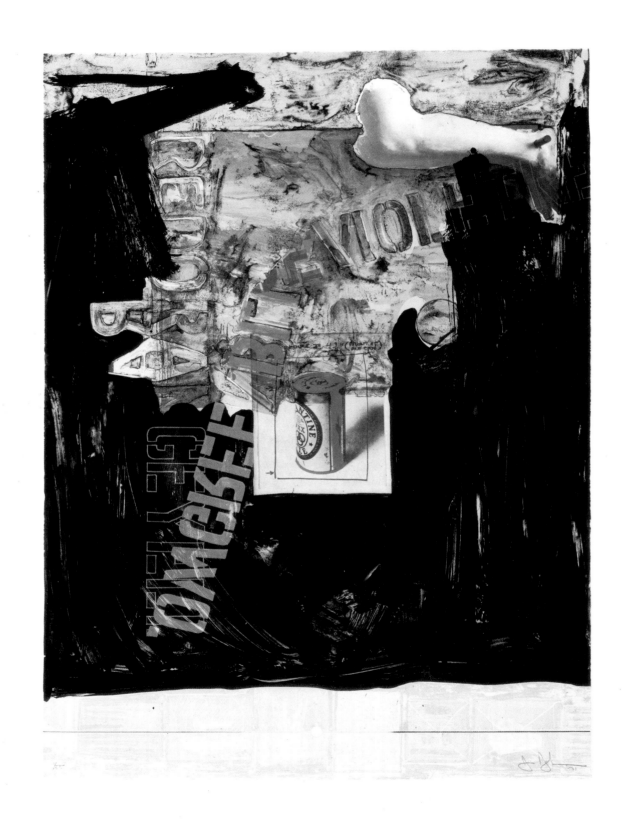

DECOY. U.L.A.E., 1971.
Lithograph, printed in color, 41½ × 29⁹⁄₁₆″ (105.4 × 75.1 cm).
The Museum of Modern Art, New York. Gift of Celeste Bartos.

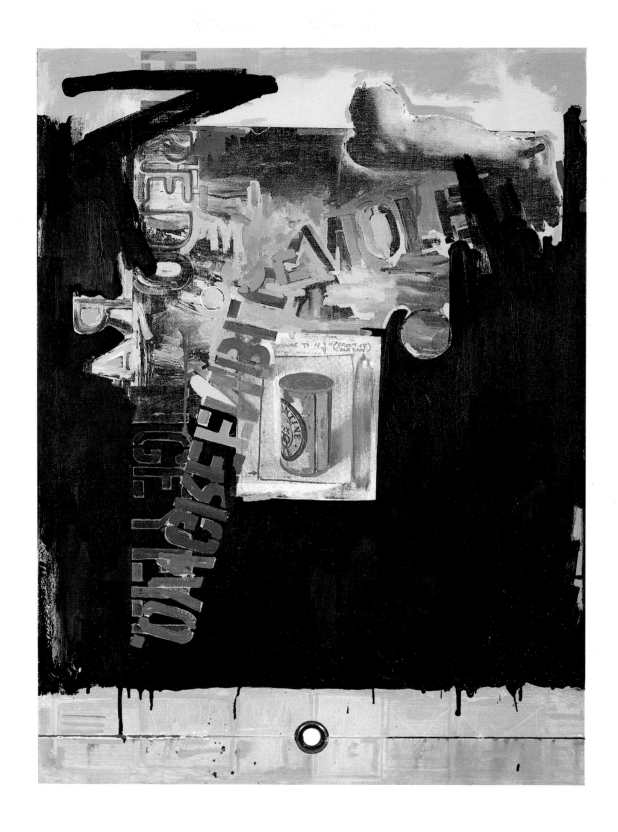

DECOY. 1971.
Oil on canvas with brass grommet, 41 × 29½″ (104.1 × 74.9 cm).
Collection Kimiko and John Powers, New York.

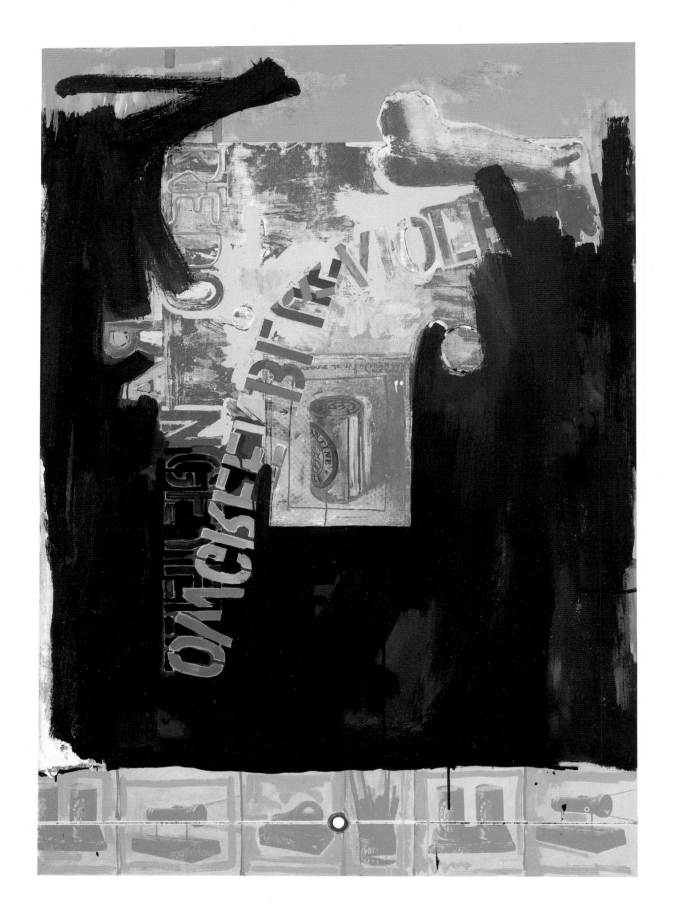

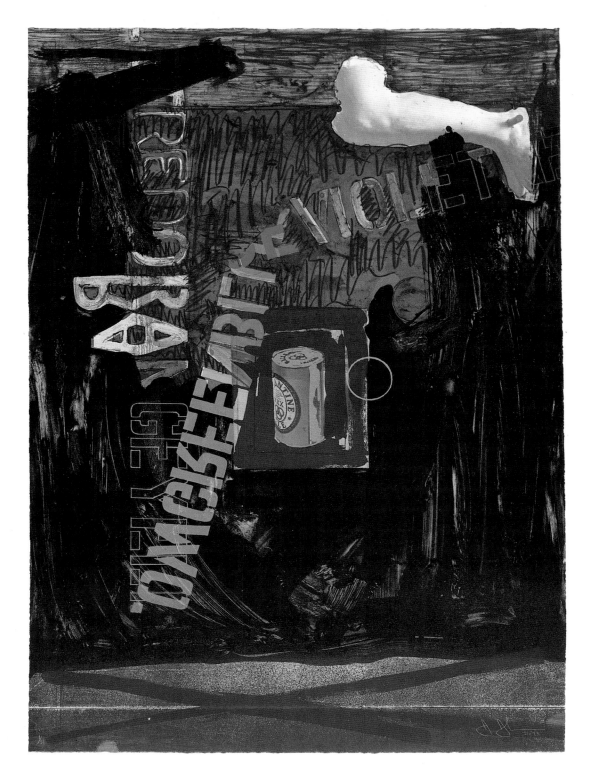

opposite: DECOY. 1971.
Oil on canvas with brass grommet, 72 × 50″ (182.9 × 127 cm).
Collection Mr. and Mrs. Victor W. Ganz, New York.

above: DECOY II. U.L.A.E., 1973.
Lithograph, printed in color, 41 7/16 × 29 5/8″ (105.3 × 75.2 cm).
The Museum of Modern Art, New York. Gift of Celeste Bartos.

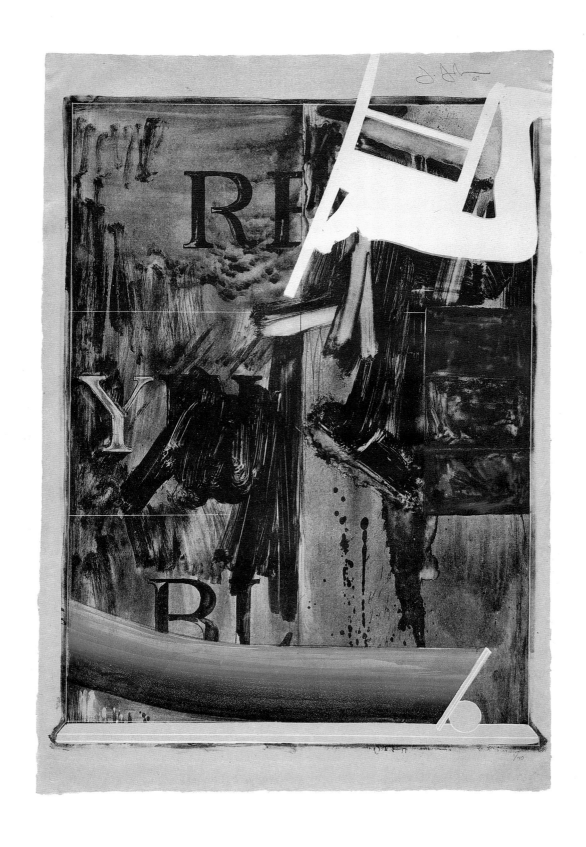

WATCHMAN. U.L.A.E., 1967.
Lithograph, printed in color, 36¹/₁₆ × 24³/₁₆″ (91.6 × 61.4 cm).
The Museum of Modern Art, New York. Gift of the Celeste and Armand Bartos Foundation.

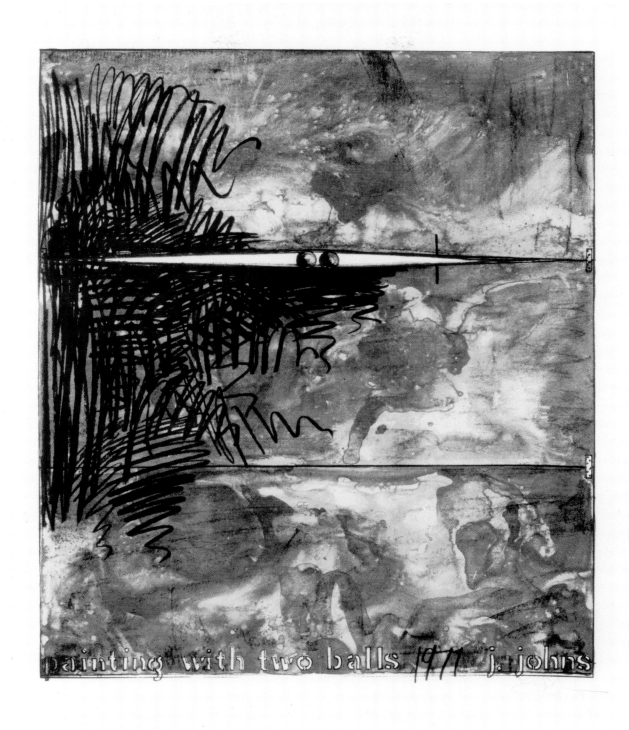

PAINTING WITH TWO BALLS (Grays). The artist, 1971.
Silkscreen, printed in gray and black, 34⅞ × 28¼″ (88.6 × 71.8 cm).
Courtesy Brooke Alexander, Inc., New York.

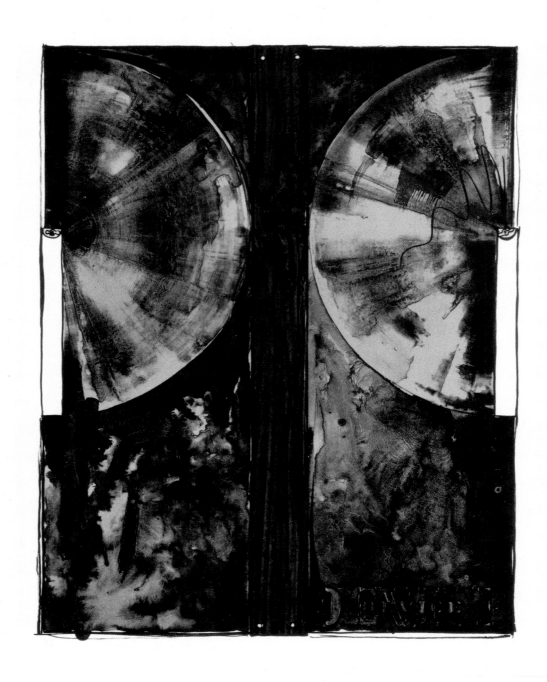

above: DEVICE—BLACK STATE. Gemini G.E.L., 1972.
Lithograph, printed in gray and black, 32¼ × 25¾″ (81.9 × 65.4 cm).
Lent by the publisher, Los Angeles.

opposite: FOOL'S HOUSE. Gemini G.E.L., 1972.
Lithograph, printed in color, 43¾ × 28¾″ (111.1 × 73 cm).
The Museum of Modern Art, New York. John B. Turner Fund.

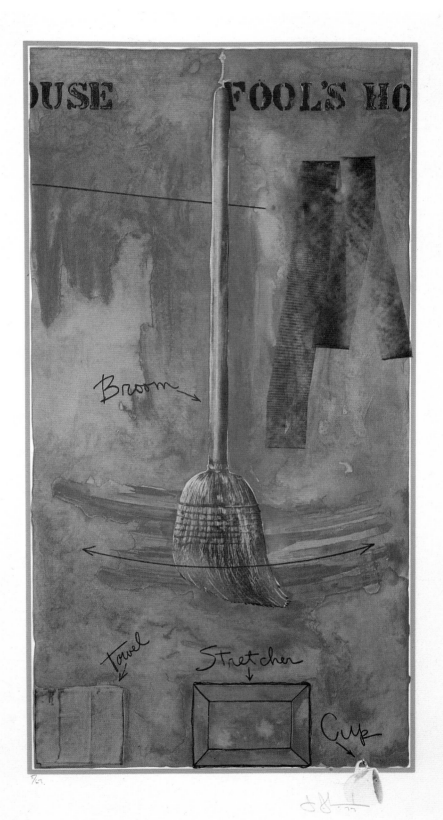

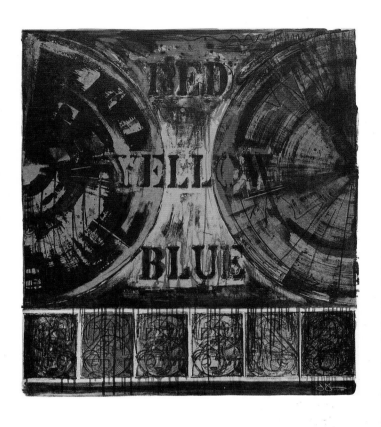

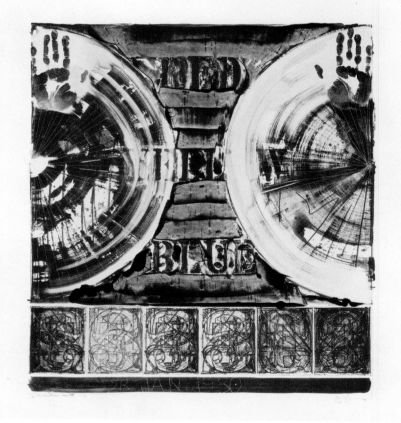

above: UNTITLED. Gemini G.E.L., 1980.
Lithograph, printed in color, 34¼ × 30¼″ (87 × 76.8 cm).
Collection Leslie and Johanna Garfield, New York.

right: Cancellation proof for UNTITLED. 1980.
Lithograph, 39¹/₁₆ × 35¾″ (99.2 × 90.8 cm).
Collection the artist, New York.

Voice. U.L.A.E., 1967.
Lithograph, printed in black and silver, 48⅜ × 31¹¹⁄₁₆″ (122.9 × 80.5 cm).
The Museum of Modern Art, New York. Gift of the Celeste and Armand Bartos Foundation.

83

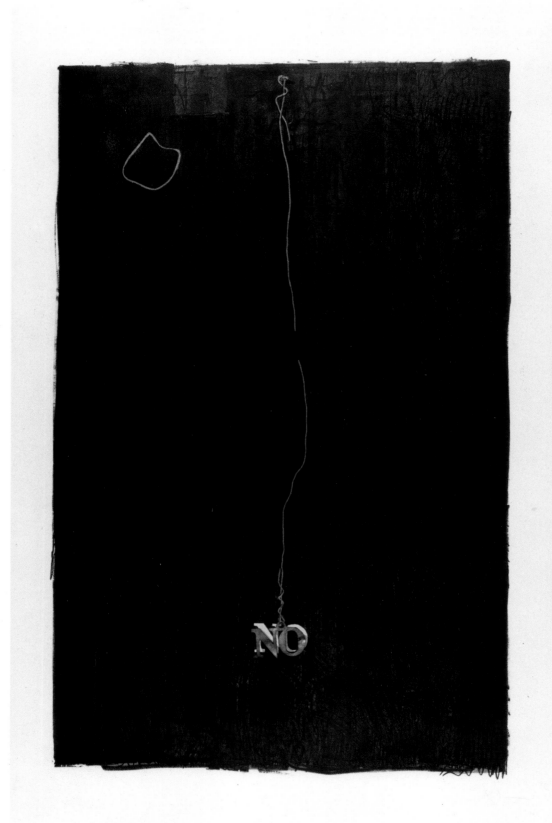

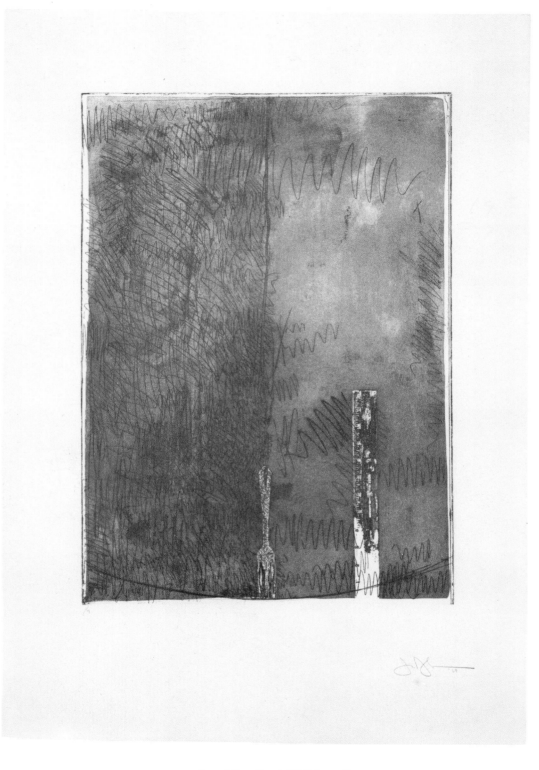

opposite: No. Gemini G.E.L., 1969.
Embossed lithograph, printed in color with collage, 56 × 35⅞″ (142.2 × 91.1 cm).
The Museum of Modern Art, New York. Gift of Philip Johnson (by exchange).

above: UNTITLED (Ruler and Fork) II. U.L.A.E., 1969.
Etching and aquatint, printed in gray, 41¼ × 27¹⁵⁄₁₆″ (104.8 × 71 cm).
The Museum of Modern Art, New York. Gift of the Celeste and Armand Bartos Foundation.

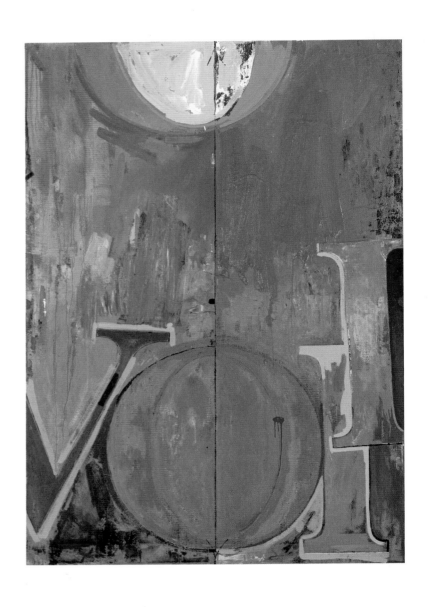

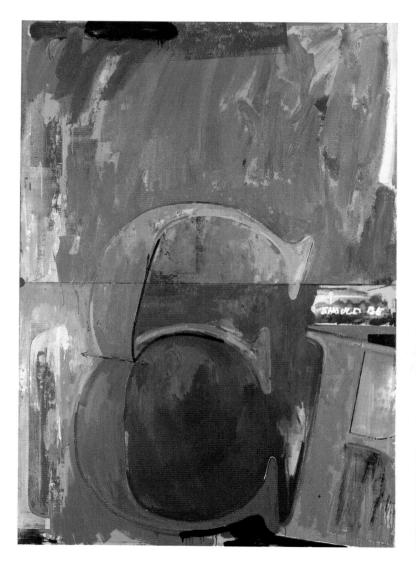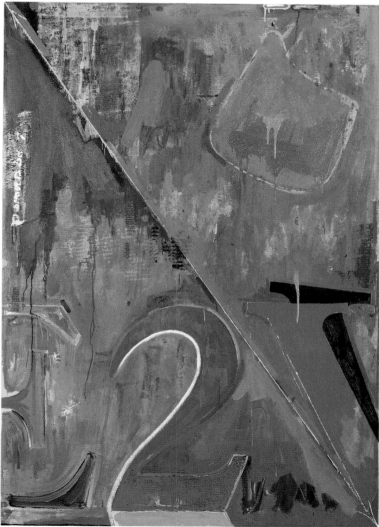

VOICE 2. 1971.
Oil and collage on canvas, three panels, each 72 × 50″ (182.9 × 127 cm).
Oeffentliche Kunstsammlung, Kunstmuseum Basel.

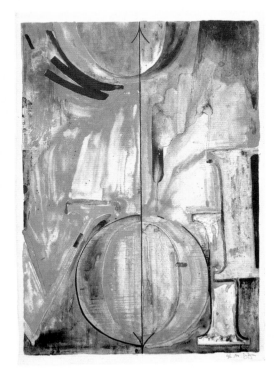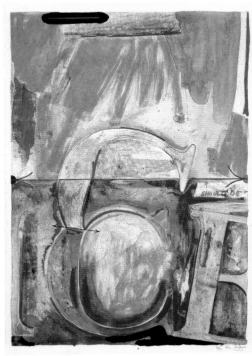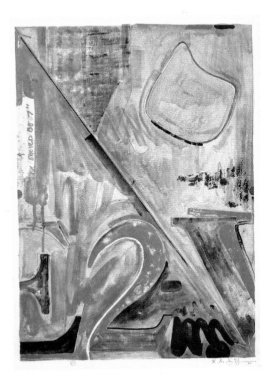

VOICE 2. U.L.A.E., 1982.
Lithograph, printed in color on three sheets, each 36 × 24⅝″ (91.4 × 62.5 cm).
The Museum of Modern Art, New York. Gift of Celeste Bartos.

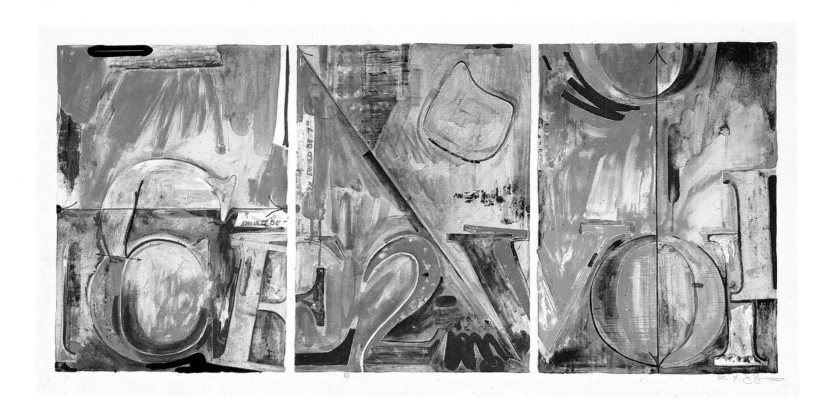

VOICE 2. Unpublished, 1982.
Lithograph, printed in color, 38⅝ × 75³⁄₁₆″ (98.1 × 191 cm).
Collection the artist, New York.

VOICE 2. U.L.A.E., 1982.
Lithograph, printed in color,
19 13/16 × 25 7/16″ (50.3 × 64.6 cm).
The Museum of Modern Art, New York.
Gift of Celeste Bartos.

VOICE 2. U.L.A.E., 1982.
Lithograph, printed in color,
19 13/16 × 25 7/16″ (50.3 × 64.6 cm).
Private collection,
West Hartford, Connecticut.

VOICE 2. U.L.A.E., 1982.
Lithograph, printed in color,
19 13/16 × 25 7/16″ (50.3 × 64.6 cm).
Collection Mr. and Mrs. Victor W. Ganz,
New York.

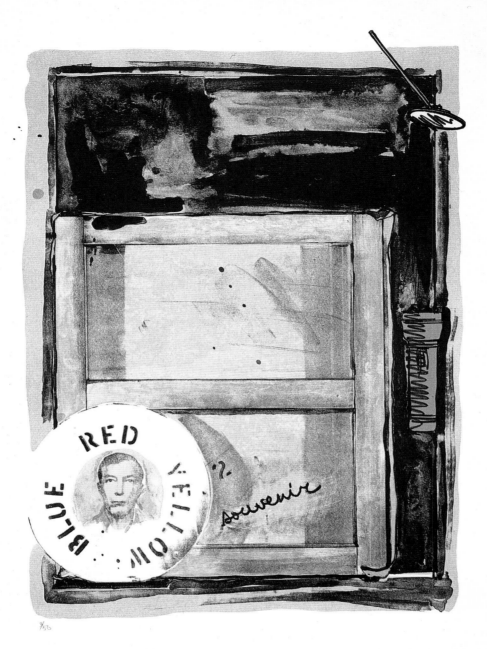

SOUVENIR. U.L.A.E., 1970.
Lithograph, printed in color, 30¹¹⁄₁₆ × 22⁵⁄₁₆″ (77.9 × 56.7 cm).
The Museum of Modern Art, New York. Gift of the Celeste and Armand Bartos Foundation.

91

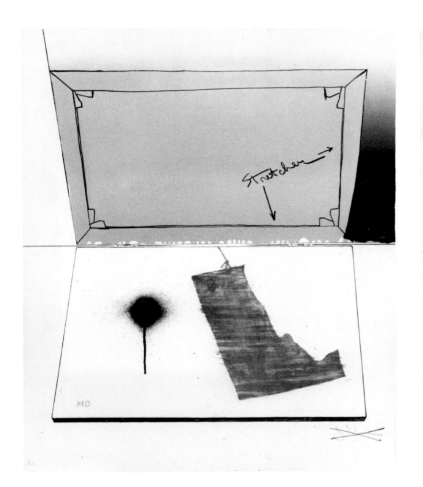
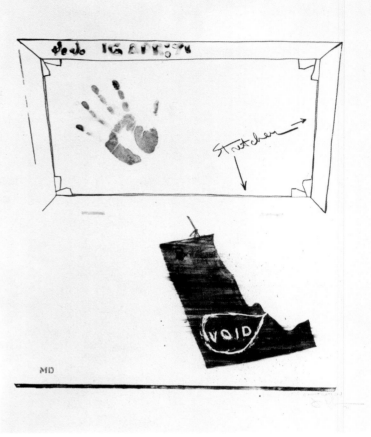

left: FRAGMENT—ACCORDING TO WHAT—HINGED CANVAS. Gemini G.E.L., 1971.
Lithograph, printed in color, 36⅛ × 29¾″ (91.8 × 75.6 cm).
The Museum of Modern Art, New York. John B. Turner Fund.

right: Cancellation proof for FRAGMENT—ACCORDING TO WHAT—HINGED CANVAS. 1971.
Lithograph, printed in color, 36 × 29⅝″ (91.4 × 75.2 cm).
Collection the artist, New York.

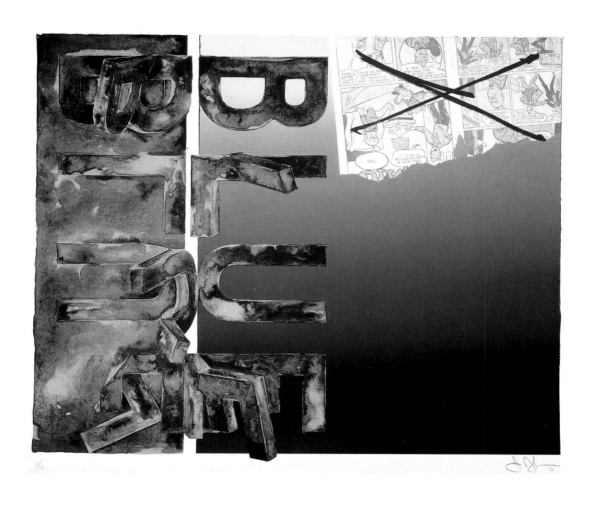

FRAGMENT—ACCORDING TO WHAT—BENT "BLUE" (Second State). Gemini G.E.L., 1971.
Lithograph, printed in color with transfer, 25½ × 28¾″ (64.8 × 73 cm).
Collection the artist, New York.

93

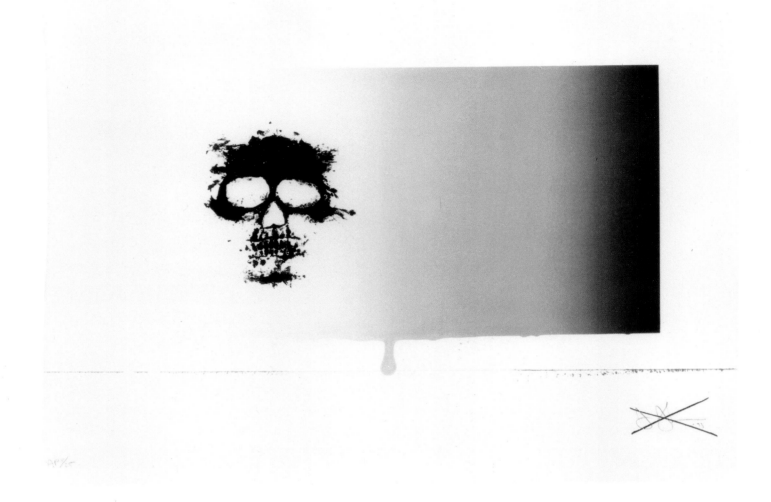

UNTITLED (Skull) from the portfolio REALITY AND PARADOXES. Multiples, Inc., 1973.
Silkscreen, printed in color, 24 × 33″ (61 × 83.8 cm).
Collection Peter and Susan Ralston, New York.

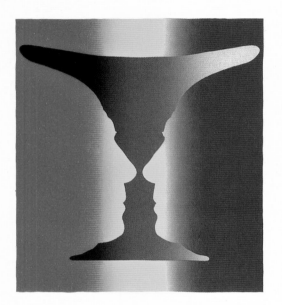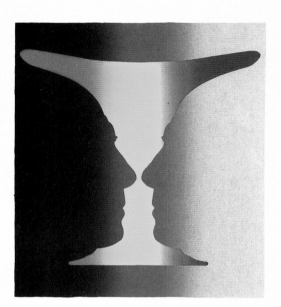

CUPS 4 PICASSO. U.L.A.E., 1972.
Lithograph, printed in color, 22¼ × 32¼″ (56.5 × 81.9 cm).
The Museum of Modern Art, New York. Gift of Celeste Bartos.

95

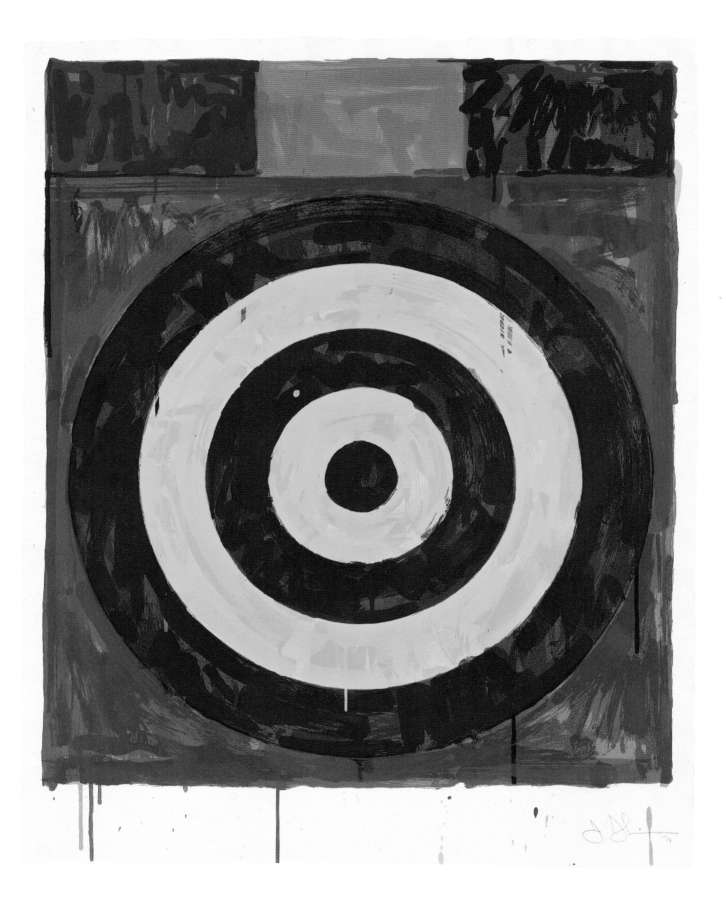

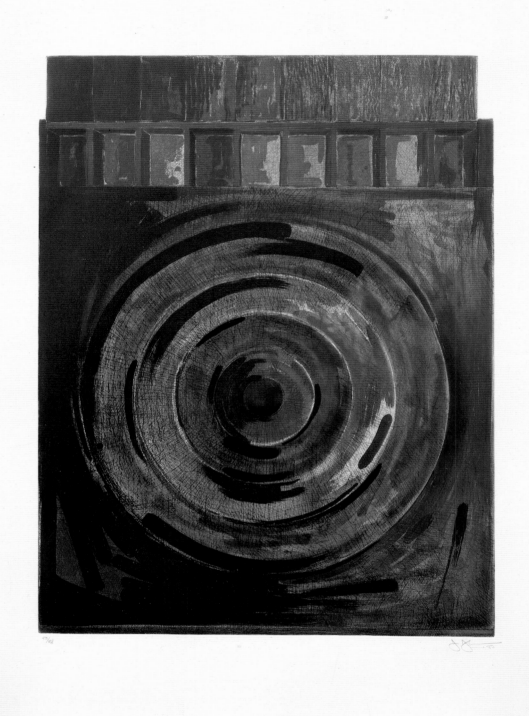

opposite: Target. Simca Print Artists and the artist, 1974.
Silkscreen, printed in color, 34⅞ × 27⅜″ (88.6 × 69.5 cm).
Collection Leslie and Johanna Garfield, New York.

above: Target with Plaster Casts. Petersburg Press, 1980.
Etching and aquatint, printed in color, 29⁹⁄₁₆ × 22⁵⁄₁₆″ (75.1 × 56.7 cm).
Collection Leslie and Johanna Garfield, New York.

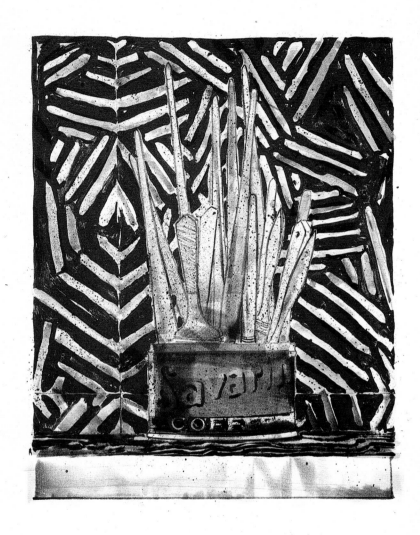

above: SAVARIN 5 (Corpse and Mirror). U.L.A.E., 1978.
Lithograph, printed in color, 26 × 19¹⁵⁄₁₆″ (66 × 50.6 cm).
The Museum of Modern Art, New York. Gift of Celeste Bartos.

opposite: SAVARIN. U.L.A.E., 1977.
Lithograph, printed in color, 45½ × 34⅝″ (115.6 × 87.9 cm).
The Museum of Modern Art, New York. Gift of Celeste Bartos.

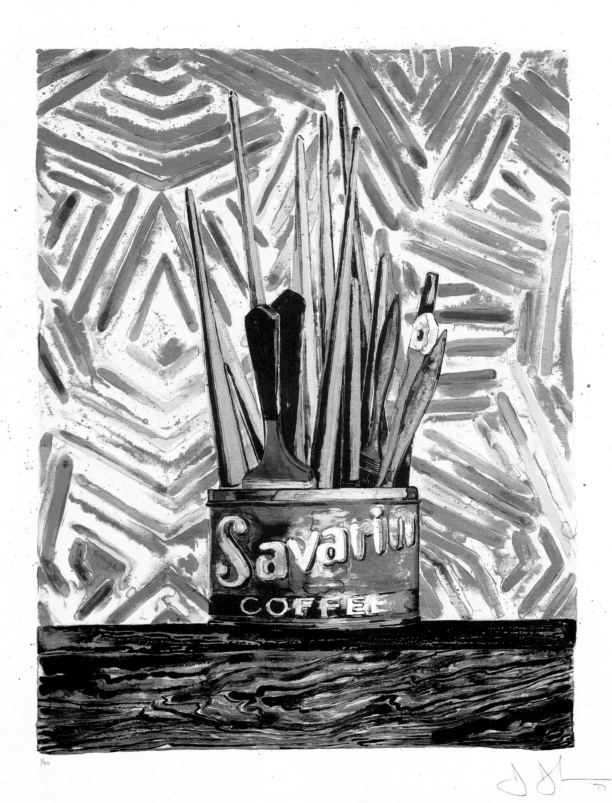

1/50 [signature] '77

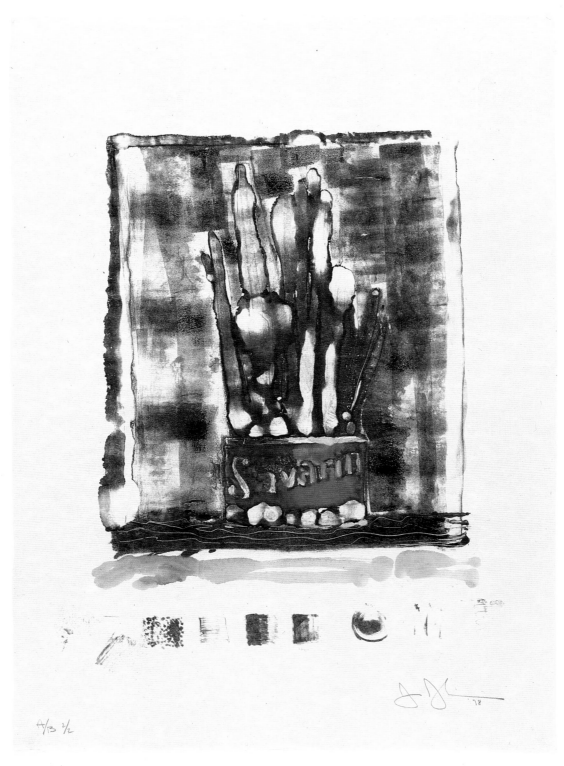

A/13 2/2

above: SAVARIN. 1978.
Lithograph and monotype, printed in color, 27⅜ × 19⁵⁄₁₆″ (69.5 × 49.1 cm).
Collection Carol and Morton Rapp, Toronto.

opposite: SAVARIN. 1982.
Lithograph and monotype, printed in color, 50 × 38″ (127 × 96.5 cm).
Collection Nelson Blitz, Jr., New York.

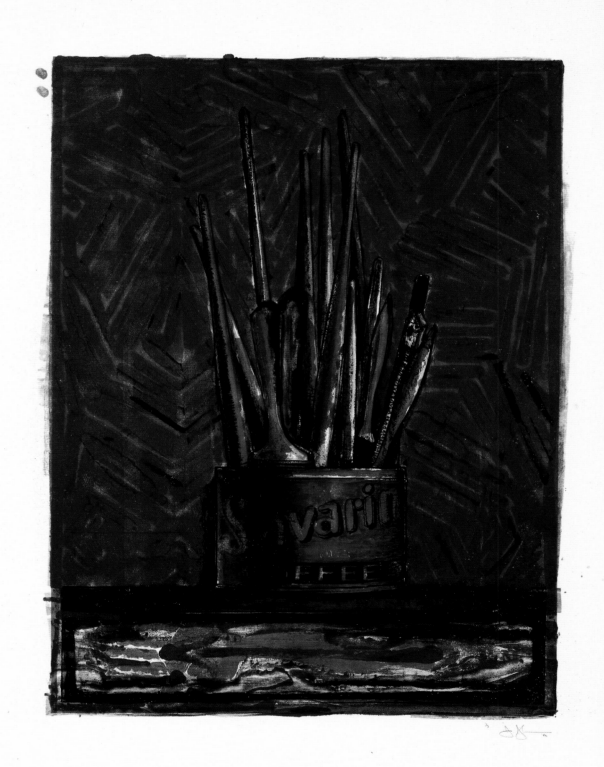

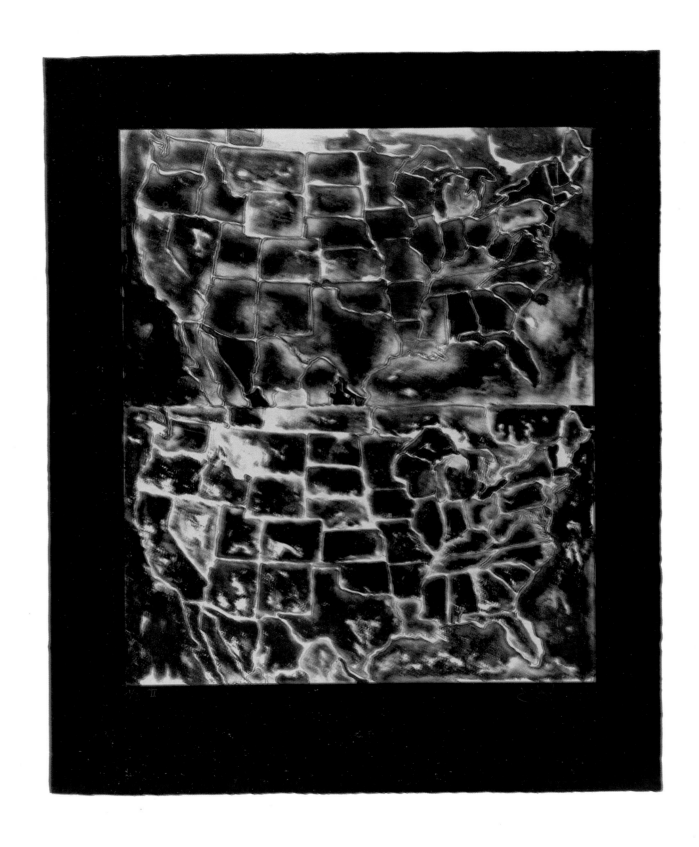

TWO MAPS II. U.L.A.E., 1966.
Lithograph, 33 11/16 × 26 5/16" (85.6 × 66.8 cm).
The Museum of Modern Art, New York. Gift of the Celeste and Armand Bartos Foundation.

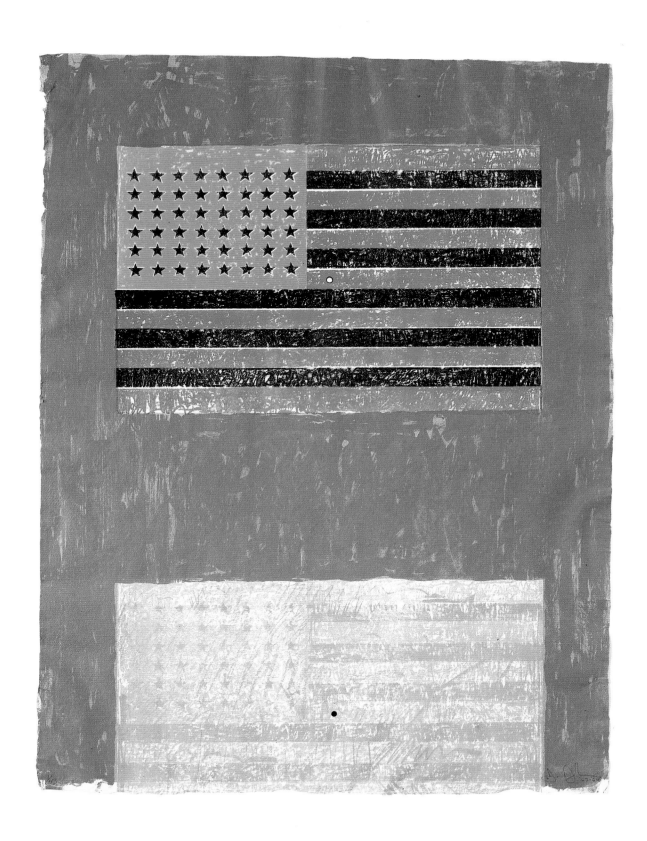

FLAGS. U.L.A.E., 1968.
Lithograph, printed in color, 34⅝ × 25⅞″ (87.9 × 65.7 cm).
The Museum of Modern Art, New York. Gift of the Celeste and Armand Bartos Foundation.

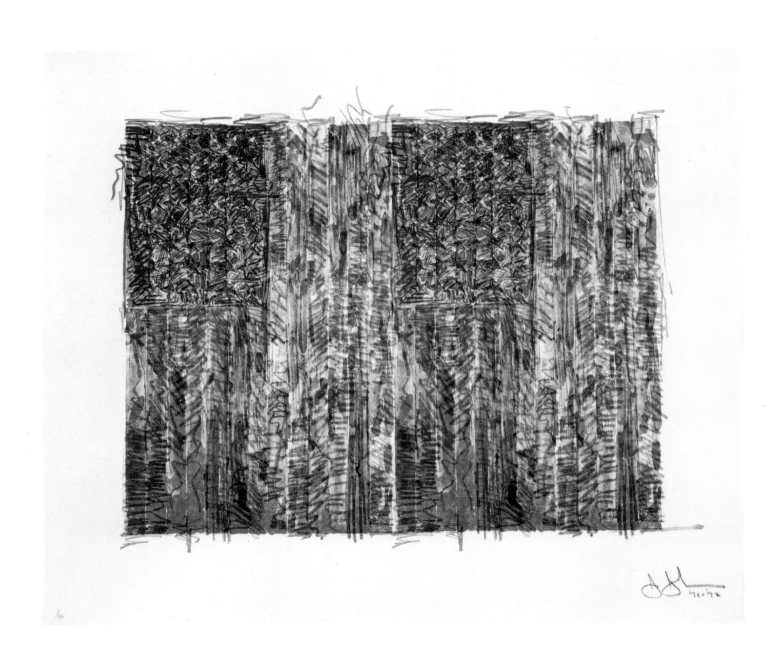

Two Flags (Gray). U.L.A.E., 1972.
Lithograph, printed in gray, 27⁹⁄₁₆ × 32¹³⁄₁₆″ (70 × 83.3 cm).
The Museum of Modern Art, New York. Gift of Celeste Bartos.

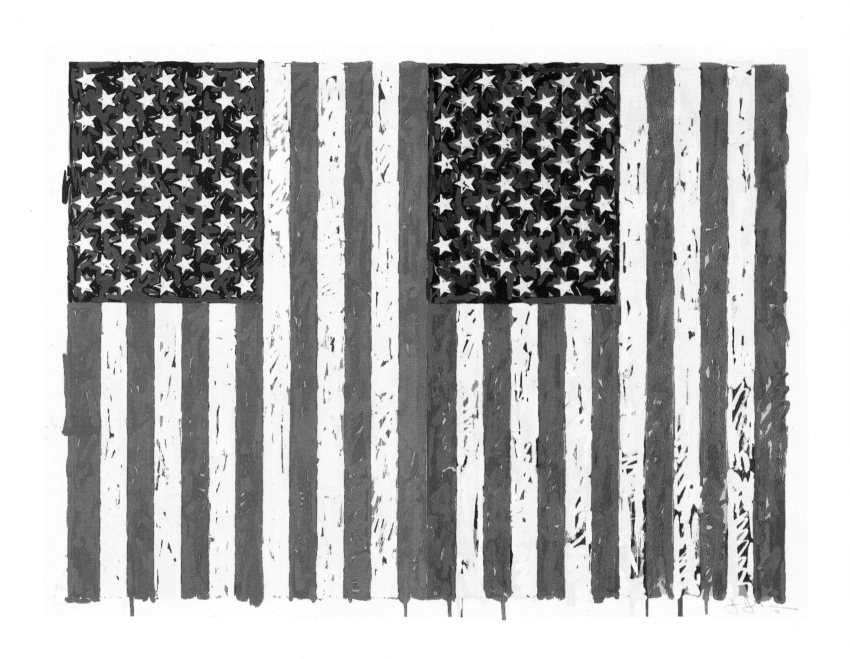

FLAGS I. Simca Print Artists and the artist, 1973.
Silkscreen, printed in color, 27½ × 35″ (69.9 × 88.9 cm).
Collection Leslie and Johanna Garfield, New York.

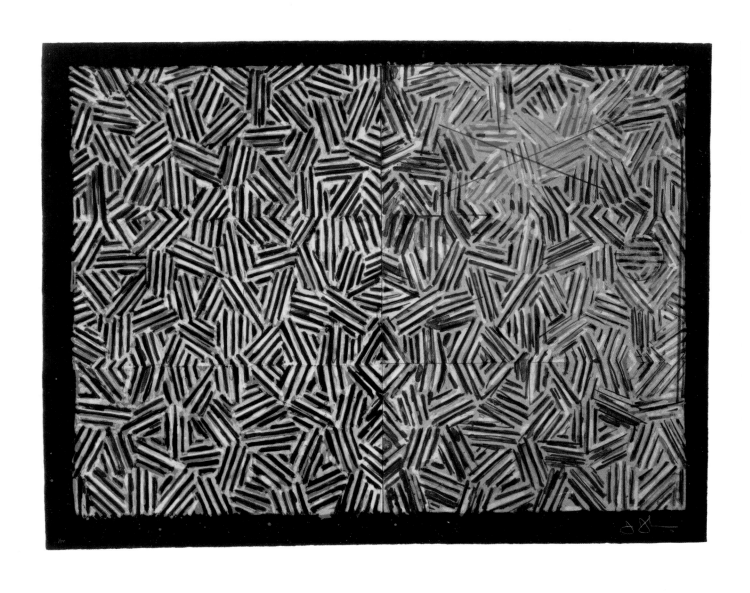

CORPSE AND MIRROR. U.L.A.E., 1976.
Lithograph, printed in white, gray, and black, 30¾ × 39⅝" (78.1 × 100.6 cm).
The Museum of Modern Art, New York. Gift of Celeste Bartos.

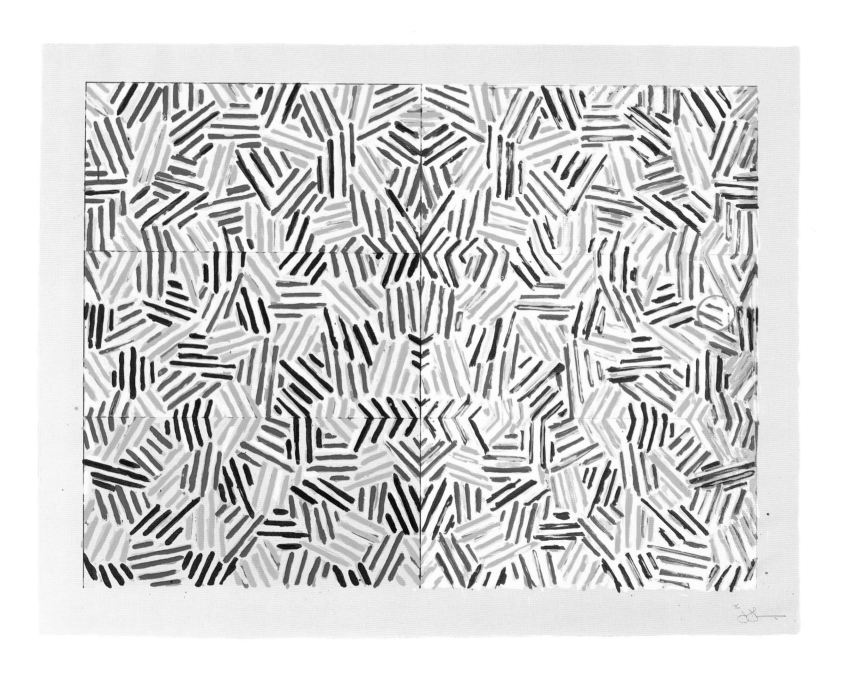

CORPSE AND MIRROR. Simca Print Artists and the artist, 1976.
Silkscreen, printed in color, 42¼ × 53″ (107.3 × 134.6 cm).
Collection Brooke and Carolyn Alexander, New York.

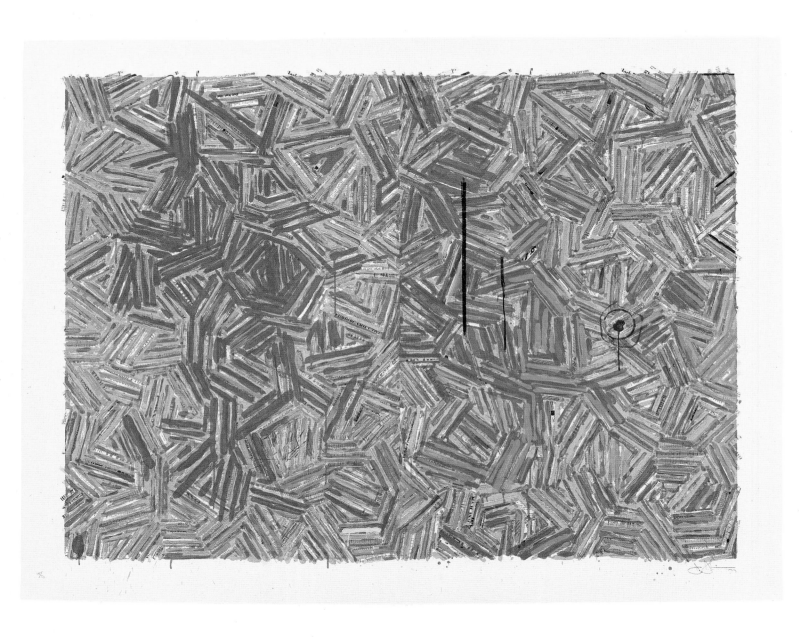

THE DUTCH WIVES. Simca Print Artists and the artist, 1977.
Silkscreen, printed in color, 42$^{15}/_{16}$ × 56″ (109.1 × 142.2 cm).
The Museum of Modern Art, New York.
Elizabeth Bliss Parkinson, Mrs. John D. Rockefeller 3rd,
Mrs. Alfred R. Stern, and Jeanne C. Thayer Funds.

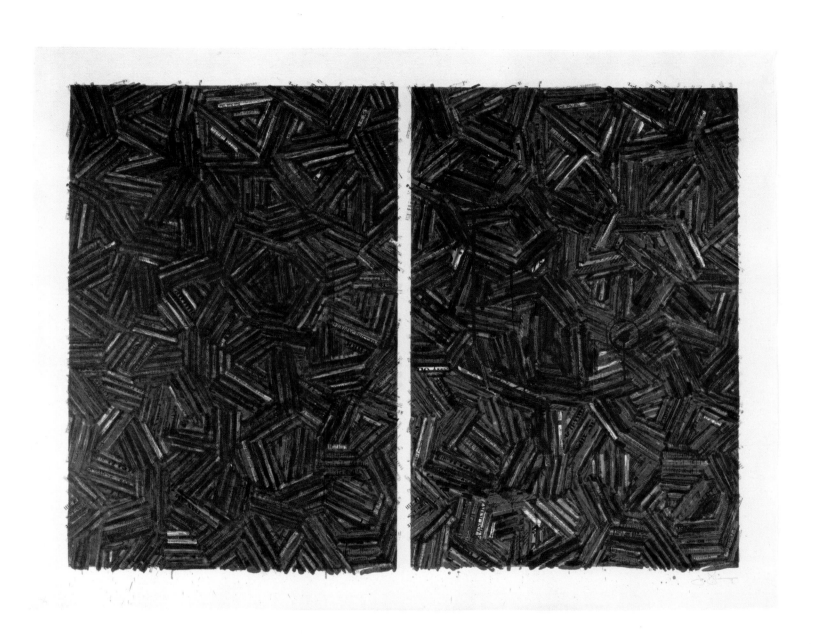

THE DUTCH WIVES. Simca Print Artists and the artist, 1978.
Silkscreen, printed in color, 43 × 56 1/16″ (109.2 × 142.4 cm).
The Museum of Modern Art, New York.
Gift of Mr. and Mrs. Harry Kahn.

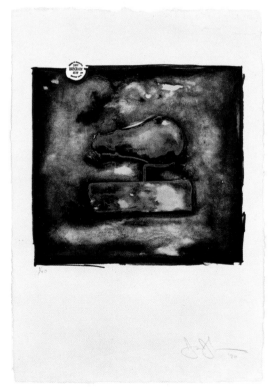

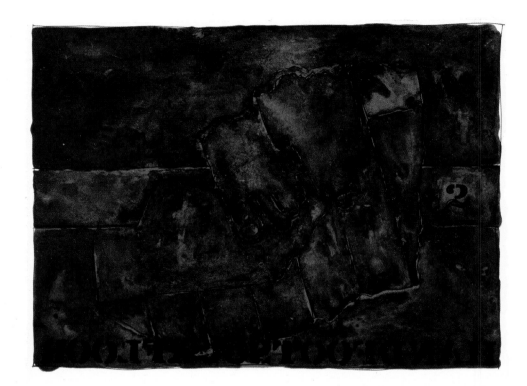

left: LIGHT BULB. U.L.A.E., 1970.
Lithograph, printed in black and silver with rubber stamp, 19 1/16 × 12″ (48.4 × 30.5 cm).
The Museum of Modern Art, New York. Gift of the Celeste and Armand Bartos Foundation.

right: HANDFOOTSOCKFLOOR—BLACK STATE from the series CASTS FROM UNTITLED. Gemini G.E.L., 1974.
Lithograph, 16 × 19 3/4″ (40.6 × 50.2 cm).
Lent by the publisher, Los Angeles.

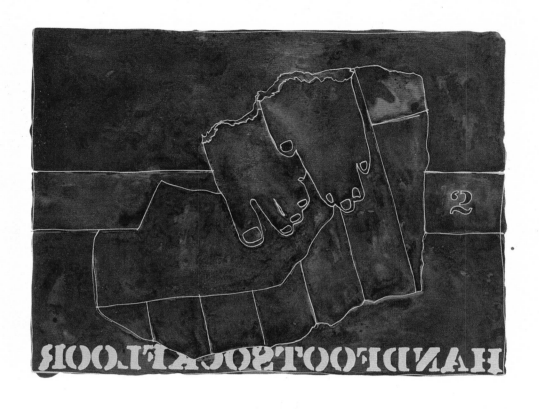

HandFootSockFloor from the series Casts from Untitled. Gemini G.E.L., 1974.
Lithograph, printed in color, 30¾ × 22¾" (78.1 × 57.8 cm).
Lent by the publisher, Los Angeles.

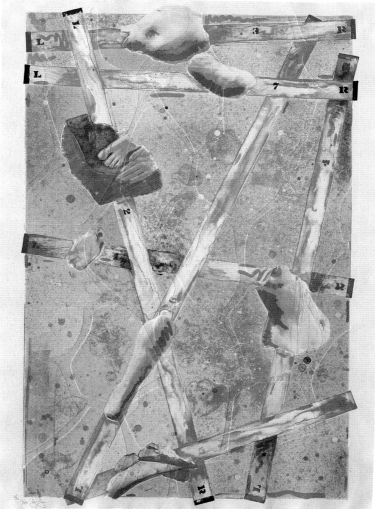

FOUR PANELS FROM UNTITLED 1972. Gemini G.E.L., 1974.
Lithograph, printed in color with embossing on four sheets, each 40 × 28½″ (101.6 × 72.4 cm).
The Museum of Modern Art, New York. Jeanne C. Thayer Fund and purchase.

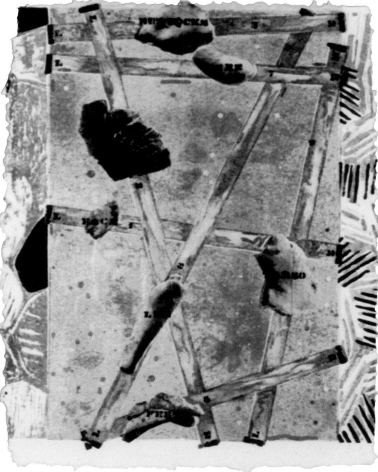

FOUR PANELS FROM UNTITLED 1972 (GRAYS AND BLACK). Gemini G.E.L., 1975.
Lithograph, printed in gray and black with embossing on four sheets, each 41 × 32″ (104.1 × 81.3 cm).
Collection Kate Ganz, London.

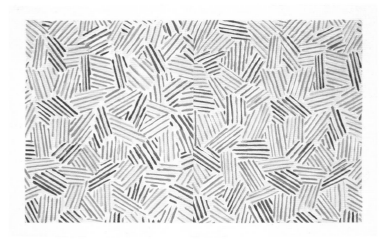

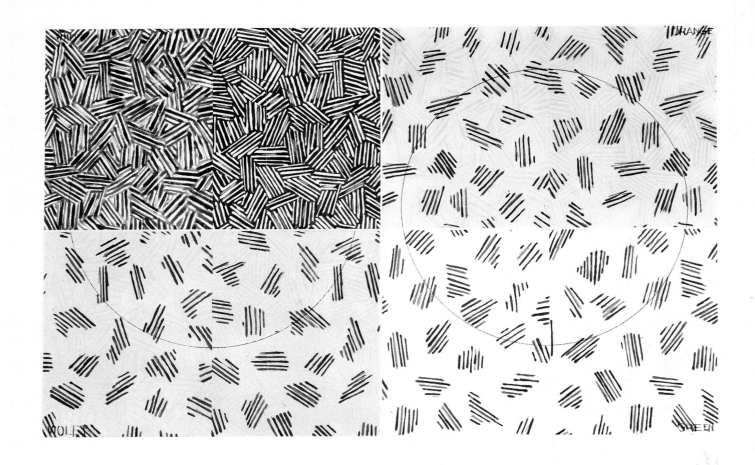

opposite above: HATCHING (Front Endpaper) from FOIRADES/FIZZLES by Samuel Beckett. Petersburg Press, 1976.
Aquatint and drypoint, printed in color, 13 1/16 × 19 7/8" (33.2 × 50.5 cm).
The Museum of Modern Art, New York. Gift of Celeste and Armand Bartos.

opposite below: Cancellation proof for HATCHING (Front Endpaper) from FOIRADES/FIZZLES by Samuel Beckett. 1978.
Aquatint and drypoint, 30 × 41 9/16" (76.2 × 105.6 cm).
Collection the artist, New York.

below: WORDS (Buttock Knee Sock . . .) from FOIRADES/FIZZLES by Samuel Beckett. Petersburg Press, 1976.
Etching and aquatint, 13 1/16 × 19 7/8" (33.2 × 50.5 cm).
The Museum of Modern Art, New York. Gift of Celeste and Armand Bartos.

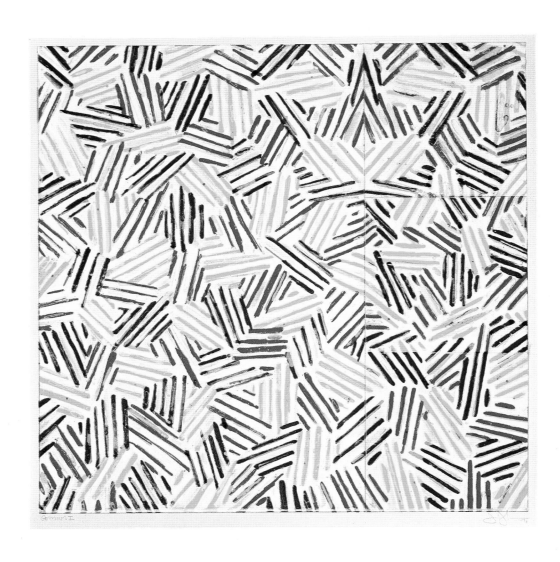

#6 (after "Untitled 1975") from the series 6 Lithographs (after "Untitled 1975"). Gemini G.E.L., 1976. Lithograph, printed in color, 30⅛ x 29¾" (76.5 × 75.6 cm). Lent by the publisher, Los Angeles.

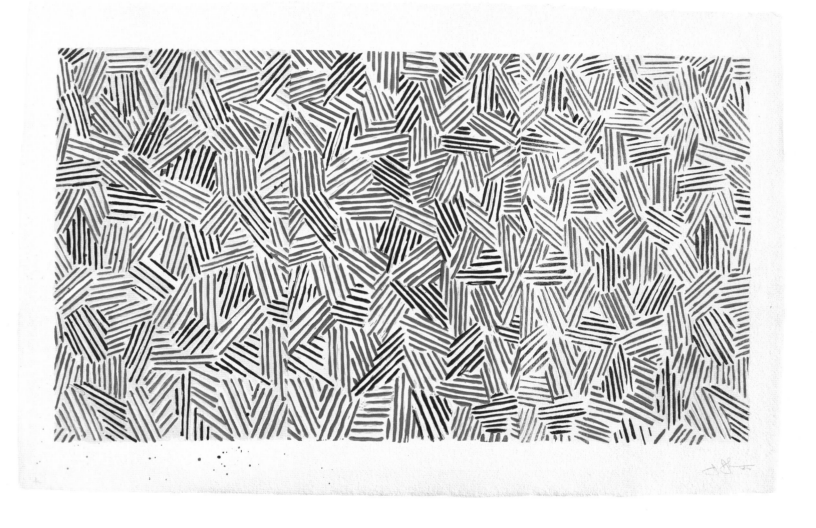

SCENT. U.L.A.E., 1976.
Lithograph, linoleum cut, and woodcut, printed in color, 31⅜ × 46¹⁵⁄₁₆″ (79.7 × 119.2 cm).
The Museum of Modern Art, New York. Gift of Celeste Bartos.

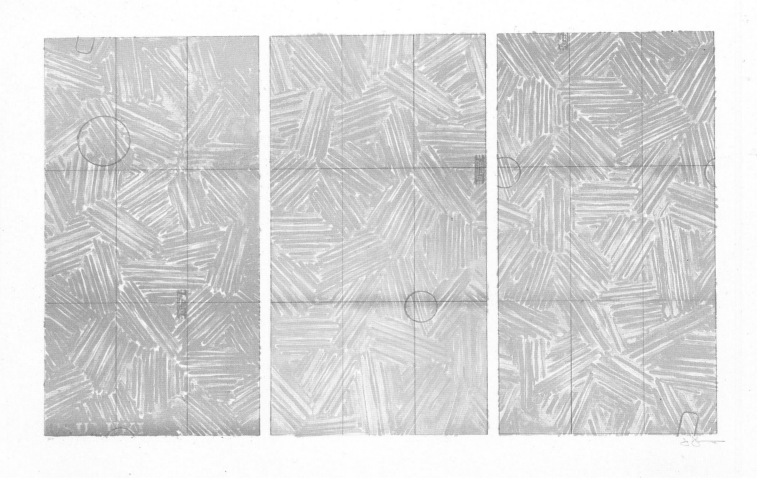

above: USUYUKI. U.L.A.E., 1979.
Lithograph, printed in color, 34 7/16 × 50 5/16″ (87.5 × 127.8 cm).
The Museum of Modern Art, New York. Gift of Celeste Bartos.

opposite left: USUYUKI. Simca Print Artists and the artist, 1980.
Silkscreen, printed in color, 52 × 20″ (132.1 × 50.8 cm).
Collection PaineWebber Group Inc., New York.

opposite right: USUYUKI. U.L.A.E., 1980.
Lithograph, printed in color, 52½ × 20¼″ (133.4 × 51.4 cm).
The Museum of Modern Art, New York. Gift of Celeste Bartos.

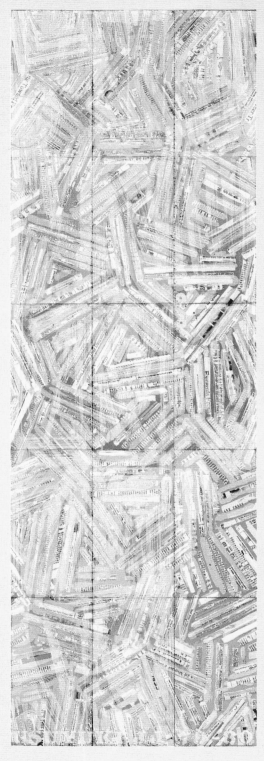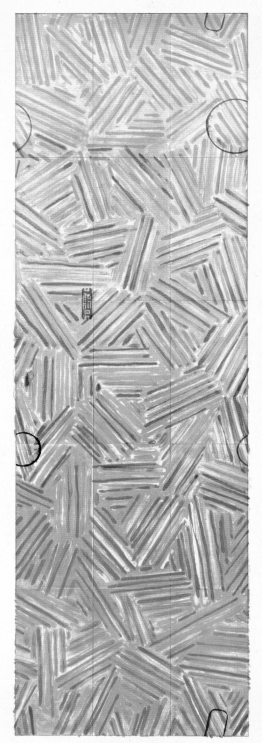

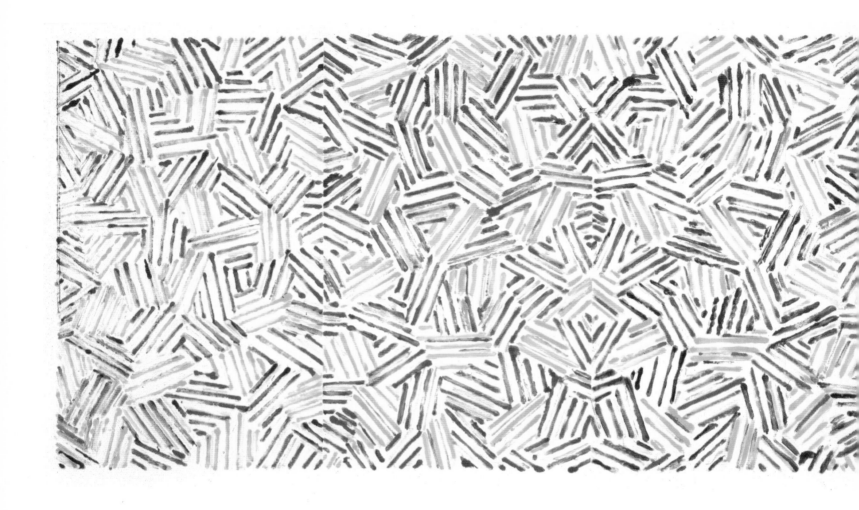

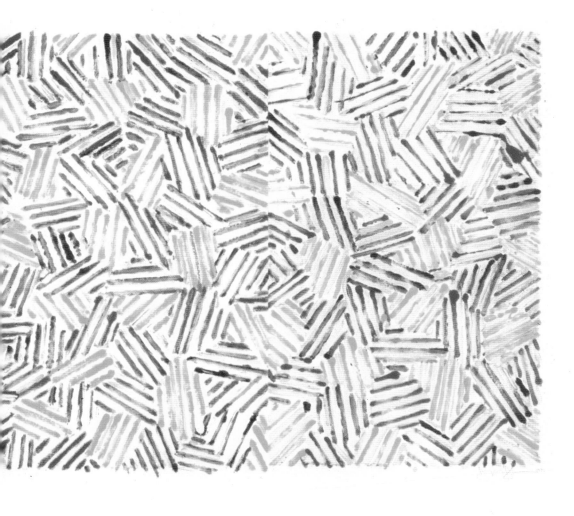

above: UNTITLED. 1983.
Monotype, printed in color, approximately 37½ × 96½″ (95.3 × 245.1 cm).
Collection Robert and Jane Meyerhoff, Phoenix, Maryland.

right: CICADA II.
Simca Print Artists and the artist, 1981.
Silkscreen, printed in color, 24 × 19″ (61 × 48.3 cm).
The Museum of Modern Art, New York. Given anonymously.

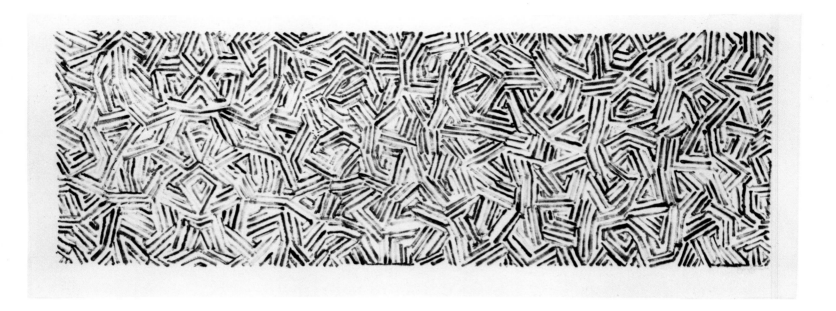

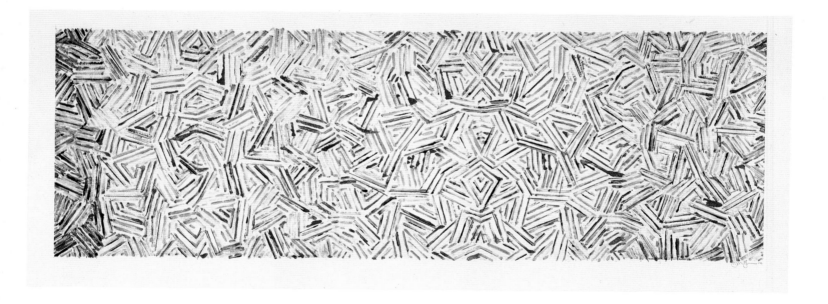

top: UNTITLED. 1983.
Monotype, 37⅝ × 96⅝" (95.6 × 245.4 cm).
Collection the artist, New York.

bottom: UNTITLED. 1983.
Monotype, printed in color, 37⅝ × 96⅝" (95.6 × 245.4 cm).
Collection the artist, New York.

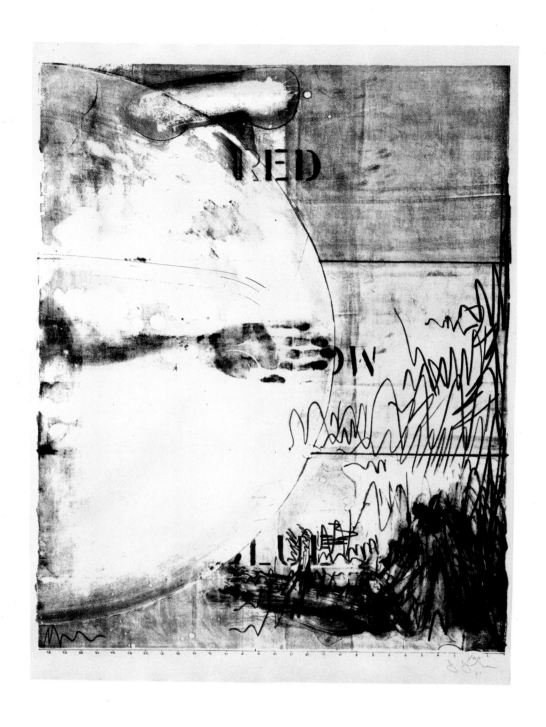

HATTERAS. U.L.A.E., 1963.
Lithograph, 41⅜ × 29½″ (105.1 × 74.9 cm).
The Museum of Modern Art, New York. Gift of the Celeste and Armand Bartos Foundation.

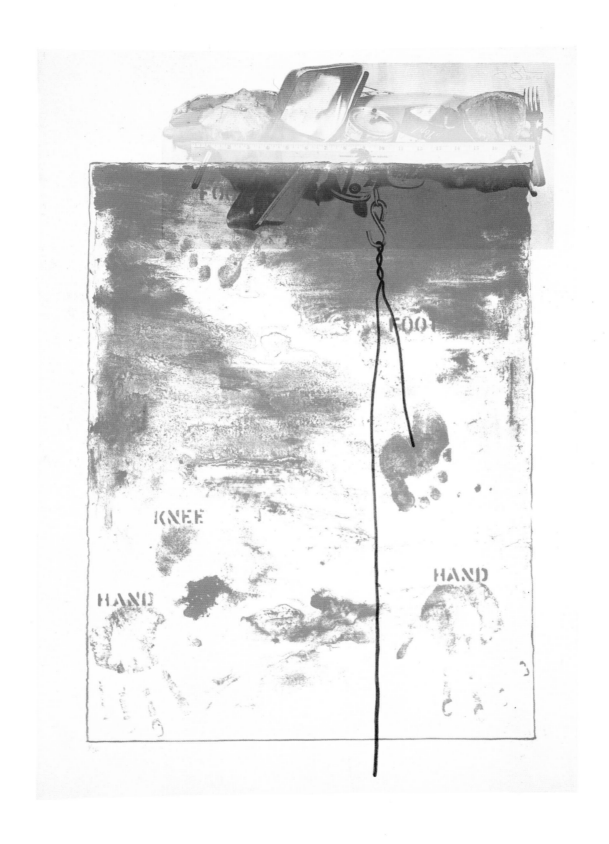

126

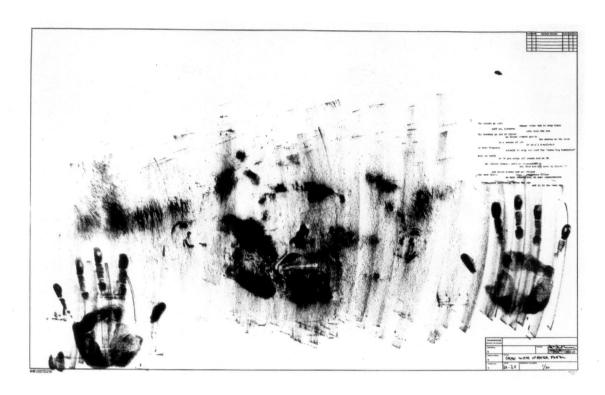

top: SKIN WITH O'HARA POEM. U.L.A.E., 1965.
Lithograph, 22 × 34″ (55.9 × 86.4 cm).
The Museum of Modern Art, New York. Gift of the Celeste and Armand Bartos Foundation.

bottom: A CARTOON FOR TANYA. Unpublished, 1972.
Lithograph, 24¼ × 37″ (61.6 × 94 cm).
Collection Mr. and Mrs. Victor W. Ganz, New York.

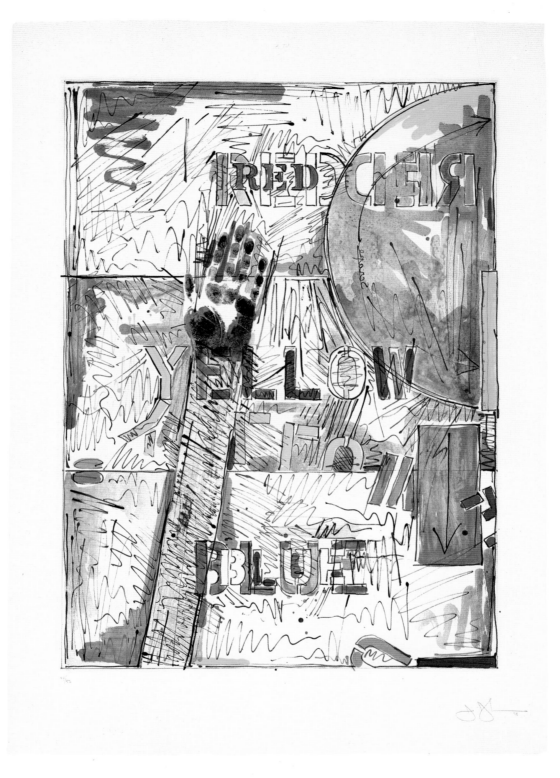

above: LAND'S END. Petersburg Press, 1978.
Etching and aquatint, printed in color, 42 × 29½″ (106.7 × 74.9 cm).
Collection Elinor K. and Edmund Grasheim, New York.

opposite: LAND'S END. Gemini G.E.L., 1979.
Lithograph, 52 × 36″ (132.1 × 91.4 cm).
Collection James W. Oxnam, New York.

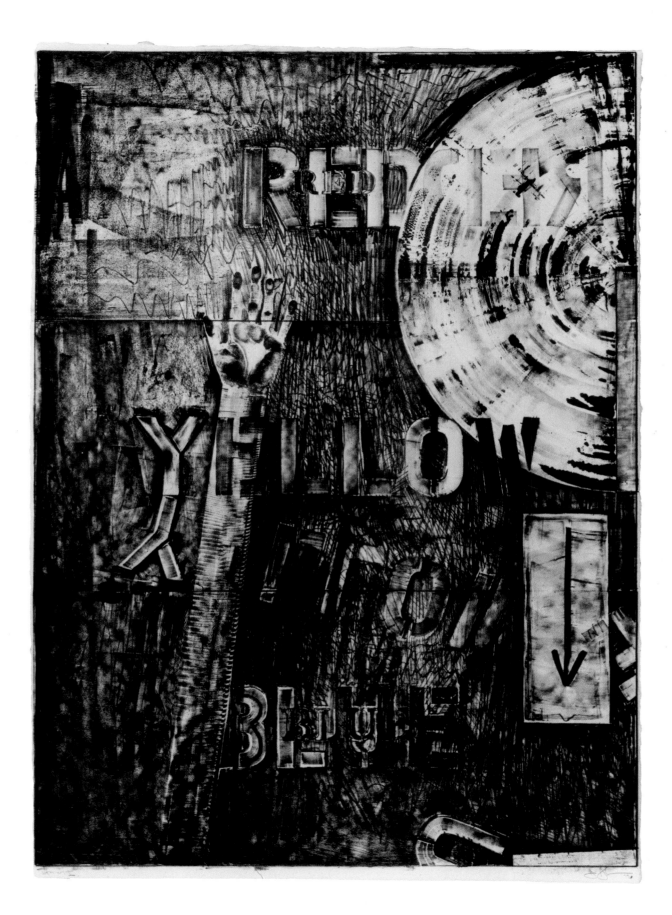

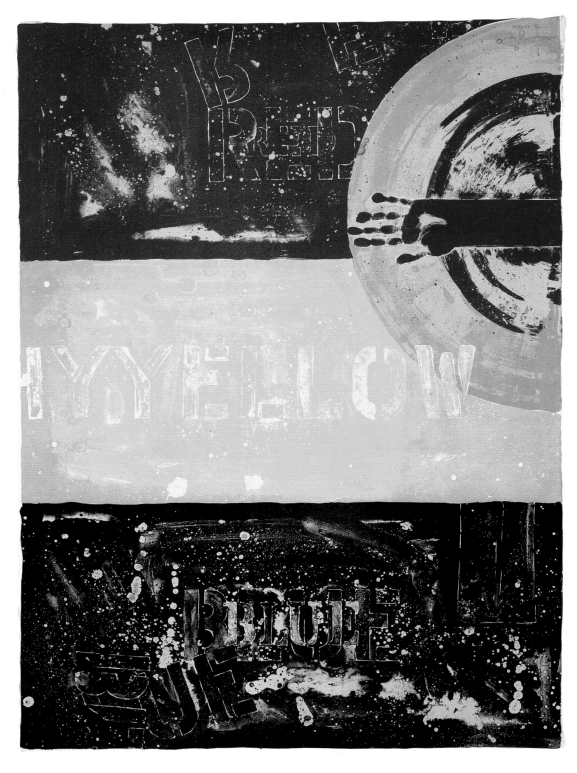

above: PERISCOPE I. Gemini G.E.L., 1979.
Lithograph, printed in color, 50¼ × 36¼″ (127.6 × 92.1 cm).
Collection Mr. and Mrs. Donald B. Marron, New York.

opposite: PERISCOPE II. Gemini G.E.L., 1979.
Lithograph, 56¼ × 41″ (142.9 × 104.1 cm).
Collection Mr. and Mrs. Victor W. Ganz, New York.

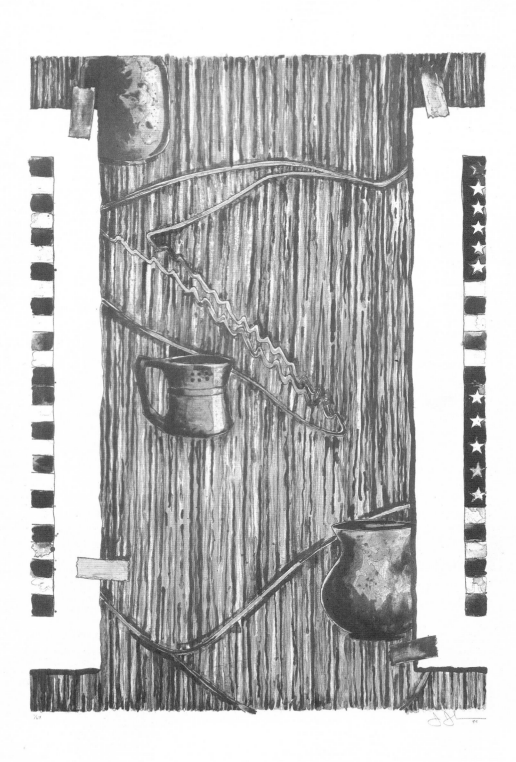

HC 3/3

opposite: Ventriloquist. U.L.A.E., 1985.
Lithograph, printed in color, 41½ × 27¹⁵⁄₁₆″ (105.4 × 71 cm).
The Museum of Modern Art, New York. Gift of Emily Landau.

above: Frontispiece for Poems by Wallace Stevens. The Arion Press, 1985.
Etching and aquatint, 11¾ × 8⁵⁄₁₆″ (29.8 x 21.1 cm).
The Museum of Modern Art, New York. Gift of Mrs. Alfred R. Stern.

SELECTED BIBLIOGRAPHY

MONOGRAPHS AND INDIVIDUAL-EXHIBITION CATALOGS

Bernstein, Roberta. *Jasper Johns Decoy: The Print and the Painting* (exhibition catalog). Hempstead, N.Y.: Emily Lowe Gallery, Hofstra University, 1972.

————. *"Things the Mind Already Knows": Jasper Johns—Painting and Sculpture 1954–1974*. Ann Arbor: UMI Research Press, 1985.

Castleman, Riva. *Jasper Johns: Lithographs* (exhibition catalog). New York: The Museum of Modern Art, 1970.

Crichton, Michael. *Jasper Johns* (exhibition catalog). New York: Harry N. Abrams and the Whitney Museum of American Art, 1977.

Field, Richard S. *Jasper Johns: Prints 1960–1970* (exhibition catalog). New York: Praeger Publishers; Philadelphia: Philadelphia Museum of Art, 1970.

————. *Jasper Johns: 1st Etchings, 2nd State* (exhibition catalog). Los Angeles: Betty Gold Fine Modern Prints, 1971.

————. *Jasper Johns: Matrix 20* (exhibition catalog). Hartford: Wadsworth Atheneum, 1976.

————. *Jasper Johns: Screenprints* (exhibition catalog). New York: Brooke Alexander, Inc., 1977.

————. *Jasper Johns: Prints 1970–1977* (exhibition catalog). Middletown, Conn.: Davison Art Center, Wesleyan University, 1978.

Francis, Richard. *Jasper Johns*. New York: Abbeville Press, 1984.

Geelhaar, Christian. *Jasper Johns: Working Proofs* (exhibition catalog). Basel: Kunstmuseum Basel, 1979; London: Petersburg Press, 1980.

Goldman, Judith. *Foirades/Fizzles* (exhibition catalog). New York: Whitney Museum of American Art, 1977.

————. *Jasper Johns: Prints 1977–1981* (exhibition catalog). Boston: Thomas Segal Gallery, 1981.

————. *Jasper Johns: 17 Monotypes*. West Islip, N.Y.: Universal Limited Art Editions, 1982.

Hopkins, Henry. *Jasper Johns: Figures 0 to 9*. Los Angeles: Gemini G.E.L., 1968.

Hopps, Walter. *Jasper Johns: Fragments—According to What/Six Lithographs*. Los Angeles: Gemini G.E.L., 1971.

Huber, Carlo, ed. *Jasper Johns Graphik* (exhibition catalog). Bern: Verlag Kornfeld & Klipstein, 1970.

Jasper Johns: Drawings and Prints 1975–1979 (exhibition catalog). Houston: Janie C. Lee Gallery, 1979.

Jasper Johns: Lithographs 1973–1975. Los Angeles: Gemini G.E.L., 1975.

Jasper Johns Litografii (exhibition catalog). Bucharest: Ateneul Roman, 1970.

Jasper Johns Screenprints (exhibition catalog). Tokyo: Gallery Mukai, 1978.

Leeper, John Palmer. *Jasper Johns: The Graphic Work* (exhibition catalog). San Antonio: Marion Koogler McNay Art Institute, 1969.

Rose, Barbara. *Jasper Johns: 6 Lithographs (after "Untitled 1975") 1976*. Los Angeles: Gemini G.E.L., 1976.

Rosenblum, Robert. Preface to portfolio *0–9*. West Islip, N.Y.: Universal Limited Art Editions, 1963.

Rosenblum, Robert, Toru Takemitsu, et al. *Jasper Johns 0–9* (exhibition catalog). Tokyo: Minami Gallery, 1967.

Shapiro, David. *Jasper Johns Drawings 1954–1984*. New York: Harry N. Abrams, 1984.

Solomon, Alan R. *Jasper Johns: Lead Reliefs* (brochure). Los Angeles: Gemini G.E.L., 1969.

Stanislawski, Ryszard. *Jasper Johns litografie* (exhibition catalog). Lodz: Museum Sztuki w Lodzi, 1970.

Subotić, Irina. *Antoni Tapies–Jasper Johns Litografije* (exhibition catalog). Belgrade: Muzej Savremene Umetnosti, 1969.

ARTICLES

Bernstein, Roberta. "Johns and Beckett: *Foirades/Fizzles*." *Print Collector's Newsletter* 7 (November–December 1976), pp. 141–45.

————. "Jasper Johns and the Figure: Part One—Body Imprints." *Arts Magazine* 52 (October 1977), pp. 142–44.

Cage, John. "Jasper Johns: Stories and Ideas." In *Jasper Johns* (exhibition catalog), edited by Alan R. Solomon. New York: The Jewish Museum, 1964.

Calas, Nicolas. "Jasper Johns: And/Or." In *Icons and Images of the Sixties*. New York: E. P. Dutton, 1971.

Feinstein, Roni. "Jasper Johns' *Untitled* (1972) and Marcel Duchamp's Bride." *Arts Magazine* 57 (September 1982), pp. 86–93.

Field, Richard S. "Jasper Johns' Flags." *Print Collector's Newsletter* 7 (July–August 1976), pp. 69–77.

Gidal, Peter. "Beckett and Others and Art: A System." *Studio International* 188 (November 1974), pp. 183–87.

Kaplan, Patricia. "On Jasper Johns' *According to What*." *Art Journal* 35 (Spring 1976), pp. 247–50.

Kelder, Diane. "Prints: Jasper Johns at Hofstra." *Art in America* 61 (January–February 1973), pp. 109–10.

Kozloff, Max. "The Division and Mockery of the Self." *Studio International* 179 (January 1970), pp. 9–15.

Michelson, Annette. "The Imaginary Object: Recent Prints by Jasper Johns." *Artist's Proof* 8 (1968), pp. 44–49.

Raynor, Vivien. "Jasper Johns." *Art News* 72 (March 1973), pp. 20–22.

Rose, Barbara. "The Graphic Work of Jasper Johns." Parts 1, 2. *Artforum* 8 (March 1970), pp. 39–45; 8 (September 1970), pp. 65–74.

―――. "Decoys and Doubles: Jasper Johns and the Modernist Mind." *Arts Magazine* 50 (May 1976), pp. 68–73.

―――. "To Know Jasper Johns." *Vogue* 167 (November 1977), pp. 280–85.

Shestack, Alan. "Jasper Johns: Reflections." *Print Collector's Newsletter* 8 (January–February 1978), pp. 172–74.

Steinberg, Leo. "Jasper Johns." *Metro* nos. 4–5 (May 1962); revised for Steinberg, *Jasper Johns*, New York: George Wittenborn, 1963; further revised for "Jasper Johns: The First Seven Years of His Art," in Steinberg, *Other Criteria: Confrontations with Twentieth-Century Art*, New York: Oxford University Press, 1972.

Young, Joseph E. "Jasper Johns: An Appraisal." *Art International* 13 (September 1969), pp. 50–56.

―――. "Jasper Johns' Lead-Relief Prints." *Artist's Proof* 10 (1971), pp. 36–38.

FILMS

Blackwood, Michael, dir. and prod. *Jasper Johns: Decoy.* 1972. 18 min. (The artist working on the lithograph *Decoy* at U.L.A.E.)

Martin, Katrina, dir. and prod. *Hanafuda/Jasper Johns.* 1980. 33 min. (The artist working on silkscreens at Simca Print Artists.)

Solomon, Alan R., dir., and Lane Slade, prod. *U.S.A. Artists #8: Jasper Johns.* 1966. 28 min. (Interviews of the artist and Leo Castelli.)

GENERAL

Adams, Clinton. *American Lithographers 1900–1960.* Albuquerque: University of New Mexico Press, 1983.

Beal, Graham W. J. *Artist and Printer: Six American Print Studios* (exhibition catalog). Minneapolis: Walker Art Center, 1980.

Bloch, E. Maurice. *Words and Images: Universal Limited Art Editions* (exhibition catalog). Los Angeles: Frederick S. Wight Art Gallery, U.C.L.A. Arts Council, 1978.

Boorsch, Suzanne. *Contemporary American Prints: Gifts from the Singer Collection* (exhibition catalog). New York: The Metropolitan Museum of Art, 1976.

Calas, Nicolas. *Reality and Paradoxes: A Portfolio of Seven Original Prints* (brochure). New York: Multiples, Inc., 1973.

Castleman, Riva. *Technics and Creativity: Gemini G.E.L.* (exhibition catalog). New York: The Museum of Modern Art, 1971.

―――. *Printed Art: A View of Two Decades* (exhibition catalog). New York: The Museum of Modern Art, 1980.

―――. *American Impressions: Prints Since Pollock.* New York: Alfred A. Knopf, 1985.

Contemporary Graphics Published by Universal Limited Art Editions (exhibition catalog). Minneapolis: Dayton's Gallery 12, 1968.

Davies, Hanlyn, and Hiroshi Murata. *Art and Technology: Offset Prints* (exhibition catalog). Bethlehem, Pa.: Ralph Wilson Gallery, Lehigh University, 1983.

Dückers, Alexander, and Angela Schönberger. *Druckgraphik: Wandlungen eines Mediums seit 1945* (exhibition catalog). Berlin: Staatliche Museen Preussischer Kulturbesitz, 1981.

Field, Richard S. *Recent American Etching* (exhibition catalog). Washington, D.C.: National Collection of Fine Arts, Smithsonian Institution, 1975.

―――. *Prints.* Geneva: Skira, 1981.

Fine, Ruth. *Gemini G.E.L.: Art and Collaboration* (exhibition catalog). Washington, D.C.: National Gallery of Art; New York: Abbeville Press, 1984.

Gilmour, Pat. *The Mechanized Image* (exhibition catalog). London: Arts Council of Great Britain, 1978.

Gilmour, Pat, and Anne Willsford. *Paperwork* (exhibition catalog). Canberra: Australian National Gallery, 1982.

Goldman, Judith. *Print Publishing in America* (exhibition catalog). N.p.: United States International Communications Agency, [1979].

―――. *American Prints and Printmaking 1956–1981* (exhibition catalog; *Print Review* no. 13). New York: Pratt Graphics Center, 1981.

―――. *American Prints: Process and Proofs* (exhibition catalog). New York: Whitney Museum of American Art and Harper & Row, 1981.

Gray, Cleve. "Tatyana Grosman's Workshop." *Art in America* 53 (December–January 1965–66), pp. 83–85.

Ives, Colta, et al. *The Painterly Print: Monotypes from the Seventeenth to the Twentieth Century* (exhibition catalog). New York: The Metropolitan Museum of Art, 1980.

Johnson, Elaine L. *Contemporary Painters and Sculptors as Printmakers* (exhibition catalog). New York: The Museum of Modern Art, 1966.

Johnson, Una E. *American Prints and Printmakers*. Garden City, N.Y.: Doubleday & Co., 1980.

Kelder, Diane. "Tradition and Craftsmanship in Modern Prints." *Art News* 70 (January 1972), pp. 56–59, 69–73.

Kozloff, Max. "Three-Dimensional Prints and the Retreat from Originality." *Artforum* 4 (December 1965), pp. 25–27.

Larson, Philip. "Words in Print." *Print Collector's Newsletter* 5 (July 1974), pp. 53–56.

Leering, J. *Experiment in Grafiek: Gemini G.E.L.* (exhibition catalog). Eindhoven: Van Abbemuseum, 1971.

Marano, Lizbeth. *Parasol and Simca: Two Presses/Two Processes* (exhibition catalog). Lewisburg, Pa.: Center Gallery, Bucknell University, 1984.

Menaker, Deborah, et al. *The Modern Art of the Print: Selections from the Collection of Lois and Michael Torf* (exhibition catalog). Williamstown, Mass.: Williams College Museum of Art; Boston: Museum of Fine Arts, 1984.

The Pop Art Print (exhibition catalog). Fort Worth: The Fort Worth Art Museum, 1984.

Prints by Four New York Painters: Helen Frankenthaler, Jasper Johns, Robert Motherwell, Barnett Newman (exhibition catalog). New York: The Metropolitan Museum of Art, 1969.

Ronte, Dieter. "Amerikanische Druckgrafik nach 1945." In *Amerikanische Kunst von 1945 bis Heute,* edited by Dieter Honisch and Jens Christian Jensen. Cologne: DuMont, 1976.

Sperling, Louise, and Richard S. Field. *Offset Lithography* (exhibition catalog). Middletown, Conn.: Davison Art Center, Wesleyan University 1973.

Tomkins, Calvin. "The Skin of the Stone." In *The Scene: Reports on Post-Modern Art*. New York: Viking Press, 1976.

Towle, Tony. *Contemporary American Prints from Universal Limited Art Editions: The Rapp Collection* (exhibition catalog). Toronto: Art Gallery of Ontario, 1979.

Towle, Tony, and Christian Geelhaar. *25 Jahre Universal Limited Art Editions 1957–1982* (exhibition catalog). Düsseldorf: W. Wittrock Kunsthandel, [1982].

Watrous, James. *A Century of American Printmaking 1880–1980*. Madison: University of Wisconsin Press, 1984.

Whitney, David. *Johns, Stella, Warhol: Works in Series* (exhibition catalog). Corpus Christi: Art Museum of South Texas, 1972.

Zerner, Henri. "Universal Limited Art Editions." *L'Oeil* (French ed.) no. 120 (December 1964), pp. 36–43, 82.

CATALOG OF THE EXHIBITION

Dates of publication follow names of publishers; dates following titles of works refer to production period; dates following titles and given in parentheses do not appear on the works. The publisher Universal Limited Art Editions is cited as U.L.A.E. In the dimensions noted, the first set refers to the dominant inked area, the second to the paper, height preceding width. Works in the collection of The Museum of Modern Art are indicated with an asterisk (*). Catalog (Field) numbers refer to Richard S. Field, *Jasper Johns: Prints 1960–1970,* exhibition catalog (New York: Praeger Publishers; Philadelphia: Philadelphia Museum of Art, 1970), and Richard S. Field, *Jasper Johns: Prints 1970–1977,* exhibition catalog (Middletown, Conn.: Wesleyan University, 1978). Page references are included for works reproduced in the plate section.

Works being shown only in New York are indicated with a dagger (†).

Target. West Islip, U.L.A.E., 1960. Lithograph, 12³⁄₁₆ × 12³⁄₁₆″ (30.9 × 30.9 cm); 22⅝ × 17⅝″ (57.5 × 44.7 cm). Gift of Mr. and Mrs. Armand P. Bartos.* (Field 1.) *Ilus. p. 53.*

Coat Hanger. West Islip, U.L.A.E., 1960. Lithograph, 25⁹⁄₁₆ × 21¹⁄₁₆″ (64.9 × 53.5 cm); 36 × 27″ (91.4 × 68.6 cm). Gift of Mr. and Mrs. Armand P. Bartos.* (Field 2.) *Illus. p. 60.*

Coat Hanger II. West Islip, U.L.A.E., 1960. Lithograph, 26¼ × 21¼″ (66.7 × 54 cm); 35½ × 24¾″ (90.2 × 62.9 cm). Collection Peter and Susan Ralston, New York. (Field 3.)

0–9. West Islip, U.L.A.E., 1960. Lithograph, 24 × 18⅞″ (61 × 47.9 cm); 29⅞ × 22½″ (75.9 × 57.2 cm). Gift of Mr. and Mrs. Armand P. Bartos.* (Field 4.) *Illus. p. 56.*

Flag. West Islip, U.L.A.E., 1960. Lithograph, 17½ × 26¾″ (44.5 × 67.9 cm); 22¼ × 30″ (56.5 × 76.2 cm). Gift of Mr. and Mrs. Armand P. Bartos.* (Field 5.) *Illus. p. 58.*

Flag II. West Islip, U.L.A.E., 1960. Lithograph, printed in white, 17⅝ × 27″ (44.7 × 68.6 cm); 24 × 32″ (61 × 81.3 cm). Collection Mr. and Mrs. Victor W. Ganz, New York. (Field 6.) *Illus. p. 59.*

Flag III. West Islip, U.L.A.E., 1960. Lithograph, printed in gray, 17½ × 26¾″ (44.5 × 67.9 cm); 22⁷⁄₁₆ × 30⅛″ (57 × 76.5 cm). Gift of the Celeste and Armand Bartos Foundation.* (Field 7.)

Alphabets. Unpublished, (1962); printed at U.L.A.E. Lithograph, 34¼ × 23¹¹⁄₁₆″ (87 × 60.2 cm); 36⅛ × 24¹⁄₁₆″ (91.8 × 61.1 cm). Acquired with matching funds from James R. Epstein and the National Endowment for the Arts.* *Illus. p. 57.*

Trial proof for *Alphabets.* 1962. Lithograph, 34¼ × 24¼″ (87 × 61.6 cm); 41¼ × 29⁹⁄₁₆″ (104.8 × 75.1 cm). Collection the artist, New York.

Painting with Two Balls I. West Islip, U.L.A.E., 1962. Lithograph, printed in color, 20¹⁵⁄₁₆ × 17″ (53.2 × 43.2 cm); 26⁹⁄₁₆ × 20⅜″ (67.5 × 51.8 cm). Gift of the Celeste and Armand Bartos Foundation.* (Field 8.) *Illus. p. 62.*

False Start I. West Islip, U.L.A.E., 1962. Lithograph, printed in color, 18 × 13¾″ (45.7 × 34.9 cm); 30³⁄₁₆ × 22¼″ (76.7 × 56.5 cm). Gift of the Celeste and Armand Bartos Foundation.* (Field 10.) *Illus. p. 61.*

False Start II. West Islip, U.L.A.E., 1962. Lithograph, printed in color, 18 × 13¾″ (45.7 × 34.9 cm); 30⅝ × 21⅞″ (77.8 × 55.6 cm). Gift of the Celeste and Armand Bartos Foundation.* (Field 11.)

Device. West Islip, U.L.A.E., 1962. Lithograph, 29⁷⁄₁₆ × 20¼″ (74.8 × 51.4 cm); 31½ × 22⅝″ (80 × 57.5 cm). Gift of the Celeste and Armand Bartos Foundation.* (Field 12.)

Red, Yellow, Blue. 1962–63. West Islip, U.L.A.E., 1963. Lithograph, 10½ × 8″ (26.7 × 20.3 cm); 18¹⁄₁₆ × 12¾″ (45.9 × 32.4 cm). Gift of the Celeste and Armand Bartos Foundation.* (Field 14.)

Hatteras. West Islip, U.L.A.E., 1963. Lithograph, 38¼ × 29⅛″ (97.2 × 74 cm); 41⅜ × 29½″ (105.1 × 74.9 cm). Gift of the Celeste and Armand Bartos Foundation.* (Field 15.) *Illus. p. 125.*

Hand. West Islip., U.L.A.E., 1963. Lithograph, 13¹¹⁄₁₆ × 9⁷⁄₁₆″ (34.8 × 24 cm); 22½ × 17½″ (57.1 × 44.5 cm). Gift of the Celeste and Armand Bartos Foundation.* (Field 16.) *Illus. frontispiece.*

0–9. 1960–63. West Islip, U.L.A.E., 1963. Portfolio of ten lithographs, each (variable) 16¹⁄₁₆ × 12³⁄₁₆″ (40.8 × 31 cm); 20½ × 15½″ (52.1 × 39.4 cm). Gift of the Celeste and Armand Bartos Foundation.* (Field 17–26.) *Illus. pp. 54–55.*

1 from the portfolio 0–9. West Islip, U.L.A.E., 1963. Lithograph, printed in gray, 16¹⁄₁₆ × 12³⁄₁₆″ (40.8 × 31 cm); 20½ × 15½″ (52.1 × 39.4 cm). Gift of the Celeste and Armand Bartos Foundation.* (Field 28.)

1 from the portfolio 0–9. West Islip, U.L.A.E., 1963. Lithograph, printed in color, 16¹⁄₁₆ × 12³⁄₁₆″ (40.8 × 31.1 cm); 20½ × 15½″ (52.1 × 39.4 cm). Gift of the Celeste and Armand Bartos Foundation.* (Field 38.)

Ale Cans. West Islip, U.L.A.E., 1964. Lithograph, printed in color, 14¼ × 11³⁄₁₆″ (36.2 × 28.4 cm); 22⅞ × 17¾″ (58.1 × 45.1 cm). Gift of the Celeste and Armand Bartos Foundation.* (Field 47.) *Illus. p. 63.*

Skin with O'Hara Poem. 1963–65. West Islip, U.L.A.E., 1965. Lithograph, 21 × 33¹⁄₁₆″ (53.3 × 84 cm); 22 × 34″ (55.9 × 86.4 cm). Gift of the Celeste and Armand Bartos Foundation.* (Field 48.) *Illus. p. 127.*

Pinion. 1963–66. West Islip, U.L.A.E., 1966. Lithograph, printed in color, 38⁹⁄₁₆ × 24½″ (97.9 × 62.2 cm); 40⅛ × 28¹⁄₁₆″ (101.9 × 71.3 cm). Gift of the Celeste and Armand Bartos Foundation.* (Field 49.) *Illus. p. 126.*

Two Maps I. 1965–66. West Islip, U.L.A.E., 1966. Lithograph, printed in white, 31⅝ × 25⅜″ (80.3 × 64.5 cm); 33⅜ × 26½″ (84.8 × 67.3 cm). Gift of the Celeste and Armand Bartos Foundation.* (Field 51.)

Two Maps II. West Islip, U.L.A.E., 1966. Lithograph, 25⁹⁄₁₆ × 20¾″ (64.9 × 52.7 cm); 33¹¹⁄₁₆ × 26⁵⁄₁₆″ (85.6 × 66.8 cm). Gift of the Celeste and Armand Bartos Foundation.* (Field 52.) *Illus. p. 102.*

Passage I. West Islip, U.L.A.E., 1966. Lithograph, printed in color, 26 × 32⅞″ (66 × 83.5 cm); 28⅛ × 36⅜″ (71.4 × 92.4 cm). Gift of the Celeste and Armand Bartos Foundation.* (Field 57.) *Illus. p. 73.*

Passage II. West Islip, U.L.A.E., 1966. Lithograph, printed in white, 26 × 32⅞″ (66 × 83.5 cm); 27¹⁵⁄₁₆ × 36⅛″ (71 × 91.8 cm). Gift of the Celeste and Armand Bartos Foundation.* (Field 58.)

Voice. 1966–67. West Islip, U.L.A.E., 1967. Lithograph, printed in black and silver, 45¼ × 30¹³⁄₁₆″ (115.6 × 78.3 cm); 48⅜ × 31¹¹⁄₁₆″ (122.9 × 80.5 cm). Gift of the Celeste and Armand Bartos Foundation.* (Field 59.) *Illus. p. 83.*

Watchman. West Islip, U.L.A.E., 1967. Lithograph, printed in color, 34¼ × 23⅝″ (87 × 60 cm); 36¹⁄₁₆ × 24³⁄₁₆″ (91.6 × 61.4 cm). Gift of the Celeste and Armand Bartos Foundation.* (Field 60.) *Illus. p. 78.*

Target I. West Islip, U.L.A.E., 1967. Etching, 4¹⁄₁₆ × 4¹⁄₁₆″ (10.3 × 10.3 cm); 5¾ × 5½″ (14.6 × 14 cm). Gift of the Celeste and Armand Bartos Foundation.* (Field 64.)

Flags. 1967–68. West Islip, U.L.A.E., 1968. Lithograph, printed in color; composition and sheet: 34⅝ × 25⅞″ (87.9 × 65.7 cm). Gift of the Celeste and Armand Bartos Foundation.* (Field 70.) *Illus. p. 103.*

Title page from the portfolio *First Etchings*. 1967. West Islip, U.L.A.E., 1968. Etching, 4⅞ × 8¼″ (12.4 × 21 cm); 6 × 9⁵⁄₁₆″ (15.2 × 23.7 cm). Gift of the Celeste and Armand Bartos Foundation.* (Field 77.)

Flashlight from the portfolio *First Etchings*. 1967. West Islip, U.L.A.E., 1968. Etching and photoengraving, 15⁷⁄₁₆ × 14¹³⁄₁₆″ (39.2 × 37.6 cm); 25⅜ × 19⅝″ (64.5 × 49.8 cm). Gift of the Celeste and Armand Bartos Foundation.* (Field 71.)

Lightbulb from the portfolio *First Etchings*. 1967. West Islip, U.L.A.E., 1968. Etching and photoengraving, 12½ × 8⅞″ (31.8 × 22.5 cm); 26 × 20⅛″ (66 × 51.1 cm). Gift of the Celeste and Armand Bartos Foundation.* (Field 72.)

Ale Cans from the portfolio *First Etchings*. 1967. West Islip, U.L.A.E., 1968. Etching and photoengraving, 18⁷⁄₁₆ × 11¼″ (46.8 × 28.6 cm); 25⅜ × 19¹¹⁄₁₆″ (64.5 × 50 cm). Gift of the Celeste and Armand Bartos Foundation.* (Field 73.)

Paintbrushes from the portfolio *First Etchings*. 1967. West Islip, U.L.A.E., 1968. Etching and photoengraving, 22½ × 12⁷⁄₁₆″ (57.1 × 31.6 cm); 25¼ × 19½″ (64.1 × 49.5 cm). Gift of the Celeste and Armand Bartos Foundation.* (Field 74.) *Illus. p. 64.*

Flag from the portfolio *First Etchings*. 1967. West Islip, U.L.A.E., 1968. Etching and photoengraving, 22⅛ × 17¾″ (56.2 × 45.1 cm); 26 × 20¹⁄₁₆″ (66 × 51 cm). Gift of the Celeste and Armand Bartos Foundation.* (Field 75.) *Illus. p. 64.*

Numbers from the portfolio *First Etchings*. 1967. West Islip, U.L.A.E., 1968. Etching and photoengraving, 13¼ × 16⅜″ (33.7 × 41.6 cm); 26 × 20¹⁄₁₆″ (66 × 51 cm). Gift of the Celeste and Armand Bartos Foundation.* (Field 76.) *Illus. p. 64.*

Ale Cans from the portfolio *First Etchings, Second State*. 1967–69. West Islip, U.L.A.E., 1969. Etching and aquatint, 5 × 8¼″ (12.7 × 21 cm); 26¹⁄₁₆ × 19⁷⁄₁₆″ (66.2 × 49.4 cm). Gift of the Celeste and Armand Bartos Foundation.* (Field 84.)

Flashlight from the portfolio *First Etchings, Second State*. 1967–69. West Islip, U.L.A.E., 1969. Etching and aquatint, 9⁵⁄₁₆ × 13³⁄₁₆″ (23.6 × 33.4 cm); 26¹⁄₁₆ × 19⁷⁄₁₆″ (66.2 × 49.4 cm). Gift of the Celeste and Armand Bartos Foundation.* (Field 78.)

Lightbulb I from the portfolio *First Etchings, Second State*. 1967–69. West Islip, U.L.A.E., 1969. Etching and photoengraving, 3⅞ × 4¾″ (9.8 × 12.1 cm); 26 × 19⁹⁄₁₆″ (66 × 49.7 cm). Gift of the Celeste and Armand Bartos Foundation.* (Field 86.)

Lightbulb from the portfolio *First Etchings, Second State*. 1967–69. West Islip, U.L.A.E., 1969. Etching and aquatint, 6⅝ × 8¾″ (16.9 × 22.2 cm); 26⅛ × 19½″ (66.4 × 49.5 cm). Gift of the Celeste and Armand Bartos Foundation.* (Field 79.)

Painted Bronze from the portfolio *First Etchings, Second State*. 1967–69. West Islip, U.L.A.E., 1969. Etching and photoengraving, 3½ × 3⁹⁄₁₆″ (8.9 × 9 cm); 25⅞ × 19½″ (65.7 × 49.5 cm). Gift of the Celeste and Armand Bartos Foundation.* (Field 87.)

Ale Cans from the portfolio *First Etchings, Second State*. 1967–69. West Islip, U.L.A.E., 1969. Etching and aquatint, 11³⁄₁₆ × 11³⁄₁₆″ (28.4 × 28.4 cm); 25⅞ × 19½″ (65.7 × 49.5 cm). Gift of the Celeste and Armand Bartos Foundation.* (Field 80.)

Painted Bronze from the portfolio *First Etchings, Second State*. 1967–69. West Islip, U.L.A.E., 1969. Etching and photoengraving, 4⅞ × 4¹⁄₁₆″ (12.4 × 10.3 cm); 26 × 19½″ (66 × 49.5 cm). Gift of the Celeste and Armand Bartos Foundation.* (Field 88.)

Paintbrushes from the portfolio *First Etchings, Second State*. 1967–69. West Islip, U.L.A.E., 1969. Etching, aquatint, and roulette, 17½ × 11⁹⁄₁₆″ (44.5 × 29.4 cm); 26 × 19½″ (66 × 49.5 cm). Gift of the Celeste and Armand Bartos Foundation.* (Field 81.)

Flag from the portfolio *First Etchings, Second State*. 1967–69. West Islip, U.L.A.E., 1969. Etching and roulette, 11⅝ × 17⁷⁄₁₆″ (29.5 × 44.3 cm); 25⅞ × 19¹¹⁄₁₆″ (65.7 × 50 cm). Gift of the Celeste and Armand Bartos Foundation.* (Field 82.) *Illus. p. 65.*

Numbers from the portfolio *First Etchings, Second State*. 1967–69. West Islip, U.L.A.E., 1969. Etching, 13³⁄₁₆ × 9¹³⁄₁₆″ (33.5 × 24.9 cm); 26 × 19¹¹⁄₁₆″ (66 × 50 cm). Gift of the Celeste and Armand Bartos Foundation.* (Field 83.) *Illus. p. 65.*

White Target. 1967–68. West Islip, U.L.A.E., 1968. Lithograph, printed in white, 13⁵⁄₁₆ × 13³⁄₁₆″ (33.8 × 33.5 cm); 29⁹⁄₁₆ × 21⅝″ (75.1 × 54.9 cm). Gift of the Celeste and Armand Bartos Foundation.* (Field 91.)

Target with Four Faces. New York, the artist, 1968. Silkscreen, printed in color, 36⅜ × 26⁵⁄₁₆″ (92.4 × 66.8 cm); 41¼ × 29⅝″ (104.8 × 75.2 cm). Gift of David Whitney.* (Field 92.)

Black and White Numerals. Los Angeles, Gemini G.E.L., 1968. Series of ten lithographs, each (variable) 27¾ × 21¾″ (70.5 × 55.3 cm); 37 × 30″ (94 × 76.2 cm). John B. Turner Fund.* (Field 94–103.) *Illus. pp. 66, 68–70, 72.*

Color Numerals. Los Angeles, Gemini G.E.L., 1969. Series of ten lithographs, printed in color, each (variable) 27¾ × 21¾″ (70.5 × 55.3 cm); 38 × 31″ (96.5 × 78.7 cm). Collection Mr. and Mrs. Victor W. Ganz, New York. (Field 104–13.) *Illus. pp. 67 [Figure 1], 71 [Figure 7].*

Gray Alphabets. Los Angeles, Gemini G.E.L., 1968. Lithograph, printed in gray, 51¼ × 34⁷⁄₁₆″ (130.2 × 87.5 cm); 59¹⁵⁄₁₆ × 41¹⁵⁄₁₆″ (152.2 × 106.5 cm). John B. Turner Fund.* (Field 114.)

No. Los Angeles, Gemini G.E.L., 1969. Embossed lithograph, printed in color with collage, 46¹⁵⁄₁₆ × 28¹¹⁄₁₆″ (119.2 × 72.9 cm); 56 × 35⅞″ (142.2 × 91.1 cm). Gift of Philip Johnson (by exchange).* (Field 117.) *Illus. p. 84.*

Untitled (Ruler and Fork) I. West Islip, U.L.A.E., 1969. Etching, 29⅛ × 19¾″ (74 × 50.2 cm); 36½ × 24¼″ (92.7 × 61.6 cm). Gift of the Celeste and Armand Bartos Foundation.* (Field 123.)

Untitled (Ruler and Fork) II. West Islip, U.L.A.E., 1969. Etching and aquatint, printed in gray, 29¹⁄₁₆ × 19⅞″ (73.8 × 50.5 cm); 41¼ × 27¹⁵⁄₁₆″ (104.8 × 71 cm). Gift of the Celeste and Armand Bartos Foundation.* (Field 124.) *Illus. p. 85.*

Souvenir. West Islip, U.L.A.E., 1970. Lithograph, printed in color, 24¼ × 17¹¹⁄₁₆″ (61.6 × 44.9 cm); 30¹¹⁄₁₆ × 22⁵⁄₁₆″ (77.9 × 56.7 cm). Gift of the Celeste and Armand Bartos Foundation.* (Field 127.) *Illus. p. 91.*

Light Bulb. West Islip, U.L.A.E., 1970. Lithograph, printed in black and silver with rubber stamp, 10¹¹⁄₁₆ × 10½″ (27.1 × 26.7 cm); 19¹⁄₁₆ × 12″ (48.4 × 30.5 cm). Gift of the Celeste and Armand Bartos Foundation.* (Field 128.) *Illus. p. 110.*

Flags II. 1967–70. West Islip, U.L.A.E., 1970. Lithograph, printed in color; composition and sheet: 33⅜ × 24½″ (84.8 × 62.2 cm); Gift of the Celeste and Armand Bartos Foundation.* (Field 130.)

Painting with Two Balls (Grays). New York, the artist, 1971. Silkscreen, printed in gray and black, 29¾ × 24½″ (75.6 × 62.2 cm); 34⅞ × 28¼″ (88.6 × 71.8 cm). Courtesy Brooke Alexander, Inc., New York. (Field 133.) *Illus. p. 79.*

Decoy. West Islip, U.L.A.E., 1971. Lithograph, printed in color; composition and sheet: 41½ × 29⁹⁄₁₆″ (105.4 × 75.1 cm). Gift of Celeste Bartos.* (Field 134.) *Illus. p. 74.*

†**Decoy**. 1971. Oil on canvas with brass grommet, 72 × 50″ (182.9 × 127 cm). Collection Mr. and Mrs. Victor W. Ganz, New York. *Illus. p. 76.*

†**Decoy**. 1971. Oil on canvas with brass grommet, 41 × 29½″ (104.1 × 74.9 cm). Collection Kimiko and John Powers, New York. *Illus. p. 75.*

Fragment—According to What—Bent "Blue" (Second State). Los Angeles, Gemini G.E.L., 1971. Lithograph, printed in color with transfer, 24⅝ × 28⁹⁄₁₆″ (62.5 × 72.5 cm); 25½ × 28¾″ (64.8 × 73 cm). Collection the artist, New York. (Field 138.) *Illus. p. 93.*

Fragment—According to What—Hinged Canvas. Los Angeles, Gemini G.E.L., 1971. Lithograph, printed in color, 31⅞ × 29¾″ (81 × 75.6 cm); 36⅛ × 29¾″ (91.8 × 75.6 cm). John B. Turner Fund.* (Field 139.) *Illus. p. 92.*

Cancellation proof for Fragment—According to What— Hinged Canvas. 1971. Lithograph, printed in color, 32⅜ × 27¼″ (82.2 × 69.2 cm); 36 × 29⅝″ (91.4 × 75.2 cm). Collection the artist, New York. *Illus. p. 92.*

†**Voice 2**. 1971. Oil and collage on canvas, three panels, each 72 × 50″ (182.9 × 127 cm). Oeffentliche Kunstsammlung, Kunstmuseum Basel. *Illus. pp. 86–87.*

Screen Piece. Tokyo and New York, Simca Print Artists and the artist, 1972. Silkscreen, printed in color, 31¼ × 20″ (79.4 × 50.8 cm); 41⁵⁄₁₆ × 29½″ (104.9 × 74.9 cm). Collection Julian Lethbridge, New York. (Field 146.)

Device. Los Angeles, Gemini G.E.L., 1972. Lithograph, printed in color, 26½ × 20⁵⁄₁₆″ (67.3 × 51.6 cm); 38⅜ × 29″ (97.5 × 73.7 cm). John B. Turner Fund.* (Field 152.)

Device—Black State. Los Angeles, Gemini G.E.L., 1972. Lithograph, printed in gray and black, 26¼ × 20⅛″ (66.7 × 51.1 cm); 32¼ × 25¾″ (81.9 × 65.4 cm). Lent by the publisher. (Field 153.) *Illus. p. 80.*

Fool's House. Los Angeles, Gemini G.E.L., 1972. Lithograph, printed in color, 40¹¹⁄₁₆ × 20″ (103.3 × 50.8 cm); 43¾ × 28¾″ (111.1 × 73 cm). John B. Turner Fund.* (Field 154.) *Illus. p. 81.*

Fool's House—Black State. Los Angeles, Gemini G.E.L., 1972. Lithograph, printed in black and gray, 40¾ × 20⅛″ (103.5 × 51.1 cm); 44 × 26″ (111.8 × 66 cm). Lent by the publisher. (Field 155.)

Two Flags (Gray). 1970–72. West Islip, U.L.A.E., 1972. Lithograph, printed in gray, 22 × 27½″ (55.9 × 69.9 cm); 27⁹⁄₁₆ × 32¹³⁄₁₆″ (70 × 83.3 cm). Gift of Celeste Bartos.* (Field 164.) *Illus. p. 104.*

A Cartoon for Tanya. Unpublished, 1972; printed at U.L.A.E. Lithograph, 22⅝ × 35⅞″ (57.5 × 91.1 cm); 24¼ × 37″ (61.6 × 94 cm). Collection Mr. and Mrs. Victor W. Ganz, New York. (Field 166.) *Illus. p. 127.*

Cups 4 Picasso. West Islip, U.L.A.E., 1972. Lithograph, printed in color, 14⅛ × 32¼″ (35.9 × 81.9 cm); 22¼ × 32¼″ (56.5 × 81.9 cm). Gift of Celeste Bartos.* (Field 167.) *Illus. p. 95.*

Decoy II. 1971–73. West Islip, U.L.A.E., 1973. Lithograph, printed in color; composition and sheet: 41⁷⁄₁₆ × 29⅝″ (105.3 × 75.2 cm). Gift of Celeste Bartos.* (Field 169.) *Illus. p. 77.*

Untitled (Skull) from the portfolio Reality and Paradoxes. New York, Multiples, Inc., 1973. Silkscreen, printed in color, 17¼ × 31″ (43.8 × 78.8 cm); 24 × 33″ (61 × 83.8 cm). Collection Peter and Susan Ralston, New York. (Field 172.) *Illus. p. 94.*

Flags I. Tokyo and New York, Simca Print Artists and the artist, 1973. Silkscreen, printed in color, 26⅞ × 33⅝″ (68.3 × 85.4 cm); 27½ × 35″ (69.9 × 88.9 cm). Collection Leslie and Johanna Garfield, New York. (Field 173.) *Illus. p. 105.*

Flags II. Tokyo and New York, Simca Print Artists and the artist, 1973. Silkscreen, 26¾ × 33⅝″ (67.9 × 85.4 cm); 27½ × 35″ (69.9 × 88.9 cm). Collection Leslie and Johanna Garfield, New York. (Field 174.)

Face from the series Casts from Untitled. Los Angeles, Gemini G.E.L., 1974. Lithograph, printed in color, 14¾ × 13¹⁄₁₆″ (37.5 × 33.2 cm); 30¾ × 22¾″ (78.1 × 57.8 cm). Lent by the publisher. (Field 177.)

Face—Black State from the series Casts from Untitled. Los Angeles, Gemini G.E.L., 1974. Lithograph, 14¾ × 13⅛″ (37.5 × 33.3 cm); 15¾ × 13¾″ (40 × 34.9 cm). Lent by the publisher. (Field 178.)

HandFootSockFloor from the series Casts from Untitled. Los Angeles, Gemini G.E.L., 1974. Lithograph, printed in color, 14¾ × 19¹¹⁄₁₆″ (37.5 × 50 cm); 30¾ × 22¾″ (78.1 × 57.8 cm). Lent by the publisher. (Field 179.) *Illus. p. 111.*

HandFootSockFloor—Black State from the series Casts from Untitled. Los Angeles, Gemini G.E.L., 1974. Lithograph, 15¾ × 19¼″ (40 × 48.9 cm); 16 × 19¾″ (40.6 × 50.2 cm). Lent by the publisher. (Field 180.) *Illus. p. 110.*

Target. Tokyo and New York, Simca Print Artists and the artist, 1974. Silkscreen, printed in color, 34³⁄₁₆ × 25¹⁵⁄₁₆″ (86.8 × 65.9 cm); 34⅞ × 27⅜″ (88.6 × 69.5 cm). Collection Leslie and Johanna Garfield, New York. (Field 192.) *Illus. p. 96.*

Four Panels from Untitled 1972. 1973–74. Los Angeles, Gemini G.E.L., 1974. Lithograph, printed in color with embossing on four sheets; A: 38³⁄₁₆ × 26¹⁄₁₆″ (97 × 66.2 cm); B: 38⅝₁₆ × 25⅛″ (97.3 × 63.8 cm); C: 38³⁄₁₆ × 25″ (97 × 63.5 cm); D: 39⁵⁄₁₆ × 25¹¹⁄₁₆″ (99.9 × 65.2 cm); each sheet: 40 × 28½″ (101.6 × 72.4 cm). Jeanne C. Thayer Fund and purchase.* (Field 194–97.) *Illus. pp. 112–13.*

Four Panels from Untitled 1972 (Grays and Black). 1973–75. Los Angeles, Gemini G.E.L., 1975. Lithograph, printed in gray and black with embossing on four sheets; A: 38¹³⁄₁₆ × 32⅛″ (98.6 × 81.6 cm); B: 38¹³⁄₁₆ × 31⅞″ (98.6 × 81 cm); C: 38½ × 32⁷⁄₁₆″ (97.8 × 82.4 cm); D: 39³⁄₁₆ × 32⁵⁄₁₆″ (99.5 × 82.1 cm); each sheet: 41 × 32″ (104.1 × 81.3 cm). Collection Kate Ganz, London. (Field 198–201.) *Illus. pp. 114–15.*

0–9. London and New York, Petersburg Press, 1975. Etching, drypoint, and aquatint, 4½ × 9¼″ (11.4 × 23.5 cm); 15½ × 12½″ (39.4 × 31.8 cm). Collection Mr. Thomas H. Lee, Thomas H. Lee Company, Boston. (Field 206.)

Scent. 1975–76. West Islip, U.L.A.E., 1976. Lithograph, linoleum cut, and woodcut, printed in color, 28½ × 44⅜″ (72.4 × 112.7 cm); 31⅜ × 46¹⁵⁄₁₆″ (79.7 × 119.2 cm). Gift of Celeste Bartos.* (Field 208.) *Illus. p. 119.*

Corpse and Mirror. London and New York, Petersburg Press, 1976. Aquatint and drypoint, printed in color, 10⅜ × 14″ (26.4 × 35.6 cm); 25¾ × 19¾″ (65.4 × 50.2 cm). Private collection, New York. (Field 209.)

Corpse and Mirror. West Islip, U.L.A.E., 1976. Lithograph, printed in white, gray, and black, 28¹³⁄₁₆ × 37¹⁵⁄₁₆″ (73.2 × 96.4 cm); 30¾ × 39⅝″ (78.1 × 100.6 cm). Gift of Celeste Bartos.* (Field 210.) *Illus. p. 106.*

Corpse and Mirror. Tokyo and New York, Simca Print Artists and the artist, 1976. Silkscreen, printed in color, 37¹¹⁄₁₆ × 49¹¹⁄₁₆″ (95.7 × 126.2 cm); 42¼ × 53″ (107.3 × 134.6 cm). Collection Brooke and Carolyn Alexander, New York. (Field 211.) *Illus. p. 107.*

Foirades/Fizzles by Samuel Beckett. London and New York, Petersburg Press, 1976. Thirty-three etchings, aquatints, and drypoints, and one lithograph; page: 13¹⁄₁₆ × 9¹⁵⁄₁₆″ (33.2 × 25.2 cm). Gift of Celeste and Armand Bartos.* (Field 215–48.) *Illus. pp. 67, 116–17.*

Foirades/Fizzles by Samuel Beckett. London and New York, Petersburg Press, 1976. Thirty-three etchings, aquatints, and drypoints; page: 13¹⁄₁₆ × 9¹⁵⁄₁₆″ (33.2 × 25.2 cm). Lent by the publisher. (Field 215–47.)

Cancellation proof for *Hatching* (Front Endpaper) from *Foirades/Fizzles* by Samuel Beckett. 1978. Aquatint and drypoint, 23³⁄₁₆ × 36⅝″ (58.9 × 93 cm); 30 × 41⁹⁄₁₆″ (76.2 × 105.6 cm). Collection the artist, New York. *Illus. p. 116.*

Cancellation proof for *Flagstones* (Back Endpaper) from *Foirades/Fizzles* by Samuel Beckett. 1978. Etching, aquatint, and drypoint, 34⅝ × 18⁷⁄₁₆″ (87.9 × 46.8 cm); 41⅝ × 29¹⁵⁄₁₆″ (105.7 × 76 cm). Collection the artist, New York.

#1 (after "Untitled 1975") from the series 6 Lithographs (after "Untitled 1975"). Los Angeles, Gemini G.E.L., 1976. Lithograph, printed in color, 28¾ × 28⅝" (73 × 72.7 cm); 30⅛ × 29⅞" (76.5 × 75.9 cm). Lent by the publisher. (Field 249.)

#2 (after "Untitled 1975") from the series 6 Lithographs (after "Untitled 1975"). Los Angeles, Gemini G.E.L., 1976. Lithograph, printed in color, 29⅛ × 28¹³⁄₁₆" (74 × 73.2 cm); 30⅛ × 29¾" (76.5 × 75.6 cm). Lent by the publisher. (Field 250.)

#3 (after "Untitled 1975") from the series 6 Lithographs (after "Untitled 1975"). Los Angeles, Gemini G.E.L., 1976. Lithograph, printed in color, 28½ × 28⅝" (72.4 × 72.7 cm); 30⅛ × 29¾" (76.5 × 75.6 cm). Lent by the publisher. (Field 251.)

#6 (after "Untitled 1975") from the series 6 Lithographs (after "Untitled 1975"). Los Angeles, Gemini G.E.L., 1976. Lithograph, printed in color, 28¹³⁄₁₆ × 28⅞" (73.2 × 73.3 cm); 30⅛ × 29¾" (76.5 × 75.6 cm). Lent by the publisher. (Field 254.) *Illus. p. 118.*

Untitled. West Islip, U.L.A.E., 1977. Lithograph, printed in color, 24¹³⁄₁₆ × 37³⁄₁₆" (63 × 94.5 cm); 27½ × 39¹⁵⁄₁₆" (69.9 × 101.4 cm). Gift of Celeste Bartos.* (Field 258.)

Savarin. West Islip, U.L.A.E., 1977. Lithograph, printed in color, 39½ × 34¹⁄₁₆" 100.3 × 86.5 cm); 45½ × 34⅝" (115.6 × 87.9 cm). Gift of Celeste Bartos.* (Field 259.) *Illus. p. 99.*

The Dutch Wives. Tokyo and New York, Simca Print Artists and the artist, 1977. Silkscreen, printed in color, 40½ × 50⅛" (102.9 × 127.3 cm); 42¹⁵⁄₁₆ × 56" (109.1 × 142.2 cm). Elizabeth Bliss Parkinson, Mrs. John D. Rockefeller 3rd, Mrs. Alfred R. Stern, and Jeanne C. Thayer Funds.* *Illus. p. 108.*

Savarin 1 (Cookie). West Islip, U.L.A.E., 1978. Lithograph, printed in black and gray, 16⁵⁄₁₆ × 11³⁄₁₆" (41.4 × 28.4 cm); 25⅞ × 20⅛" (65.7 × 51.1 cm). Gift of Celeste Bartos.*

Savarin 3 (Red). West Islip, U.L.A.E., 1978. Lithograph, printed in color, 21¼ × 15¹¹⁄₁₆" (54 × 39.8 cm); 26¹⁄₁₆ × 20¹⁄₁₆" (66.2 × 51 cm). Gift of Celeste Bartos.*

Savarin 5 (Corpse and Mirror). West Islip, U.L.A.E., 1978. Lithograph, printed in color, 18⅞ × 13⅝" (47.9 × 34.6 cm); 26 × 19¹⁵⁄₁₆" (66 × 50.6 cm). Gift of Celeste Bartos.* *Illus. p. 98.*

Savarin. 1978. Lithograph and monotype, printed in color, 21¹⁄₁₆ × 15³⁄₁₆" (53.5 × 38.6 cm); 27⅜ × 19⁵⁄₁₆" (69.5 × 49.1 cm). Collection Carol and Morton Rapp, Toronto. *Illus. p. 100.*

The Dutch Wives. Tokyo and New York, Simca Print Artists and the artist, 1978. Silkscreen, printed in color, 40¹¹⁄₁₆ × 51¼" (103.3 × 130.2 cm); 43 × 56¹⁄₁₆" (109.2 × 142.4 cm). Gift of Mr. and Mrs. Harry Kahn.* *Illus. p. 109.*

Land's End. London and New York, Petersburg Press, 1978. Etching and aquatint, printed in color, 34⅜ × 24⅝" (87.3 × 62.5 cm); 42 × 29½" (106.7 × 74.9 cm). Collection Elinor K. and Edmund Grasheim, New York. *Illus. p. 128.*

Land's End. Los Angeles, Gemini G.E.L., 1979. Lithograph, 50¹³⁄₁₆ × 35¹³⁄₁₆" (129.1 × 91 cm); 52 × 36" (132.1 × 91.4 cm). Collection James W. Oxnam, New York. *Illus. p. 129.*

Periscope I. Los Angeles, Gemini G.E.L., 1979. Lithograph, printed in color; composition and sheet: 50¼ × 36¼" (127.6 × 92.1 cm). Collection Mr. and Mrs. Donald B. Marron, New York. *Illus. p. 130.*

Cancellation proof for *Periscope I*. 1980. Lithograph, printed in color; composition and sheet: 49¹⁵⁄₁₆ × 35¹⁵⁄₁₆" (126.8 × 91.3 cm). Collection the artist, New York.

Periscope II. Los Angeles, Gemini G.E.L., 1979. Lithograph, 52 × 39¾" (132.1 × 101 cm); 56¼ × 41" (142.9 × 104.1 cm). Collection Mr. and Mrs. Victor W. Ganz, New York. *Illus. p. 131.*

Usuyuki. West Islip, U.L.A.E., 1979. Lithograph, printed in color, 32⅞ × 45¹⁵⁄₁₆" (83.5 × 116.7 cm); 34⁷⁄₁₆ × 50⁵⁄₁₆" (87.5 × 127.8 cm). Gift of Celeste Bartos.* *Illus. p. 120.*

Trial proof for *Usuyuki*. 1979. Lithograph, printed in color, 28¹⁄₁₆ × 44⅝" (71.3 × 113.3 cm); 40⅛ × 59½" (101.9 × 151.1 cm). Collection the artist, New York.

Target with Four Faces. London and New York, Petersburg Press, 1979. Etching and aquatint, printed in color, 23½ × 18" (59.7 × 45.7 cm); 30 × 22" (76.2 × 55.9 cm). Collection Leslie and Johanna Garfield, New York.

Cicada. 1979. From the portfolio *Marginalia: Homage to Shimizu*. Tokyo, The Marginalia Publication Group, Nantenshi Gallery, 1981. Silkscreen, printed in color, 17½ × 13⁷⁄₁₆" (44.5 × 34.1 cm); 22¼ × 18¼" (56.5 × 46.4 cm). Collection Emily Fisher Landau, New York.

Untitled. 1977–80. Los Angeles, Gemini G.E.L., 1980. Lithograph, printed in color; composition and sheet: 34¼ × 30¼" (87 × 76.8 cm). Collection Leslie and Johanna Garfield, New York. *Illus. p. 82.*

Cancellation proof for *Untitled*. 1980. Lithograph, 34 × 30¾" (86.4 × 78.1 cm); 39¹⁄₁₆ × 35¾" (99.2 × 90.8 cm). Collection the artist, New York. *Illus. p. 82.*

Target with Plaster Casts. London and New York, Petersburg Press, 1980. Etching and aquatint, printed in color, 23½ × 17½" (59.7 × 44.5 cm); 29⁹⁄₁₆ × 22⁵⁄₁₆" (75.1 × 56.7 cm). Collection Leslie and Johanna Garfield, New York. *Illus. p. 97.*

Usuyuki. Tokyo and New York, Simca Print Artists and the artist, 1980. Silkscreen, printed in color, 45 × 14¹³⁄₁₆" (114.3 × 37.6 cm); 52 × 20" (132.1 × 50.8 cm). Collection PaineWebber Group Inc., New York. *Illus. p. 121.*

Usuyuki. West Islip, U.L.A.E., 1980. Lithograph, printed in color, 47 × 17¹³⁄₁₆" (119.4 × 45.2 cm); 52½ × 20¼" (133.4 × 51.4 cm). Gift of Celeste Bartos.* *Illus. p. 121.*

Cicada II. 1979–81. Tokyo and New York, Simca Print Artists and the artist, 1981. Silkscreen, printed in color, 17⁷⁄₁₆ × 13⅜" (44.3 × 34 cm); 24 × 19" (61 × 48.3 cm). Given anonymously.* *Illus. p. 123.*

Cicada (**Red**). 1979–81. Tokyo and New York, Simca Print Artists and the artist, 1981. Silkscreen, printed in color, 17½ × 13⁷⁄₁₆″ (44.5 × 34.1 cm); 22¼ × 18¼″ (56.5 × 46.4 cm). Collection Kimiko and John Powers, New York.

Cicada (**Orange**). 1979–81. Tokyo and New York, Simca Print Artists and the artist, 1981. Silkscreen, printed in color, 17½ × 13⁷⁄₁₆″ (44.5 × 34.1 cm); 22¼ × 18¼″ (56.5 × 46.4 cm). Collection Kimiko and John Powers, New York.

Cicada (**Yellow**). 1979–81. Tokyo and New York, Simca Print Artists and the artist, 1981. Silkscreen, printed in color, 17½ × 13⁷⁄₁₆″ (44.5 × 34.1 cm); 22¼ × 18¼″ (56.5 × 46.4 cm). Collection Kimiko and John Powers, New York.

Cicada (**Green**). 1979–81. Tokyo and New York, Simca Print Artists and the artist, 1981. Silkscreen, printed in color, 17½ × 13⁷⁄₁₆″ (44.5 × 34.1 cm); 22¼ × 18¼″ (56.5 × 46.4 cm). Collection Kimiko and John Powers, New York.

Cicada (**Blue**). 1979–81. Tokyo and New York, Simca Print Artists and the artist, 1981. Silkscreen, printed in color, 17½ × 13⁷⁄₁₆″ (44.5 × 34.1 cm); 22¼ × 18¼″ (56.5 × 46.4 cm). Collection Kimiko and John Powers, New York.

Cicada (**Violet**). 1979–81. Tokyo and New York, Simca Print Artists and the artist, 1981. Silkscreen, printed in color, 17½ × 13⁷⁄₁₆″ (44.5 × 34.1 cm); 22¼ × 18¼″ (56.5 × 46.4 cm). Collection Kimiko and John Powers, New York.

Usuyuki. Tokyo and New York, Simca Print Artists and the artist, 1981. Silkscreen, printed in color, 28⁵⁄₁₆ × 45⅜″ (71.9 × 115.3 cm); 29½ × 47¼″ (74.9 × 120 cm). Collection PaineWebber Group Inc., New York.

Savarin. 1977–81. West Islip, U.L.A.E., 1981. Lithograph, printed in color, 39⅞ × 29⁹⁄₁₆″ (101.3 × 75.1 cm); 50¼ × 38⁵⁄₁₆″ (127.6 × 97.3 cm). Gift of Celeste Bartos.*

Savarin. 1982. Lithograph and monotype, printed in color, 42⅜ × 35¹⁄₁₆″ (107.6 × 89.1 cm); 50 × 38″ (127 × 96.5 cm). Collection Nelson Blitz, Jr., New York. *Illus. p. 101.*

Untitled (**Blue**). London and New York, Petersburg Press, 1982. Etching and aquatint, printed in color, 33½ × 24″ (85.1 × 61 cm); 42⅛ × 29¾″ (107 × 75.6 cm). Lent by the publisher.

Voice 2. West Islip, U.L.A.E., 1982. Lithograph, printed in color on three sheets: A: 34 × 23½″ (86.4 × 59.7 cm); B: 34⁷⁄₁₆ × 23⁵⁄₁₆″ (87.5 × 59.2 cm); C: 34⅝ × 23⅜″ (87.9 × 59.4 cm); each sheet: 36 × 24⅝″ (91.4 × 62.5 cm). Gift of Celeste Bartos.* *Illus. p. 88.*

Voice 2. Unpublished, 1982; printed at U.L.A.E. Lithograph, printed in color, 34⅝ × 71⅛″ (87.9 × 180.7 cm); 38⅝ × 75³⁄₁₆″ (98.1 × 191 cm). Collection the artist, New York. *Illus. p. 89.*

Voice 2. Unpublished, 1982; printed at U.L.A.E. Lithograph, printed in color, 34⅝ × 71⅛″ (87.9 × 180.7 cm); 38⅝ × 75³⁄₁₆″ (98.1 × 191 cm). Collection the artist, New York.

Voice 2. Unpublished, 1982; printed at U.L.A.E. Lithograph, printed in color, 34⅝ × 71⅛″ (87.9 × 180.7 cm); 38⅝ × 75³⁄₁₆″ (98.1 × 191 cm). Collection the artist, New York.

Voice 2. West Islip, U.L.A.E., 1982. Lithograph, printed in color, 8¾ × 18½″ (22.2 × 47 cm); 19¹³⁄₁₆ × 25⁷⁄₁₆″ (50.3 × 64.6 cm). Gift of Celeste Bartos.* *Illus. p. 90.*

Voice 2. West Islip, U.L.A.E., 1982. Lithograph, printed in color, 8¾ × 18½″ (22.2 × 47 cm); 19¹³⁄₁₆ × 25⁷⁄₁₆″ (50.3 × 64.6 cm). Private collection, West Hartford, Connecticut. *Illus. p. 90.*

Voice 2. West Islip, U.L.A.E., 1982. Lithograph, printed in color, 8¾ × 18½″ (22.2 × 47 cm); 19¹³⁄₁₆ × 25⁷⁄₁₆″ (50.3 × 64.6 cm). Collection Mr. and Mrs. Victor W. Ganz, New York. *Illus. p. 90.*

Voice 2. West Islip, U.L.A.E., 1982. Lithograph, printed in color, 8¹³⁄₁₆ × 18⅛″ (22.4 × 46 cm); 17⅛ × 23¼″ (43.5 × 59.1 cm). Gift of Celeste Bartos.*

Voice 2. West Islip, U.L.A.E., 1983. Lithograph, printed in color, 8¾ × 18¹¹⁄₁₆″ (22.2 × 47.5 cm); 19¹¹⁄₁₆ × 25⅞″ (50 × 65.7 cm). Gift of Celeste Bartos.*

Untitled. 1983. Monotype, 31¹⁄₁₆ × 90⅝″ (78.9 × 230.2 cm); 37⅝ × 96⅝″ (95.6 × 245.4 cm). Collection the artist, New York. *Illus. p. 124.*

Untitled. 1983. Monotype, printed in color, 31¹⁄₁₆ × 89¹⁵⁄₁₆″ (78.9 × 228.4 cm); 37⅝ × 96⅝″ (95.6 × 245.4 cm). Collection the artist, New York. *Illus. p. 124.*

Untitled. 1983. Monotype, printed in color, 31⅝ × 90¾″ (80.3 × 230.5 cm); 37¹¹⁄₁₆ × 96½″ (95.7 × 245.1 cm). Collection the artist, New York.

Untitled. 1983. Monotype, printed in color, 31 × 91⅛″ (78.7 × 231.5 cm); 37¹⁵⁄₁₆ × 97″ (96.4 × 246.4 cm). Collection the artist, New York.

Untitled. 1983. Monotype, printed in color, approximately 32 × 90″ (81.3 × 228.6 cm); 37½ × 96½″ (95.3 × 245.1 cm). Collection Mr. and Mrs. Donald B. Marron, New York.

Untitled. 1983. Monotype, printed in color, approximately 32 × 90″ (81.3 × 228.6 cm); 37½ × 96½″ (95.3 × 245.1 cm). Collection Robert and Jane Meyerhoff, Phoenix, Maryland. *Illus. pp. 122–23.*

Untitled. 1983. Monotype, printed in color, approximately 32 × 90″ (81.3 × 228.6 cm); 37½ × 96½″ (95.2 × 245.1 cm). Collection Kimiko and John Powers, New York.

Untitled. 1983. Monotype, printed in color, approximately 32 × 90″ (81.3 × 228.6 cm); 37½ × 96½″ (95.3 × 245.1 cm). Collection Equitable Real Estate Group, New York.

Ventriloquist. West Islip, U.L.A.E., 1985. Lithograph, printed in color, 33⁷⁄₁₆ × 23⅛″ (85 × 58.7 cm); 41½ × 27¹⁵⁄₁₆″ (105.4 × 71 cm). Gift of Emily Landau.* *Illus. p. 132.*

Poems by **Wallace Stevens**. San Francisco, The Arion Press, 1985. Etching and aquatint; page: 11¾ × 8⁵⁄₁₆″ (29.8 × 21.1 cm). Gift of Mrs. Alfred R. Stern.* *Illus. p. 133.*

LENDERS TO THE EXHIBITION

Kunstmuseum Basel

Brooke and Carolyn Alexander, New York
Nelson Blitz, Jr., New York
Kate Ganz, London
Mr. and Mrs. Victor W. Ganz, New York
Leslie and Johanna Garfield, New York
Elinor K. and Edmund Grasheim, New York
Jasper Johns, New York
Emily Fisher Landau, New York
Julian Lethbridge, New York
Mr. and Mrs. Donald B. Marron, New York
Robert and Jane Meyerhoff, Phoenix, Maryland
James W. Oxnam, New York
Kimiko and John Powers, New York
Peter and Susan Ralston, New York
Carol and Morton Rapp, Toronto
Two anonymous lenders

Brooke Alexander, Inc., New York
Equitable Real Estate Group, New York
Gemini G.E.L., Los Angeles
Mr. Thomas H. Lee, Thomas H. Lee Company, Boston
PaineWebber Group Inc., New York
Petersburg Press, London and New York

INDEX

Page numbers in boldface refer to plates. Works are prints unless otherwise noted. Dates and/or mediums are indicated only where necessary to distinguish between works having identical titles.

According to What (painting), 30–31, 32
Ale Cans (1964), 18, 20, **63**
Ale Cans (1968) from the portfolio *First Etchings*, 24
Alphabets, 17, **57**
Arrive/Depart (painting), 30

Beckett, Samuel, 28, 36
Black and White Numerals (series), 29, **66, 68–70, 72**
Blackburn, Robert, 13, 27

Cage, John, 20
Callery, Mary, 13
Canvas (painting), 34
Cartoon for Tanya, A, **127**
Castelli, Leo, 48
Casts from Untitled (series), 34, **110–11**
Cézanne, Paul, 11, 48
Cicada, 41–42
Cicada II, 41, **123**
Coat Hanger (painting), 23
Coat Hanger (drawing), 23
Coat Hanger, 18, 22, 29, **60**
Color Numerals (series), 29, 35, **67, 71**
Corpse and Mirror (painting), 31, 37, 39, 40, 44
Corpse and Mirror II (painting), 39, 40
Corpse and Mirror (aquatint and drypoint), 21, 31, 39
Corpse and Mirror (lithograph), 21, 31, 39–40, **106**
Corpse and Mirror (silkscreen), 21, 31, 40, **107**
Crane, Hart, 19
Crichton, Michael, 32
Crommelynck, Aldo, 28, 36, 45
Crommelynck, Piero, 28
Cups 4 Picasso, 48, **95**

Decoy (painting, 1971 [coll. Ganz]), 26, **76**
Decoy (painting, 1971 [coll. Powers]), 26, **75**
Decoy, 26, 28–29, 33, **74**
Decoy II, 26, 28, 33, **77**
Device (1962), 18, 19, 22
Device (1972), 22
Device—Black State, 22, **80**
Dubuffet, Jean, 35
Duchamp, Marcel, 29–30, 31, 44, 48
The Dutch Wives (painting), 32, 37
The Dutch Wives (1977), 21, 32, 41, **108**
The Dutch Wives (1978), 21, 32, **109**

Eddingsville (painting), 19
End Paper (painting), 37

False Start I, 16, 17, 20, **61**
False Start II, 16, 17, 20
Felsen, Sidney, 29
Field Painting (painting), 30–31
First Etchings (portfolio), 18, 24–25, 26, **64**
First Etchings, Second State (portfolio), 25, **65**
Flag (1960), 14, 20, **58**
Flag II (1960), 14, 20, **59**
Flag III (1960), 14–15, 20
Flag (1968) from the portfolio *First Etchings*, 24, **64**
Flag (1969) from the portfolio *First Etchings, Second State*, 25, **65**
Flags (painting), 21
Flags (1968), 21, **103**
Flags I (1973), 21, 39, 40, **105**
Flags II (1970), 21
Flashlight from the portfolio *First Etchings*, 24
Foirades/Fizzles (book with text by Samuel Beckett), 28, 32, 36–37, 38, 39, **67, 116–17**
Fool's House, 22, 32, **81**
Four Panels from Untitled 1972, 22, 34–35, 36, **112–13**
Four Panels from Untitled 1972 (Grays and Black), 35, 36, **114–15**
Fragment—According to What—Bent "Blue" (Second State), 30–31, 33, 40, **93**
Fragment—According to What—Hinged Canvas, 30, 33, 44, **92**
Fragment—According to What—Hinged Canvas cancellation proof, **92**

Geelhaar, Christian, 46
Goldston, Bill, 28
Grinstein, Stanley, 29
Grosman, Maurice, 11
Grosman, Tatyana, 11–13, 15–16, 26–27, 28, 44

Hand, 19
HandFootSockFloor from the series *Casts from Untitled*, 34, **111**
HandFootSockFloor—Black State from the series *Casts from Untitled*, 34, **110**
Harlem Light (painting), 33
Hatching (Front Endpaper) from *Foirades/Fizzles*, **116**
Hatching (Front Endpaper) from *Foirades/Fizzles*, cancellation proof, **116**
Hatteras, 19, 45, 46, **125**
Hayter, Stanley William, 27
Heinrici, Alexander, 38
Hopps, Walter, 20
Hugnet, Georges, 25

In Memory of My Feelings—Frank O'Hara (painting), 24
In the Studio (painting), 45
Inokuma, Genichiro, 39

Kawanishi, Hiroshi, 39
Kline, Franz, 13

Land's End (1978), 19, 45, **128**
Land's End (1979), 45, **129**
Land's End II, 45
Leonardo da Vinci, 48
Lieberman, William S., 12
Light Bulb (1970), 34, **110**
Lightbulb (1968) from the portfolio *First Etchings*, 24
Lozingot, Serge, 35

Magritte, René, 48
Matisse, Henri, 18
Monet, Claude, 43
Munch, Edvard, 21–22, 44

No (painting), 29
No, 29, **84**
#6 (after "Untitled 1975") from the series *6 Lithographs (after "Untitled 1975")*, **118**
Numbers (1968) from the portfolio *First Etchings*, 24, **64**
Numbers (1969) from the portfolio *First Etchings, Second State*, 25, **65**
Numeral 1 from *Foirades/Fizzles*, **67**

O'Hara, Frank, 16, 19–20, 24
Ohr, George, 45

Paintbrushes from the portfolio *First Etchings*, 24, **64**
Painted Bronze (sculptures), 18
Painting with Two Balls (painting), 17, 38
Painting with Two Balls (drawings), 17
Painting with Two Balls I, 16, 17, 20, **62**
Painting with Two Balls (Grays), 38, **79**
Passage I, 18, 23, 25, 26, **73**
Passage II (painting), 23
Perilous Night (painting), 45
Periscope, 45, 46
Periscope I, 19, 45, 46, **130**
Periscope II, 19, 45, 46, **131**
Peto, John Frederick, 32, 48
Picasso, Pablo, 11, 13, 18, 25, 28, 45, 46, 48
Pinion, 18, 19, 21, 23, **126**
Poems (selected poems by Wallace Stevens), frontispiece for, 45–46, 47, **133**
Portrait—Viola Farber (painting), 33
Priede, Zigmunds, 27, 28

Rauschenberg, Robert, 13
Reality and Paradoxes (portfolio), **94**
Red, Yellow, Blue, 17
Redon, Odilon, 37, 47, 48
Ritt, Charles, 29, 35
Rivers, Larry, 12, 15

Savarin (1977), 44, **99**
Savarin (1978), 43–44, **100**
Savarin (1981), 44
Savarin (1982), 18, 44, **101**
Savarin 5 (Corpse and Mirror), **98**
Scent (painting), 37
Scent, 37, 39, **119**
Screen Piece (paintings), 23
Screen Piece, 23, 39
Shimada, Takeshi, 39

6 Lithographs (after "Untitled 1975") (series), 40, **118**
Skin with O'Hara Poem, 19, **127**
Smith, James, 28
Souvenir, **91**
Steinberg, Leo, 18
Stevens, Wallace, 46
Steward, Donn, 26, 28

Target (1960), 13, **53**
Target (1974), **96**
Target with Four Faces (painting), 34, 45
Target with Four Faces (1968), 38, 45
Target with Four Faces (1978), 45
Target with Plaster Casts (painting), 34, 45
Target with Plaster Casts, 45, **97**
Targets (painting), 21
Targets, 21
Toulouse-Lautrec, Henri de, 11
Two Flags (painting), 39
Two Flags (Gray), 21, 39, **104**
Two Maps I, 20–21, 34
Two Maps II, 20–21, 34, **102**
Tyler, Ken, 29

Untitled (painting, 1972), 31–32, 33–34, 37, 40
Untitled (painting, 1975), 37, 41
Untitled (painting, 1979), 43
Untitled (1980), **82**
Untitled (1980) cancellation proof, **82**
Untitled (1982), 45
Untitled (monotypes, 1983), 22, 43, 44, **122–24**
Untitled (Ruler and Fork) II, 27, **85**
Untitled (Skull) from the portfolio *Reality and Paradoxes*, **94**
Usuyuki (lithograph, 1979), 22, 42–43, **120**
Usuyuki (silkscreen, 1980), 22, 41, 42–43, **121**
Usuyuki (lithograph, 1980), 22, 42–43, **121**
Usuyuki (silkscreen, 1981), 22, 41, 42–43

Ventriloquist, 22, 45, 47, **132**
Viola, 32, 33
Voice (painting), 23, 24, 46
Voice, 18, 23, 34, **83**
Voice 2 (painting), 23, 46, 47, **86–87**
Voice 2 (lithograph on three sheets, 1982), 22, 46, 47, **88**
Voice 2 (unpublished lithograph, 1982), 22, 46, **89**
Voice 2 (lithographs, 1982), 22, 46–47, **90**
Voice 2 (1983), 22, 46, 47

Wall Piece (paintings), 23, 34
Wall Piece (drawings), 23, 34
Watchman, **78**
Wayne, June, 27
Whistler, James Abbott McNeill, 15
Wittgenstein, Ludwig, 48
Words (Buttock Knee Sock...) from *Foirades/Fizzles*, **117**

Yokoo, Tadanori, 39

0–9, **56**
0–9 (portfolio), 13–14, 29, **54–55**
Zigrosser, Carl, 12